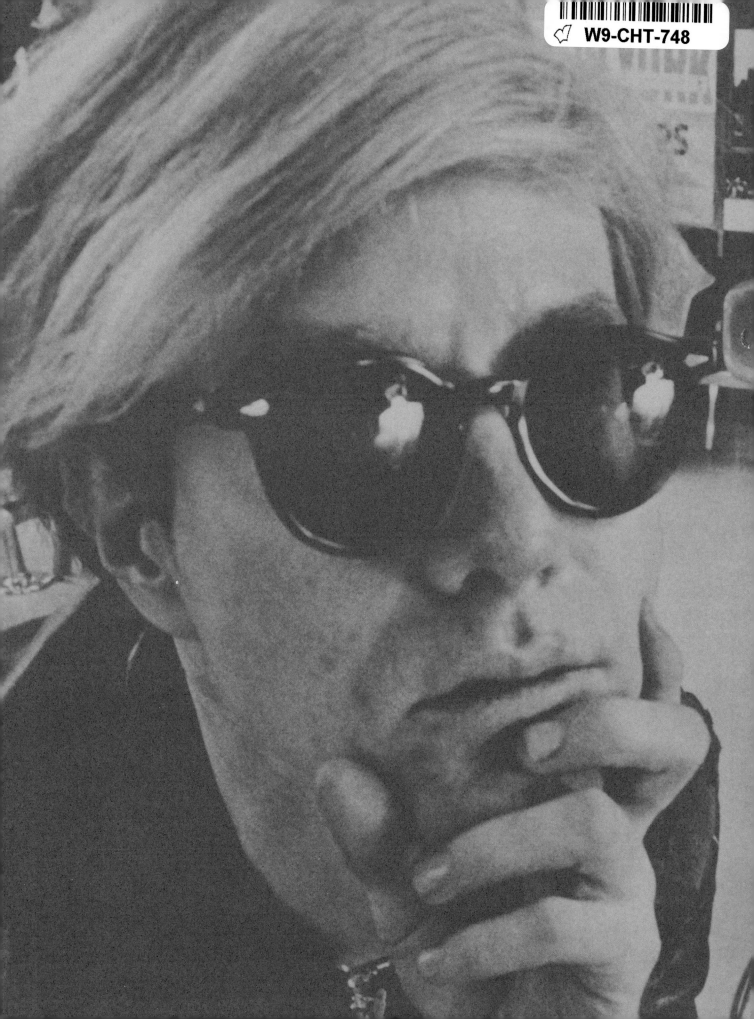

THE ANDY WARHOL MUSEUM

THE ANDY WARHOL MUSEUM

The Andy Warhol Museum is one of the museums
of Carnegie Institute and is a collaborative project of
Carnegie Institute, Dia Center for the Arts, and
The Andy Warhol Foundation for the Visual Arts, Inc.

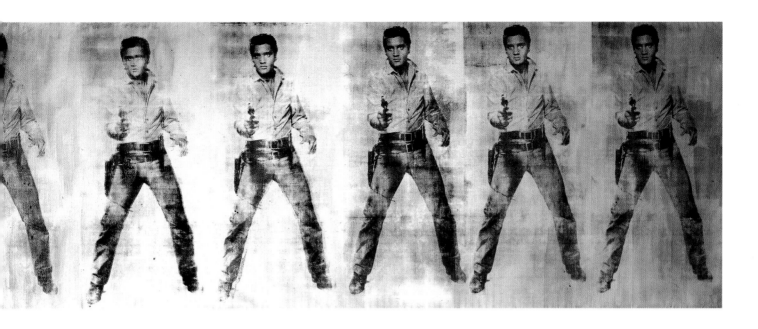

Essays by

Callie Angell

Avis Berman

Arthur C. Danto

Mark Francis

Richard Hellinger

Bennard B. Perlman

Helen Searing

Compact disc by

Steve Rowland

The Andy Warhol Museum, Pittsburgh

Distributed Art Publishers, New York

Cantz Publishers, Stuttgart

Trade Edition published in 1994 by
Distributed Art Publishers, Inc.
636 Broadway, 12th Floor
New York, New York 10012
212.473.5119 telephone
212.673.2887 fax

European Trade Edition published
in 1994 by Cantz Verlag
Senefelder Strasse 9
D-73760 Ostfildern
(0) 711.44.99.30 telephone
(0) 711.44.14.579 fax

ISBN 0-88038-026-3 (Museum edition)
ISBN 1-881616-34-7 (Trade edition)
ISBN 3-89322-644-3 (Trade edition Cantz/Europe)

Library of Congress Cataloging-in-Publication Data
The Andy Warhol Museum: the inaugural publication/
with contributions by Callie Angell...[et al.].
 p. cm.
Includes bibliographical references.
ISBN 0-88039-026-3
1. Andy Warhol Museum. 2. Warhol, Andy, 1928-1987 – Archives.
1. Angell, Callie. 11. Andy Warhol Museum.
N6537.W28A79 1994
700' .92-dc20 94-7351
 CIP

Printed in Germany by Cantz

All works illustrated are in the collection of
The Andy Warhol Museum unless otherwise noted.

The Andy Warhol Museum
117 Sandusky Street
Pittsburgh, Pennsylvania 15212

Title page:
Elvis (Eleven Times), c. 1963
Synthetic polymer paint and silkscreen on canvas
82 x 438 in. (208.3 x 1012.5 cm)
Founding Collection, Contribution
The Andy Warhol Foundation for the Visual Arts, Inc.

CONTENTS

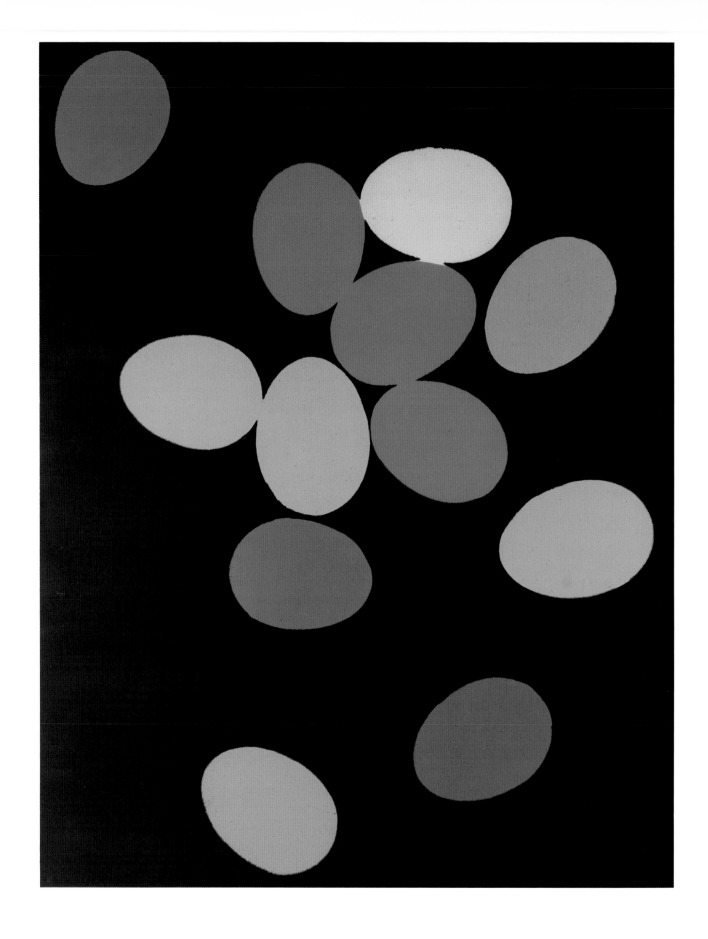

Eggs, 1982
Synthetic polymer paint and silkscreen on canvas, 90 x 70 in. (228.6 x 177.8 cm)
Founding Collection, Contribution The Andy Warhol Foundation for the Visual Arts, Inc.

DIRECTOR'S FOREWORD

The 1876 centennial celebration of the founding of the United States stimulated the creation of institutions that would make the history and pleasures of the visual arts more widely available. Civic leaders recognized the need to provide cultural amenities for the public as part of the rewards for participating in an increasingly industrialized society. They hoped that access to the fine arts would contribute to social harmony and the moral improvement of the population at large. Although the Pennsylvania Academy of the Fine Arts had been founded in 1805, the great civic institutions such as The Metropolitan Museum of Art in New York, the Corcoran Gallery of Art in Washington, D.C., and The Art Institute of Chicago, among others, were not established until after the Civil War when the philanthropic spirit of new industrial wealth became manifest.

Conceived as veritable temples of art—imposing buildings adorned in the classical style—these museums presented the art of other cultures and encouraged devotion to accepted accomplishments of the past. Such works were regarded as representative of the highest level of aesthetic achievement. It took another three-quarters of a century before the American public—or, for that matter, American institutions of higher learning—attached significance to the art of their own country. Only after World War II, when American art became preeminent internationally, did Americans recognize the value of their own cultural contributions. And even this awakening had its beginnings in Europe.

In the 1930s Adolf Hitler set out to destroy the modernist expressions of German and European culture in order to establish icons that would reinforce his control over the populations he tyrannized. The Bauhaus was forced to close in 1933, and in 1939 "degenerate" art was removed from German museums and either destroyed or dispersed. The intelligentsia—artists, writers, composers, performers, scientists, and academics of all kinds—fled Germany and many of them came to live and teach in the United States. They brought with them a strong sense of the dignity of artistic life, as well as new ways of thinking about the nature of creativity.

Exposure to the supportive atmosphere engendered by these refugee artists and intellectuals, combined with the economic resurgence after World War II, gave strong encouragement to a new generation of artists in the United States. In addition, under the G.I. Bill which provided educational benefits to veterans, young people who otherwise might not have had the means to receive formal training as artists now had the opportunity to do so. As they matured, these talented American artists gained the world's attention, and the European dominance that had always characterized the cultural relationship between Europe and the United States was dramatically reversed. It was now the imagination and energy of Americans that was called upon to reinvigorate postwar European art. Among the leading American artists who found an enthusiastic reception in Europe was Andy Warhol.

The Andy Warhol Museum represents a singularly important event in American art history: the creation of the first museum devoted entirely to the work of an American artist of the postwar generation. That Andy Warhol should receive this validation is fitting, primarily because his life and work embody many of the character-

istics of his time: the extraordinary ambition of his generation, the excesses of popular culture, and the remarkable scope and originality of intellectual exploration and innovation that marked this period. With the resources of a vast collection of works of art, and the most comprehensive archives of a single artist ever assembled, The Andy Warhol Museum will give the public insights into the life and achievements of Andy Warhol the graphic artist, painter, sculptor, printmaker, filmmaker, music producer, collector, author, publisher, businessman, and celebrity.

The contents of this inaugural publication are as diverse and varied as the life and work of the artist. The book begins with an essay by Avis Berman which recounts the circumstances and actions that transformed the Warhol Museum from an idea into a reality. Architectural historian Helen Searing provides the context for Richard Gluckman's inspired renovation of an industrial-commercial warehouse to serve as the home of the museum. Explorations of Warhol's work, with an essay by curator Mark Francis and a philosophical exegesis by critic Arthur Danto, are joined by new information on the artist as filmmaker by Callie Angell, film historian. The reminiscences and research of Bennard Perlman, a college classmate and friend of Warhol's as well as an artist himself, offer a fresh look into the education and evolution of the young Andy Warhol as artist. A discussion of the origin and nature of the Warhol archives by Richard Hellinger suggests the vast and unusual range of source material about the artist, whose life is documented in a detailed and extensively illustrated chronology compiled by assistant curator Margery King.

This publication would not have been possible without the generous support of The Asahi Shimbun, Tokyo, Japan, which has graciously assisted us in recognition of our future work together on a major Warhol retrospective to be presented at three museums in Japan in 1996.

The exceptional generosity of the Commonwealth of Pennsylvania made the founding of The Andy Warhol Museum possible. Other leadership funding was provided by the Howard Heinz Endowment, the Vira I. Heinz Endowment, The Andy Warhol Foundation for the Visual Arts, Inc., The Henry L. Hillman Foundation, the Alcoa Foundation, The Henry Luce Foundation, Inc. and Philip Chosky. The endorsement of Allegheny County and City of Pittsburgh officials was essential to the success of our project.

The opening of The Andy Warhol Museum is the culmination of concepts and hopes first voiced more than twenty years ago. Since the actual planning began in 1989, the number of people who have had major roles is too great for each to be acknowledged adequately. In the essays, however, many are noted by the authors, to whom we are indebted for their original research and thoughtful inquiry.

Very little in Warhol's life and work was based on preconceived notions of style or form. He harvested ideas from everything that was going on around him and thrived on a cacophony of experiences which he edited and then subjected to his own order. We hope that, through this book and The Andy Warhol Museum, we convey some of the spirit of this extraordinary artist and his work so that he continues to reach others as he does us.

Tom Armstrong
Director

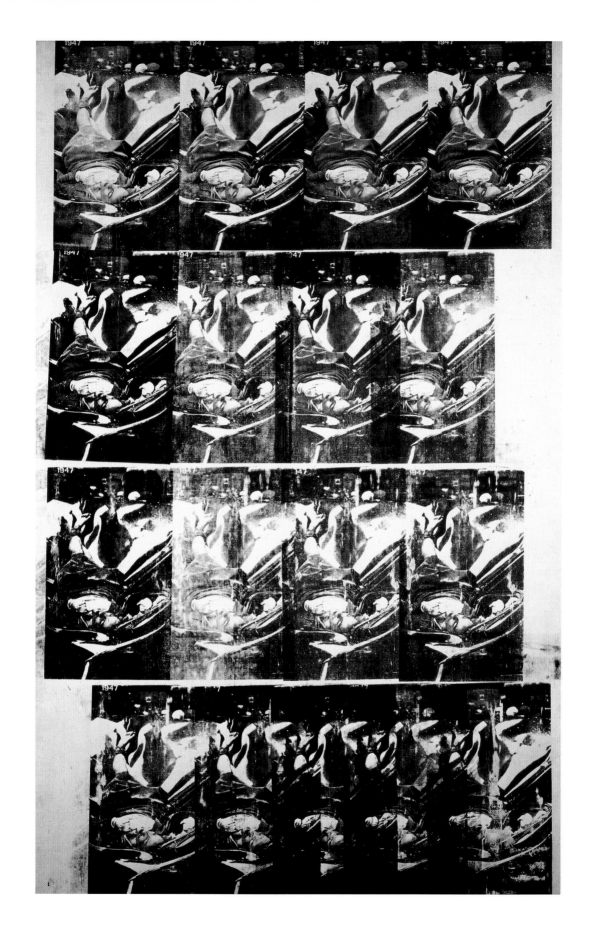

1947- White, 1963
Synthetic polymer paint and silkscreen on canvas, 122 x 78 in. (309.9 x 198.1 cm)
Founding Collection, Contribution Dia Center for the Arts

Camouflage, 1986
Synthetic polymer paint and silkscreen on canvas, 80 x 80 in. (203.2 x 203.2 cm)
Founding Collection, Contribution The Andy Warhol Foundation for the Visual Arts, Inc.

JOINT VENTURE COMMITTEE STATEMENT

In 1989, convinced of the greatness of Andy Warhol's contribution to the art of the twentieth century, our three institutions – Carnegie Institute, Dia Center for the Arts, and The Andy Warhol Foundation for the Visual Arts – came together to form The Andy Warhol Museum. Through our joint venture, one of the largest new museums in the United States has been created, with dimensions and resources far beyond those any one of us could have developed on our own.

The Carnegie Institute, at whose Saturday morning classes Andy Warhol received his first formal art lessons while attending elementary school, was founded by Andrew Carnegie and opened in 1895. It was Carnegie's first major benefaction to provide the large working-class population of Pittsburgh with access to culture, to arouse the "latent desire for the things of the spirit which lay inert in the hearts of our fellow citizens of the industrial hive." The Carnegie now comprises the Museum of Art, the Museum of Natural History, the Music Hall, and the Library of Pittsburgh in Oakland, and The Carnegie Science Center and The Andy Warhol Museum on the North Side.

The Museum of Art has long been known not only for its collections but also for the Carnegie International exhibitions, initiated by the founder in 1896 as a focus of activity to bring international contemporary art to the city. Unlike other museums founded during the same period, The Carnegie Museum of Art was dedicated to the present in accordance with Carnegie's wish that "the field for which the gallery is designed begins with the year 1896." This tradition made the Carnegie

Institute a natural partner in the effort to establish The Andy Warhol Museum in Pittsburgh.

Dia Center for the Arts is one of the largest organizations in the country dedicated to contemporary art. Dia's primary mission is to initiate and organize long-term in-depth installations and exhibitions of artists' work in collaboration both with living artists and with other arts institutions. In addition to The Andy Warhol Museum, Dia's ongoing projects include Walter De Maria's *Lightning Field* in Quemado, New Mexico; the Donald Judd and John Chamberlain installations in Marfa, Texas (now administered by the Chinati Foundation); and soon, the Cy Twombly Museum in Houston, Texas, in partnership with Cy Twombly and the Menil Foundation. A pioneer in the renovation of warehouse space for exhibitions of contemporary art, Dia also presents works from its extensive collection at its New York facility.

Working with the artist, Dia presented a series of exhibitions of Andy Warhol's work at its space on Wooster Street in New York beginning in 1986. Soon after Warhol's death the following year, Dia began to seek a permanent public site for its extensive Warhol collection (assembled by Dia and the artist to include major works from every phase of Warhol's career), and first brought the idea of a collaborative undertaking to The Carnegie in the winter of 1988. Dia will continue its involvement with The Andy Warhol Museum through an ongoing program of highly focused exhibitions of Warhol's work at its new exhibition facility in New York.

The Andy Warhol Foundation for the Visual Arts

was created with the assets of the artist's estate. From the time of Warhol's death in February 1987, it was the ambition of Frederick W. Hughes, his friend and business manager since 1967, as well as of others associated with the artist to secure Warhol's role in history by establishing a museum devoted to his work. The foundation, whose stated purpose is to promote educational and curatorial advancement in the visual arts, historic preservation, and parks, was in an ideal situation to lay the groundwork for this endeavor and has done so by contributing a vast collection of 3,000 works of art, as well as an enormous collection of archival material. Together the art and archival collections have created the most comprehensive museum devoted to the work of a single artist.

While many individuals participated in the early efforts to bring the Warhol Museum to Pittsburgh, as the essay on the founding of the museum recounts, the vision of the late Senator H. John Heinz III, who knew Warhol and was committed to the founding of the museum in his hometown and the dedication of Robert C. Wilburn, who, as President of The Carnegie from 1984 to 1992, convinced the Commonwealth of Pennsylvania to become the museum's leading patron, each deserve special acknowledgment here.

The Andy Warhol Museum is one of the museums of Carnegie Institute. Phillip M. Johnston, director, The Carnegie Museum of Art, and his staff deserve great credit for their nurturing of the project through its early stages.

The sensitive and thoughtful renovation by Richard Gluckman Architects of the Volkwein Building, chosen after a long search as the site of the museum, confirms the original sense of the collaborating institutions that a simple industrial warehouse would provide the ideal setting for the presentation of Warhol's work. When this building was first purchased in 1989, the expectation was that only part of it would be devoted to the museum. Development of the art and archival collections ultimately led to the realization that the entire 88,000 square-foot building, with approximately 42,000 square feet of public space, was needed to accommodate the museum's immense collections and multifaceted programs and activities.

Three institutions and many individuals have collaborated to create an exceptional cultural resource for an international audience. We believe that the collections of The Andy Warhol Museum, under the guidance of director Tom Armstrong and curator Mark Francis, will enrich the public's understanding of a pivotal moment in twentieth century culture by making available not only the work but the personal archive of one of America's greatest artists.

Ellsworth H. Brown
President
Carnegie Institute and
The Carnegie Library of Pittsburgh

Charles B. Wright
Executive Director
Dia Center for the Arts

Archibald L. Gillies
President
The Andy Warhol Foundation for the Visual Arts, Inc.

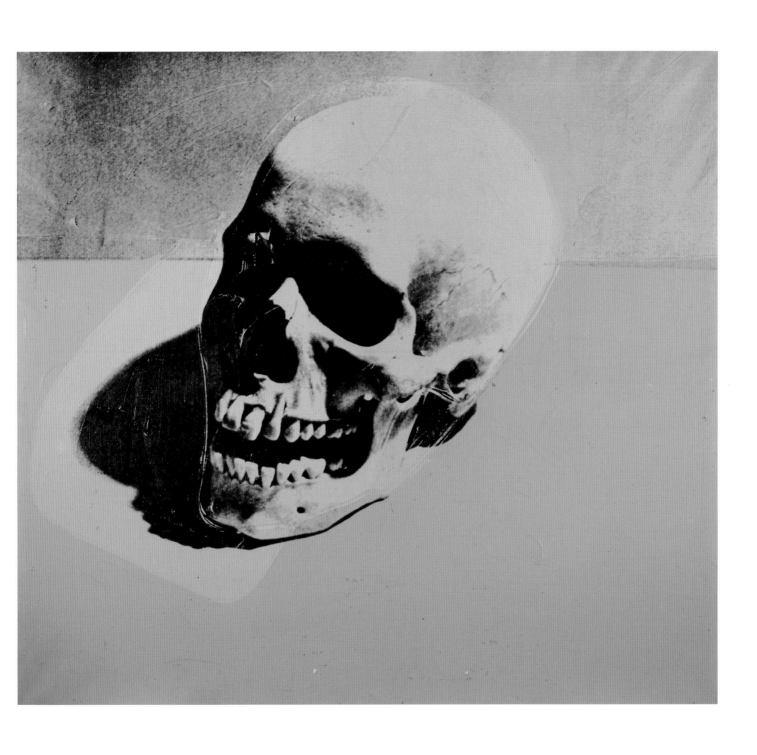

Skull, 1976
Synthetic polymer paint and silkscreen on canvas, 120 x 132 in. (304.8 x 335.3 cm)
Founding Collection, Contribution Dia Center for the Arts

13

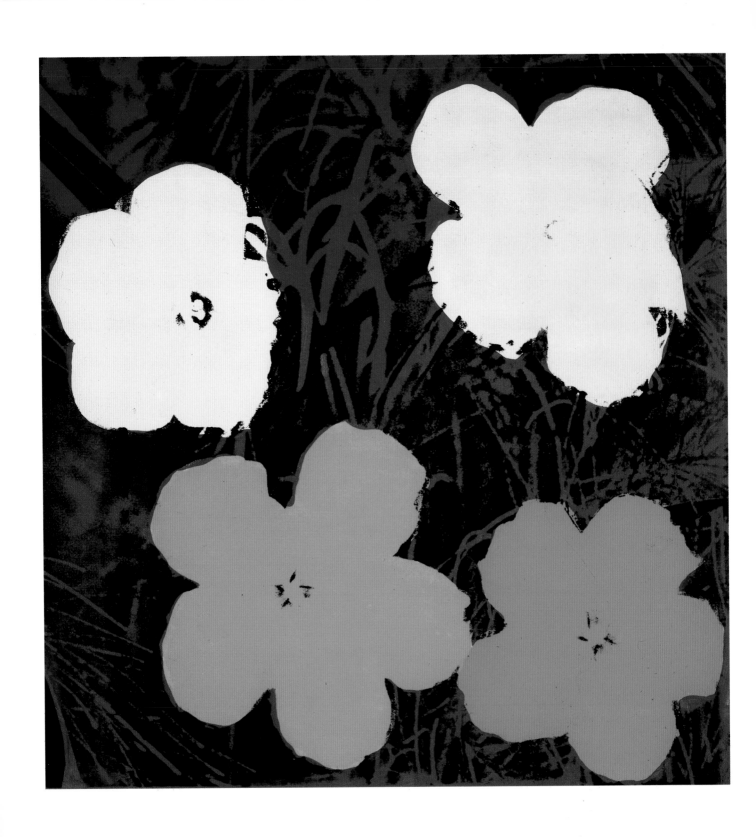

Flowers, 1967
Synthetic polymer paint and silkscreen on canvas, 48 x 48 in. (121.9 x 121.9 cm)
Founding Collection, Contribution The Andy Warhol Foundation for the Visual Arts, Inc.

14

SPONSOR'S STATEMENT

It is an honor to extend our warmest congratulations on the occasion of the opening of The Andy Warhol Museum.

The works of Andy Warhol are unique and provocative, and his widespread achievements have had a great influence in Japan. It is truly an honor for us to cooperate with The Andy Warhol Museum by supporting this inaugural publication.

With the vital involvement of The Andy Warhol Museum, The Asahi Shimbun will present the first Japanese retrospective of Andy Warhol's work, which will travel to three museums in 1996.

We would like to thank The Andy Warhol Museum and offer our best wishes for a brilliant success.

Takao Tomioka
Board Director for Cultural Affairs and Sports
The Asahi Shimbun

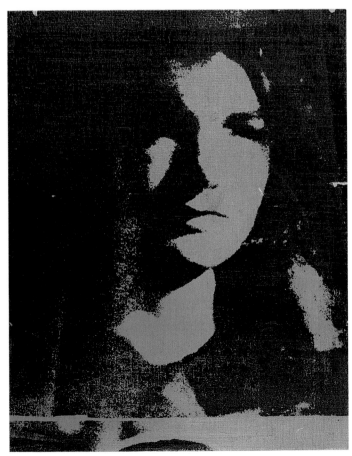

THE RIGHT PLACE:
THE FOUNDING OF THE ANDY WARHOL MUSEUM

The best way to remember Andy

is to make sure his paintings

are hung in the right place.

Fred Hughes[1]

Jackie, 1964
Synthetic polymer paint and silkscreen on canvas
4 panels, 20 x 16 in. (50.8 x 40.6 cm) each
Founding Collection, Contribution
The Andy Warhol Foundation for the Visual Arts, Inc.

The germ of what is now The Andy Warhol Museum can be traced back to the 1960s, the 1970s, or the 1980s, depending on your point of view. Did it begin in 1963, when Heiner Friedrich saw his first Warhol painting? Or in 1974, when he and Philippa de Menil established the Dia Art Foundation, which collected Warhol's work in unrivaled depth? Or is 1987, when Fred Hughes first considered giving works of art from the Andy Warhol estate to The Carnegie Museum of Art, the year to be identified as the Ur-conception? So dense is the web of luck, desire, circumstance, finesse, frustration, tenacity, and coincidence surrounding the invention of The Andy Warhol Museum that many possibilities deserve consideration. Moreover, no one can decide definitively when the *idea* of the institution was hatched, because its origins are without precedent in the mainstream history of American museums. The Warhol Museum was not the strictly regimented creation of a single, overriding sensibility, as were the galleries built by Albert Barnes and Isabella Stewart Gardner; nor was its impetus a group of leading citizens who also happened to be private collectors, which was the case with The Metropolitan Museum of Art. Nor does it fit the pattern of most other single-artist museums here and abroad, in which a few works of art are perennially displayed in the confines of their creator's former house or studio. Instead, The Andy Warhol Museum is the product of three distinct and powerful art institutions, a triple entente of divergent interests that had to learn how to cooperate with each other. And since the built-in prudence of institutional undertakings is not associated with brisk decision making, the pace of the museum's development often seemed

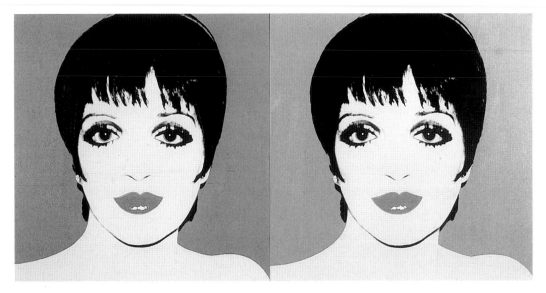

Liza Minnelli, 1979
Synthetic polymer paint and
silkscreen on canvas
40 x 40 in. (101.6 x 101.6 cm) each
Founding Collection, Contribution
Dia Center for the Arts

terribly slow. The turning points were far removed from any original brainstorms or eurekas.

That said, the first proposal for a permanent gallery devoted to the work of Andy Warhol in Pittsburgh was made about fifteen years ago. The art dealer Heiner Friedrich and his wife, Philippa de Menil, an heiress to the Schlumberger oil exploration fortune, had established the Dia Art Foundation in 1974 to encourage venturesome artists, support them financially, and set up permanent, in-depth installations of their work. By the late 1970s, they were ready to inaugurate several of these environments, and they needed advice on how to construct a legal framework for them. In 1978, Thomas B. Hess, then the curator of twentieth-century art at The Metropolitan Museum of Art, recommended that they speak to Ashton Hawkins, the museum's secretary and general counsel. Hawkins recalled that the museums in question were to be dedicated to Andy Warhol and Barnett Newman. (Among other artists collected and supported by Dia then were Donald Judd, Dan Flavin, Cy Twombly, and Walter De Maria.) At the time, Hawkins said, the concept was of a small-scale operation with works shown on a continuous basis and with some changes every six or eight months. Hawkins gave them advice, but didn't hear further about the project.[2]

In 1980 or 1981, a few years after those preliminary talks, Heiner Friedrich discussed the idea of an Andy Warhol Museum with the artist himself. Friedrich, who had successfully promoted Warhol in Europe in the 1960s, was a friend and admirer of long standing — his acquaintance went back to 1963, when he saw his first Warhol painting and was "fascinated." Friedrich worked closely with Warhol to form Dia's holdings. "Most of the works we collected were acquired from the artist's studio in consultation with Andy," Friedrich said. "We tried to find work prior to 1962. We were especially interested in the *Disaster* paintings, and we collected those in some depth."[3] Dia remained Warhol's greatest patron, and its largesse culminated in the *Shadow* series, a 1978 commission consisting of 102 canvases. Accordingly, Warhol and Friedrich were used to conferring on any and all matters having to do with the disposition and enhancement of the collection they had made together. Not only did Friedrich approach Warhol about establishing a museum for him, but when he couldn't find suitable space in New York, he raised the subject of situating it in the artist's hometown. When this happened, Friedrich recalled, Warhol smiled and said, "Why Pittsburgh?" sort of indicating, "Why not New York?" His reaction was characteristically elliptical. As Friedrich described the incident:

Andy just smiled. That was his freedom. He was always asking, in a certain way, back if something was offered to him — that was his style. He was not really so interested to have a museum in Pittsburgh, I think, because of his memories, and because New York was the place where all his fame unfolded, but he was very precisely allowing everything to happen.[4]

Nothing much did happen, however, and no more was said on the subject. Indeed, most of Dia's patronage ended by 1984, when the foundation began to have financial problems and had to retrench. In 1985 the foundation was overhauled — Friedrich resigned as director, Ashton Hawkins became chairman of the board of

Installation view,
Disaster Paintings, 1963
Dia Art Foundation
77 Wooster Street, New York

trustees, and Dia stopped purchasing art and providing stipends for artists. Charles B. Wright, an attorney and the son of two prominent Seattle collectors, was hired as executive director. Now that Dia had become mainly a lending and exhibiting organization, its expenditures were cut drastically and the scope of its projects reduced, but the commitment to Warhol was honored. At Wright's instigation, the foundation mounted three focused, long-term exhibitions of Warhol's work, running consecutively from 1986 to 1988, in its space at 77 Wooster Street in SoHo. Warhol helped design each of the shows, and it looked as if the Wooster Street rooms might evolve into a de facto Warhol museum.

On February 22, 1987, Andy Warhol died, suddenly and unexpectedly. His death, coupled with Dia's now more modest mission, moved trustees and staff to think about what to do with the nearly 200 Warhols owned by the foundation. Charlie Wright, though committed to the idealistic and lavish patronage espoused by Friedrich, was also very practical. In pondering the fate of Dia's permanent collection, he saw that it was static. Its holdings were on loan to the Menil Collection in Houston to avoid the high cost of storing art in New York. Dia no longer had the money or the gallery space to do its collection justice, and it could not sustain its dream of nurturing the making and showing of art alone. Wright suggested that Dia look for financially healthy partners who could house and preserve its collection in a manner compatible with the foundation's original spirit, and one of the first oeuvres he hoped to transfer to a safe home was that of Andy Warhol. The idea was to offer more

than 80 paintings, prints, and drawings, including the iconic *Campbell's Soup Can*, *Coca-Cola*, and *Dollar Bill*, as well as *Disaster* paintings, self-portraits, and images of celebrities from politics, sports, and Hollywood. That is, Dia was prepared to give up every Warhol it owned except for the paintings in the *Shadow* series.

Dia's trustees were amenable to Wright's solution, and he was directed to talk with representatives of the principal art institutions in New York – The Metropolitan, The Museum of Modern Art, the Whitney Museum of American Art, and the Brooklyn Museum – to see if any of them would like to affiliate with Dia and be responsible for the permanent upkeep and display of its Warhols. Given what Dia required, the response was unsatisfactory. As these museums already had works by Warhol in their collections, none wanted to take more than a few, and although some may have been willing to contribute a gallery or two in exchange for a gift of this magnitude, none was about to commit to underwriting a permanent, freestanding, single-artist environment, which is what Dia wanted.[5] (Before his death in 1988, Isamu Noguchi attempted to graft the museum of his work that he founded in Long Island City onto various New York institutions, and he too was rebuffed. In each case, the museums viewed the acquisition as an unnecessary diversion of resources rather than as a positive development.) Once Dia's board was certain that New York museums were not receptive to taking its Warhol collection, it charged Wright to look elsewhere.[6]

About the time Wright began to seek out-of-town partners for Dia, James A. Fisher, a native of Pittsburgh

Vincent Fremont and Andy Warhol at Studio 54

Frederick W. Hughes

and a trustee of Carnegie Institute, had also taken notice of Andy Warhol's demise. In August 1987, while Fisher and his wife, Edith, were vacationing in France, Robert Becker, a writer who had worked for *Interview* magazine, paid them a visit. He told them that Warhol's estate was far bigger than anyone had suspected and that the Andy Warhol Foundation for the Visual Arts, the grant-giving body incorporated a few months after the artist's death, was going to be in a position to make sizable awards to museums and other cultural institutions. Fisher, long active in museum fundraising, was chairman of the institute's development committee, and he immediately concluded that The Carnegie should make overtures to the new foundation. That fall, when he returned to Pittsburgh, he called the Warhol Foundation and was given an appointment with Frederick W. Hughes.[7]

Andy Warhol's will stipulated that, aside from bequests to family and friends, the bulk of his fortune, which included cash, real estate, jewelry, and hundreds of examples of his own work, be used to start a foundation that would aid the visual arts. That foundation would be directed by John Warhola, the artist's brother; Vincent Fremont, the Warhol studio's chief administrator; and Hughes, Warhol's friend, business manager, and executor of his estate. As executor and as president of the Warhol Foundation, Hughes had carte blanche to determine the organization's direction, and he used his power to build up the monetary value of the estate with sales, including the now legendary auction of Warhol's art collection, furniture, jewelry, and bric-à-brac, which realized more than $23 million in April 1988.

How much Fisher knew about Hughes's near absolute control of the Warhol Foundation is debatable, but he flew to New York in the autumn of 1987 to tout The Carnegie's virtues. He remembers,

I walked into 22 East 33rd Street, what was then the Warhol studio, which was in utter chaos. Just a zoo of memorabilia and records and books. It was directed by nice but odd-looking people. Up, down through this elevator, which didn't work, or did, and finally, through this jungle, I found my way to Fred's office.[8]

Fisher was shooting for $100,000 for a scholarship program for young artists in Pittsburgh or for a program to help children learn about art. He believed that the combination of Andy Warhol and young people would have appeal, and so it did for Hughes. They talked for about an hour and a half, realized that they had a great deal more to say, and went out for a lunch that lasted until four o'clock. Fisher's carefully scheduled plan of catching an early plane back to Pittsburgh vanished, but that, he said, "didn't make any difference. We left on the best of terms — we just seemed to hit it off."[9]

Hughes asked Fisher to send him as much information as he could about the Carnegie museums, and a huge box of publications, photographs, reviews, and exhibition descriptions was shipped to New York. Hughes became more and more interested in The Carnegie, and the next time the two men met, in late 1987 or early 1988, Hughes stated that he wanted to do much more than Fisher had originally requested. He proposed the idea of a major installation of Warhol's work somewhere, in New York or perhaps in Pittsburgh.

"Of course, chauvinism rose to the top," Fisher said,

Andrew Carnegie, 1981
Synthetic polymer paint and silkscreen on canvas
98 x 79 in. (248.9 x 200.7 cm)
The Carnegie Museum of Art, Pittsburgh;
Richard M. Scaife American Painting Fund

"and I began to make a pitch for Pittsburgh, all of which Fred had thought through. I didn't lead him – he led me. My idea for a scholarship program was engulfed by a much, much bigger concept."[10] Evidently, Hughes was planning to make good on this more ambitious level of commitment, because in an article on the Warhol estate that ran in the February 22, 1988 issue of *New York* magazine, it was announced that Hughes was "considering gifts to such places as the Carnegie Institute in Pittsburgh," which he characterized as being one of "the best things we can [do] with the money."[11] Thus by late-February 1988, Fred Hughes was very favorably disposed toward Pittsburgh.

While Hughes and Fisher were cementing their friendship, someone suggested to Charlie Wright that he consider Pittsburgh as a potential site for an Andy Warhol center because it was the artist's birthplace. (Wright, who doesn't think that this original insight was his own, cannot remember who first told him to try Pittsburgh. Hughes insists he was the one, but Wright is certain that they didn't discuss a proposed collaboration until after his own first trip to Pittsburgh.[12] However, since Hughes had been talking to Fisher about a massive Warhol endeavor involving The Carnegie almost exactly when Wright decided to solicit Pittsburgh, Hughes could easily have conflated the two projects.) In late 1987, knowing no one in Pittsburgh and acting quite independently of Hughes, Wright called John R. Lane, a former director of The Carnegie Museum of Art. He asked Lane what he thought of giving Dia's Warhols to Pittsburgh, and Lane replied that it was a wonderful idea, as he and John Caldwell (then The Carnegie's curator of contemporary art) had worked assiduously to reinvigorate the Carnegie International and to make the museum more hospitable to contemporary art. Indeed, during Jack Lane's directorship, Warhol had been commissioned to paint a portrait of Andrew Carnegie and invited to participate in the 1988 International.[13]

Wright wanted to know how to approach Pittsburgh, and Lane gave him several names, including that of William Lafe, a staff member of the Howard Heinz Endowment, whom Wright eventually telephoned. Lafe directed Wright to Robert C. Wilburn, the president of Carnegie Institute. In their conversation, Wright told Wilburn that Dia was prepared to donate 60 to 80 works from its Warhol collection to any local group willing to establish a museum for them. Would The Carnegie be interested in sponsoring such a venture? Wilburn was intrigued by the scheme, and agreed to meet Wright in Pittsburgh on March 15, 1988.

Wright expected to chat with Wilburn and one or two other people, but Wilburn got on the telephone and didn't get off until he had reached nearly everyone of consequence in the city. "The first time I heard about it, I felt it was something we had to get for Pittsburgh," said Wilburn.

We had very few paintings by Andy Warhol in our collection, and we saw that as being a great gap, particularly since he was from Pittsburgh. We didn't know whether we were talking about getting a small collection of paintings that we could fit into the museum, or some kind of special collection that would

Robert C. Wilburn

Phillip M. Johnston

go elsewhere. But it was very important to get the paintings to Pittsburgh. We had to make it happen.[14]

Accordingly, Wilburn took the position that it did not matter whether or not the paintings came to The Carnegie; it was more important to have them come to the city of Pittsburgh. He proposed to give Dia as many choices of affiliates as possible, by assembling everyone who might have an interest in having an art museum, creating an art museum, or running an art museum.

When Wright walked into the meeting, not only were there officials from Carnegie Institute present— Wilburn; Andrew J. Hungerman III, the chief financial officer; Phillip M. Johnston, then acting director of the Museum of Art; and Caldwell—but representatives from the city, the parks department, the cultural commission, and the Heinz and Hillman family foundations had come as well. "The room was completely full of people," Wright recalled. "I was overwhelmed by the greeting."[15] For his part, Wilburn remembered talking to the group before Charlie Wright arrived, and saying, "'We don't want to show any skepticism at this time. We want to be all-embracing and positive.' Everybody wanted to make it a sort of love affair about how much we wanted the museum in Pittsburgh."[16] Tactically, convening such a gathering of people showed what a broad base of support The Carnegie enjoyed and how much influence it exerted.

Dia and Wright were benefiting from an atmosphere of present amazement and past rue. When Johnston heard that Dia was interested in divesting itself of its classic Warhols and would consider giving them to Pittsburgh, he couldn't believe it.[17] Pittsburgh art lovers were keenly aware of what had gotten away. Several of the greatest American collectors, such as Andrew Mellon and Henry Clay Frick, were Pittsburgh industrialists who bestowed their art treasures on Washington, D.C., and New York City, respectively. Another Pittsburgh steel fortune funded the Phillips Collection, also in Washington, D.C. And as recently as the 1950s, the museum paid insufficient attention to G. David Thompson, a self-made millionaire with a superb collection of twentieth-century masters that was particularly rich in Klees and Giacomettis. His collection escaped Pittsburgh's grasp, too, and museum directors and curators have been ultrasensitive about losing locally acquired art ever since. As Jack Lane put it, "Pittsburgh has been the victim of serious cultural hemorrhaging. It was a tragedy for the city."[18] In 1988, with Dia offering a substantial number of works by a native son, everyone at the meeting was determined that Wright should get a full hearing, that the utmost enthusiasm should be shown for what he had to say, and that if conditions were right, a collection should flow to Pittsburgh. Hence from the outset, the launching of a Warhol museum was viewed as a matter of civic pride, an opportunity to redress old omissions and enhance the cultural life of the region.

The early part of the March meeting was devoted to basic explanations of Dia's philosophy of showing one artist's work in a long-term environment and the foundation's aims in enlisting another institution to manage its collections. Charlie Wright's remarks were followed by an equally rudimentary outline of The Carnegie's operations and a canvassing of other cultural groups

Charles B. Wright, III

Andrew J. Hungerman, III

about their capacity to bring the Warhol collection to Pittsburgh. As the day wore on, it became clear that the natural associate for Dia was Carnegie Institute, with its stable financial base and its Museum of Art's long-standing commitment to contemporary art.

Wright had made it a condition of the gift that a Warhol museum must be housed in a building with the feel of a warehouse or other industrial space, similar to Dia's exhibition galleries at 548 West 22nd Street in Manhattan, and the discussion switched to real estate. Specific buildings were even proposed and visited, as everyone understood that locating and buying the right building would be The Carnegie's first priority. "The Carnegie people knew from the outset that the idea was to create a freestanding place identified with Warhol, and called the Andy Warhol Museum," said Wright. "We wanted a modest warehouse structure, where people could count on going time and time again and having a direct, in-depth experience with Warhol's work."[19] Ashton Hawkins confirms that The Carnegie understood the need for an independent site to replicate the experience Dia had been founded to create: "Their vision [of the museum] was much closer to what we had hoped to achieve than that of the New York institutions, who said, 'Oh, well, we'll take some of them, but we'd never show most of them. We're not going to set up a center.'"[20] For its part, The Carnegie liked the idea of purchasing an older building and restoring it, because that was more economical than erecting an extravagant new structure. At the time, everyone involved thought that an unassuming building of 30,000 to 40,000 square feet would do just fine.

Wright felt confident enough about the reaction in Pittsburgh to report what had transpired to Fred Hughes. After Wright told Hughes that Carnegie Institute really seemed interested and that Dia was contemplating dedicating its collection to a project there, he asked if the Warhol estate would like to participate in some way. He hoped that the estate would lend a few works to Pittsburgh. Wright remembered Hughes's answer very well:

Fred immediately, right on the phone, said, "Yes, I'm on the same wavelength as you on this." I mean, it seemed almost uncanny that he right away said, "Yes. Pittsburgh, yes. Museum, yes. We'll commit, too, in some way. Let's go to Pittsburgh and take a look." I didn't really know Fred very well then, so it just was amazing to me that he was so interested in this possibility. He knew Pittsburgh better than I—he knew families, he knew collectors. And he probably was, at that point, more convinced than I was that Pittsburgh was the right place, because he knew much more about it.[21]

Wright, of course, was unaware of Hughes's talks with Jim Fisher, which accounted for the uncanny, instantaneous quality of Hughes's seconding a collaboration with The Carnegie. Nor did Wright initially fathom that when Hughes committed the estate to the project, the Andy Warhol Museum would be catapulted from a small Dia-type enterprise into a sizable repository with definitive holdings. This was soon to come, because Hughes, not a man for halfway measures, stepped out and did something extraordinary. He promised that the estate would match in value, quality, and range whatever contribution Dia was making and, wherever possible, fill gaps in Dia's collection so that every phase and period

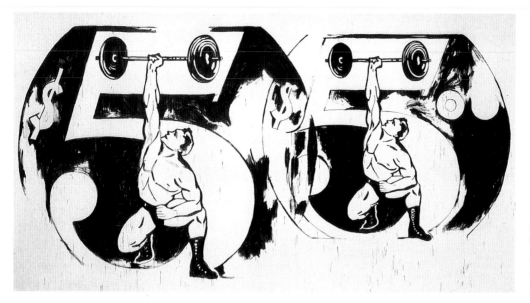

$5 Weightlifter, c. 1985-86
Synthetic polymer paint on canvas
116 x 216 in. (294.6 x 548.6 cm)
Founding Collection, Contribution
The Andy Warhol Foundation
for the Visual Arts, Inc.

of Warhol's oeuvre would be represented.[22] Within a few months, Hughes donated several hundred paintings, prints, drawings, photographs, films, videotapes, and archival materials to any future museum in Pittsburgh, and thus ensured that its collection would constitute a comprehensive record of Warhol and his times.

The staff at the Carnegie Institute and Museum of Art went into action, too. Both boards of trustees had to be persuaded that Warhol was an artist of lasting significance, and some members were skeptical. Others had doubts about creating a separate, single-artist museum instead of an integrated presentation in a wing of the existing Museum of Art building. Phillip Johnston, John Caldwell (who was shortly to leave Pittsburgh for San Francisco's Museum of Modern Art), and Milton Fine, a trustee conversant with contemporary art, argued on behalf of accepting Dia's collection and the financial responsibilities that went with it. As the person delegated to line up a proper building, Andrew Hungerman was spending the better part of lunch hours and early evenings driving around Pittsburgh and inspecting sites.[23] Some were dismissed out of hand, some were in the wrong place, and others had hidden defects, but gradually he would assemble an inventory of viable properties. After he had screened and accumulated enough of them, Wilburn, Johnston, Wright, Hughes, and Edward Hayes, counsel for the Warhol estate and foundation, were invited to look them over. On the North Side, the Buhl Science Building was considered too lavishly classical for the Dia aesthetic. On the South Side, a former jail and a furniture store had character,

but were too small. The old Duquesne Brewery, also on the South Side, had soaring ceilings that would show off the art majestically, but Hayes pegged it as a "money pit,"[24] so it was ruled out as well. In between visits from the New Yorkers, Hungerman plugged away. Knowing the real-estate and zoning communities as he did, he had city and county planners in the area, as well as all the local realtors, keeping an eye out for him, and he received automatic notification of every commercial property about to come on the market. Before the final selection was made, Hungerman went to see almost 130 buildings; of these he looked over 50 to 60 thoroughly.[25]

Charlie Wright still believed that Pittsburgh was unequivocally interested in establishing a Warhol museum. It was also where the project stood the best chance of being carried out in a manner that would meet Dia's expectations. Yet until The Carnegie affirmed its credibility by securing a building, he thought it wise to keep making inquiries. During the following weeks and months, he investigated spaces in New York and talked with groups and institutions in Miami, Minneapolis, and Seattle. Each one fell short financially, technically, aesthetically, or philosophically. And none of these candidates had the stability guaranteed by The Carnegie. These forays elsewhere reinforced Wright's conclusion that Pittsburgh was Dia's best option.

While Hungerman was struggling to find the perfect building and Wright was discreetly checking out other venues, a number of The Carnegie's board members flew to New York to familiarize themselves with Dia's gallery and its aesthetic orientation. Bob Wilburn, as the head of The Carnegie and the person with primary responsibility

Wigs, 1960
Synthetic polymer paint and crayon on canvas
70 1/8 x 40 in. (178.1 x 101.6 cm)
Founding Collection, Contribution
Dia Center for the Arts

for fundraising, thought it a good idea for the Pittsburgh contingent to meet their counterparts at Dia and at the Warhol Foundation during one of these trips to Manhattan, and he suggested a friendly discussion on how the new museum would be structured. Wilburn now looks back on that event as one of the worst mistakes he ever made; at the time, he thought he was watching the project die a gruesome death then and there. After everyone assembled at the Knickerbocker Club, one of the New York people proceeded to lecture The Carnegie party for nearly an hour on the correct way to run a museum, as if they were rubes who had never been to a big city before. Wilburn, sinking lower and lower in his chair, stole glances around the room, certain that his trustees would never touch the project again. It did not help matters that one of the trustees commented that the foundation people were arrogant and condescending, and another grumbled that the New York host had "an emperor complex." But to Wilburn's immense relief, his board got over their annoyance. They decided that the museum was bigger than any one person's attitude, and that they would continue to support it. But that was the last time Wilburn ever tried to bring all three boards together.[26]

As Andrew Hungerman had learned, finding a building was not easy, and it was becoming more and more pressing to come up with one. Finally, during the summer of 1988, Milton Fine suggested to Hungerman that he, too, go to New York to see Dia's gallery. The experience was a revelation for him, because what Wright and others were after suddenly came into focus.[27] Hunger-

man returned to Pittsburgh, lined up three or four buildings for inspection, and invited Wilburn, Johnston, Fisher, Hayes, Hughes, Wright, and others to tour them on August 24.

After viewing a furniture store, which received a lukewarm response, Hungerman took them to 117 Sandusky Street, a 1911 industrial warehouse owned by the Volkwein Music & Instruments Company. The building, in a mixed-use neighborhood on Pittsburgh's North Side, just across the bridge from the central downtown area, has a handsome façade of cream-colored terra-cotta, but Hungerman was so sure of the reaction he was going to get that he wouldn't let anyone walk through the building or even linger outside to admire it. He took the group directly to the top floor, which had almost exactly the same proportions and feeling as Dia's Manhattan facility. "When they walked off the elevator," he recalled, "I saw all the smiles come on their faces, and I felt I earned my paycheck. They seemed excited about the spaces."[28]

Everyone agreed that this was the right building, so much so that even though no formal agreement existed among the three parties, The Carnegie was determined to buy it. Fisher assured everyone that the building was in such good shape that even if the museum didn't come to pass, The Carnegie would have no trouble selling it later on.[29] Ironically, the only negative to the Volkwein building seemed to be its enormous square footage. It had about 77,000 square feet, whereas it was assumed that the Warhol museum would need only 35,000 to 40,000. After all, the concept was of a modest transfer of pictures to a proportionately modest facility. But

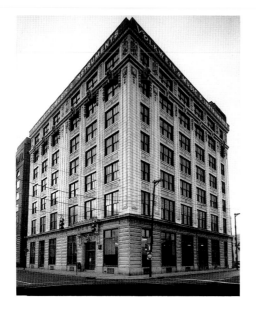

Volkwein Building, Pittsburgh

it was quickly pointed out that The Carnegie always needed storage space and perhaps objects from other museums could be housed there.

As it turned out, zeroing in on the Volkwein building was almost peripheral to the tortuous endeavors involved in obtaining it. By the time the museum and foundation people saw the building, it was no longer on the market. Allegheny General Hospital, which had already spotted the warehouse, had an option on it. "But," recalled Wilburn, "we thought if we really wanted the building, we could get it."[30] Getting it took the efforts of a well-connected Carnegie trustee, William Penn Snyder III, who was also chairman of Allegheny Hospital's board. Snyder persuaded the hospital to withdraw its option, and The Carnegie successfully matched the hospital's offer.[31]

Coming up with a winning offer was less straightforward than it might seem, for the Volkwein family didn't want money for their building. Whereas The Carnegie wanted to pay cash, the Volkweins wanted to *trade* their building for one that suited the company's needs. As the museum had no building to swap, it was put in the position of having to build one to the Volkweins' specifications. The Carnegie had to contract with a developer who would agree to be paid at a complex simultaneous closing that involved an instantaneous exchange of The Carnegie and Volkwein properties.[32] None of this was quick or easy, and as Andy Hungerman recalls:

Charlie would call me and say, "Andy, how are we doing with the building? Do you have a closing date yet?" I'd say to Charlie, "I think we're going to be able to work it out," and Charlie was always thinking, "Are these guys really going to be able to get the building?" First Dia and the Warhol Foundation were saying, "They'll never get a building that fits." Then we got a building they all loved, and we didn't seem to be able to close on it.[33]

The Volkwein building did not become the property of Carnegie Institute until the spring of 1990, more than eighteen months after the museum and foundation officials first decided that they wanted it.

With an actual building to house the future museum at least pinpointed, the next matter of importance was financing the venture. At the March 1988 meeting, everyone's best guess was that $10 million would be necessary to buy, restore, and endow a building and ready the collection for a public opening. That estimate was revised to $20 million ($15 million for construction and $5 million for an endowment) when the size of the Warhol Foundation's contribution became clear, some time in 1990; once it was proposed that The Andy Warhol Museum would receive more than 800 works of art plus the artist's voluminous archives from the foundation, the program and the facility had no choice but to expand. The Volkwein building's 77,000 square feet was not going to be too big at all, and everything related to the handling and display of art would have to be revised. Wilburn, the person chiefly responsible for finding money for the museum, could not see raising more than $14 or $15 million from private sources, so it was imperative to obtain the $6 million balance from public funding. That task did not faze him because he, like everyone else in Pittsburgh, was tantalized by the size and substance of the Warhol Foundation's benefactions. "The

recommended that about a dozen key early works on Francis's list be reserved for other museums.[48] These conclusions seemed to run counter to what Hughes had promised, and alarmed The Carnegie and Dia. Wilburn, Johnston, and Francis were unwilling to give up that entire group of paintings, so Francis and Fremont started compiling a third list of eventual gifts, and a new and sometimes tense round of back and forth discussions ensued on issues that everyone assumed had been settled long ago.

While tremors from the dissent within the Warhol Foundation continued to be felt in Pittsburgh, The Carnegie enjoyed some relief that a successful swap had been completed, and it now owned the Volkwein building. The renovation could now begin in earnest, and Mark Francis was meeting with Richard Gluckman, the project's architect. Gluckman, a specialist in redoing museum and gallery spaces, is known for restrained designs that avoid overpowering the art objects they serve. He and Francis were united in wanting to respect the early twentieth-century industrial appearance and sturdy structural shell of the building by highlighting them whenever possible. Yet they agreed that the curatorial programs had to inform the architecture—the art had to take precedence. Gluckman proposed to "accept both the restrictions and advantages" of the Volkwein building's uniform grid in order "to transform the building into a pleasing sequence of well-proportioned spaces."[49]

A central corridor became a familiar motif on each floor, with galleries emanating from that central axis.

Existing elements, such as columns, girders, beams, and slabs would provide the framework to support neutral, unadorned galleries and unobtrusive flooring. Gluckman's drive toward an understated industrial aesthetic, although one layered with elaborate and subtle decorative touches, chimed with Hughes's tastes, too. As someone who had spent years in Warhol's various studios, Hughes pressed for a subdued architectural and decorative presentation and advocated classical proportions in setting up the halls, galleries, and entryway. When Hughes disagreed on certain details—as when it was proposed to have granite rather than wood or concrete floors—he adamantly asserted, "Andy hated granite floors!" and wood or concrete they stayed.[50]

Although a core of basic decisions on the museum's lighting, layout, and other aspects of construction was solidified after a trip that Gluckman and Francis made in 1990 to look over European museums and galleries for features that might be emulated in Pittsburgh, they remained hospitable to other people's suggestions. In the late summer of 1990, they gave Senator Heinz, who was immensely interested in the Volkwein building's architectural transformation, a tour of the site. Gluckman made a presentation, complete with schematic designs taped to the walls, and waited for their guest's reaction. "Senator Heinz was very polite and sort of amused," Gluckman says.

He liked the building and the approach we were taking to it, but we got into a discussion about masonry versus metal buildings. He asked me what buildings I liked in Pittsburgh, and I managed to name two or three of the stainless steel buildings that he

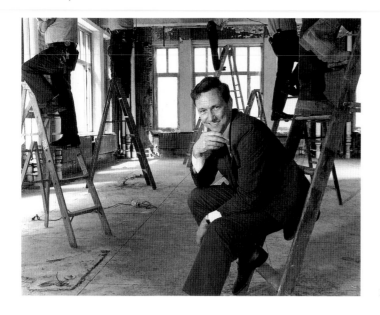

Richard Gluckman

hated the most. He said, "What's this guy doing here?" and then "You've got to see some better buildings. Make sure you take him to our research center, which is a brick building." He was being nice about it, but he was teasing me unmercifully.[51]

Nevertheless, John Heinz's comments about the superiority of brick had their effect. The main building had a dilapidated wooden addition slated to be torn down and rebuilt. Gluckman had originally opted for a steel building, but the Senator's prodding caused him to weigh the merits of brick more carefully. In retrospect, Gluckman says, "The fact that the extension is virtually all masonry has more than a little to do with him."[52]

Teresa Heinz's own preferences in materials had some influence on the Warhol Museum as well. An environmental activist, she was a partisan of "green" architecture long before Gluckman knew what it was, and when he took her through the building in 1991 it was she who persuaded him to consider such factors. Mrs. Heinz immediately noticed that there would be an inherent problem with the acoustics and said that cork was a wonderful natural material for muffling noise. Gluckman admitted that neither he nor anyone else had thought much about noise levels before. He went on to install cork in rooms intended for quiet viewing, such as the smaller drawings gallery, and in high-traffic areas such as the store and the coffee shop.

When it came time to concentrate on the renovation of the building, a yawning discrepancy emerged between proposed and actual costs per square foot. The original price of remodeling had been estimated as $25 per square foot, but that figure was based on the faulty

assumption that the Warhol Museum could emulate Dia's Manhattan facility in the level of improvement destined for the building—the façade could be sandblasted, the walls whitewashed, and a few steam lines run in.[53] This naive assumption of how raw the museum's space might remain was factored into the budgeting process without full examination, but it receded into the realm of fantasy once Francis and others became more zealous about the level of professional standards required. For example, Dia's art collection was not stored on site, nor was there any air-conditioning. The Warhol Museum was going to need storage space, offices, a theater, a bookstore, a coffee shop, and extremely sophisticated security, as well as fire-prevention and climate-control systems that did not detract from the quality of the exhibition space. As Richard Gluckman observes, "There are not many seven- or eight-story museums in the world, so we didn't have too many models to look at. The obvious one in New York dealt with its height in a totally different and unique way, and we didn't think we were going to mimic the Guggenheim ramp."[54]

The addition of skylights, elevators, a staircase, a double-height gallery between the fourth and fifth floors, and that masonry extension where a wooden one once stood, further upgraded the site. If these engineering and architectural elements increased the gravity and quality of the building, they also increased the price, which was now running at about $110 per square foot.[55]

During the odyssey of establishing the Warhol Museum, there were ups, as when everyone fell in love with the Volkwein building, and downs, as when the $6

Ellsworth H. Brown

million appropriation disappeared with no substantial gift to replace it. During the fall of 1990, there was a similar ebbing of confidence, a feeling of being mired in a swamp of frustration. There was squabbling within the Warhol Foundation and tension between it and The Carnegie on the matter of which paintings were coming to Pittsburgh. Mark Francis, who was expected to polish off the International, the largest contemporary art exhibition in the country, while attending to all the curatorial and administrative duties entailed in getting a new museum off the ground, was being pulled in too many directions at once, and both Dia and the Warhol Foundation were concerned.

Gloomiest of all, there was still no commitment of public money to the project, although Bob Wilburn swore he would get one or die trying. The New York partners were restive, asking for evidence of concrete financial commitments and seriously wondering whether Pittsburgh could pull off the project after all. No one could fail to notice that raising money in an still-deepening recession was not getting any easier. As Phillip Johnston observed,

Not unlike many people in the world, our collaborators saw Pittsburgh as a place of unending financial resource. I think the notion was that the idea of a Warhol museum would be presented, that we'd all agree to it, that we would reach the terms, that there would be a dinner party in Pittsburgh, and that everybody around the table would say, "I'll give three," and "I'll give five," and "I'll give two," and "I'll give three," and we would have the money! All we had to do was ask the right people, and the money would simply be there. So there was a continuing process of try-

ing to explain to them how, yes, Pittsburgh is an extraordinarily generous place and we have wonderful supporters, but the institution was in the middle of a $125-million capital campaign. Our challenge was to say, "... But the city is committed, and we're confident that the money will be forthcoming."[56]

The Carnegie staff knew that an infusion of belief and enthusiasm was imperative. So on November 26, 1990, the night before the next JVC meeting, the philanthropists and trustees Henry and Elsie Hillman hosted a dinner at the Pittsburgh Golf Club. The great hope was that John and Teresa Heinz would appear to help shore up The Carnegie's status in the eyes of their partners. Mrs. Heinz was out of town and could not come, but in the middle of the party, the Senator appeared and mesmerized the room. After dinner, he stood up and spoke extemporaneously about how important and innovative a project he thought The Andy Warhol Museum was, how terrific it was for Pittsburgh to have it, and of his personal commitment to seeing it through. "The room swelled with pride," Johnston says, "and our friends from New York went rushing over to Senator Heinz. It was wonderful."[57] The dinner was a great triumph, and shortly afterward it was capped by Heinz pledging a total of $5 million from his two family foundations. Tragically, his presence and support were snatched away from Pittsburgh — and the rest of the state — when he died in a plane crash on April 4, 1991.

John Heinz's death devastated thousands of people in the Pittsburgh area, and Bob Wilburn was afraid that the Warhol Museum might not recover from the blow.

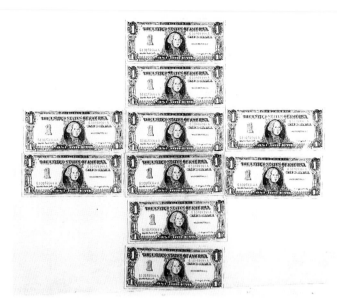

One Dollar Bills, 1962
Silkscreen on paper
25 1/4 x 37 in. (64.1 x 94 cm)
Founding Collection, Contribution
The Andy Warhol Foundation for the Visual Arts, Inc.

Now he had to work alone in soliciting money from the state, and moving forward without Senator Heinz was personally painful to him. But Wilburn was nothing if not tenacious, and his commitment to the Warhol Museum was unwavering. The enormous effort was set in motion all over again, starting with the home delegation and then revisiting and persuading the politicians he had seen before, always stressing the museum's potential economic impact and trying to get the project to the top of everyone's agenda. This time, however, instead of asking for a straight capital appropriation, he suggested that the money be dispersed over three years from the operating budget. The change found favor with the legislature, and on May 27, 1992, Wilburn informed the governor that without a guarantee of his support by a certain date, he would be forced to cancel the project. On June 1, thirty-six hours before the deadline, Wilburn received a call from the governor's office – the Warhol Museum would receive public funding.[58]

Mark Francis was then devoting himself exclusively to the museum as curator and director, but the number of designated Warhol Museum staff remained limited, and the amount of work was overwhelming. One of the looming priorities was to stop the Warhol Foundation from tinkering with the list of acquisitions and, in particular, to regain the dozen core canvases whose destiny was in dispute. Wilburn and Johnston were so adamant about securing those paintings that they threatened to walk away from the entire enterprise unless they got them. (They were also gambling that Dia would support

them in pulling out if the collection was no longer as good as it could be.) In October 1991, roughly fifteen months after objections to Francis's acquisitions list were first raised, a compromise was worked out, and The Carnegie received half the paintings at issue, plus a number of other works. The Warhol Foundation was not ungenerous, nor was it planning to desert the Warhol Museum. After the matter of the paintings had been settled, and in recognition of the showcase commitment made by the Heinz family (Senator Heinz's $5 million pledge was honored by his widow), Arch Gillies and the other foundation board members voted to make a cash grant of $2 million to the museum.[59] The Carnegie now had $7 million toward the $15 million it needed to start construction, but everything was still dependent on receiving state funding. It had become a go – no go factor for Pittsburgh and a final vote of confidence for everyone else.

Whenever his mission became especially difficult and he needed to keep himself going, Bob Wilburn repeated to himself the mantra, "We don't want this to be another collection that went somewhere else, we have to get this for Pittsburgh."[60] His labors finally paid off in the summer of 1992, after the last-minute phone call from the governor's office. Assured that $5 million from the Heinz endowments, $2 million from the Warhol Foundation, and $6 million from the state were in hand, several local charitable organizations and businesses, such as the Hillman Foundation and Alcoa, contributed enough money to reach the $15 million required by The Carnegie's board of trustees. Wilburn later confided

Liz, 1963
Synthetic polymer paint and
silkscreen on canvas
53 x 83 in. (134.6 x 210.8 cm)
Founding Collection, Contribution
The Andy Warhol Foundation for the
Visual Arts, Inc.

that he was not sure that the Warhol Museum would exist until that moment in June 1992. In retrospect, Johnston says,

When I talk to museum directors around the country, they say, "You what? You have $6 million from the state of Pennsylvania for a single-artist museum? How did your institution do that?" ...It is rather extraordinary to get that amount of money from a state for the arts...and for something as untried in this country as a single-artist museum, it is...hard to believe.[61]

Construction was scheduled to start – and did so – in September 1992.

Yet almost from the moment that the $15 million goal was attained, it became acutely apparent that, with the museum now so much grander in concept, program, and facility, it was understaffed and underfinanced. The building alone was going to cost $11 to $12 million, and the 1988 estimate of $20 million as sufficient to cover construction, operations, and endowment was upped to $35 million. Thus $20 million still had to be raised, and as regional treasuries had been exhausted by the capital campaign and the first round of Warhol solicitations, the money had to come from elsewhere. The Carnegie turned to Edith Fisher, who had served the museum for more than twenty-five years. She agreed to become the prime fund raiser for what would have to be an enormous new capital drive. Attacking the problem with great diligence, she conferred exhaustively with Gillies, Hughes, and Wright about anyone who might become a benefactor of the museum.[62]

Money-raising expertise was never mentioned to Mark Francis when he was offered the job in 1989, and it was impossible for him to begin a global funding campaign in 1992. He was only marginally less overworked than when he first arrived at The Carnegie. The myriad responsibilities historically associated with the position of chief curator – studying, publishing, and lecturing on Warhol; learning, cataloguing and interpreting the future permanent collection; planning the inaugural installation of the museum; and consulting with the architect on the construction process and the programmatic aspects of the building – took up all the hours in the day. There was no time to devote to interaction with the trustees, or raising the profile of the museum in preparation for its final sprint toward the finish line of a 1994 opening. Even if he could have found the time, it was a case of being asked to do things beyond his ken. As Francis himself acknowledged, he was a scholar and familiar with artists and their work – perfect qualifications for a curator, which he had demonstrated admirably to date – but not an institution builder.[63]

The New York partners first began hammering away at The Carnegie about the spareness of the Warhol Museum's staff in 1990,[64] but the daunting new burden of raising another $20 million gave their discontent a new urgency. Since Francis was willing to redefine his job in name as well as in fact, he agreed to be redesignated as curator and give up the title of director. In 1992 The Carnegie formed a search committee to identify a director whose strengths lay in fund-raising and administration and who had visibility and experience in the

Tom Armstrong and Andy Warhol

American museum world. At this point Ashton Hawkins suggested that if Thomas N. Armstrong III, the former director of the Whitney Museum of American Art, were available, there would be no need to initiate a search at all.[65] Armstrong, who also had directed the Abby Aldrich Rockefeller Folk Art Center in Williamsburg, Virginia, and the Pennsylvania Academy of the Fine Arts in Philadelphia, was used to running large urban museums and understood how they were financed. He was also an activist, with a flair for creating excitement. Of perhaps equal significance, Armstrong had been very friendly with Andy Warhol, and had given him a show at the Whitney. Everyone else at Dia, the Warhol Foundation, and The Carnegie concurred with Hawkins, and Armstrong was recruited during the autumn of 1992.

On April 1, 1993, Tom Armstrong became director of The Andy Warhol Museum and took over the respon-

sibility for fund-raising. Since then, he has been guiding the museum toward its opening. The Carnegie is breathing easier, and the New York partners are tranquil. "The form the museum has taken is beyond my wildest dreams," says Charlie Wright, whose initiative started things so long ago. "It's not just a Dia project, but a huge bounty."[66] Arch Gillies credits Pittsburgh with herculean persistence despite the drastic ballooning of financial, architectural, and curatorial imperatives. In the Warhol Museum, he explains, the Carnegie people "had a bear by the tail, and it just took hold. There were no wrong decisions, just decisions that had to be adjusted upwards. Nobody walked away from the bear. They might just as soon have cut the tail off, and be done with it. But they stuck with it."[67]

On May 15, 1994, The Andy Warhol Museum opens its doors to the public.

NOTES

1. Quoted in John Taylor, "Andy's Empire: Big Money and Big Questions," *New York*, February 22, 1988, p.39.

2. Interview with Ashton Hawkins, March 29, 1993. Unless otherwise stated, the information in this essay is drawn from correspondence and other documents in the possession of The Carnegie Museum of Art and from the author's taped interviews conducted on behalf of The Andy Warhol Museum in 1993. The recordings have been transcribed, edited, corrected, and deposited in the museum's archive for final processing.

3. Interview with Heiner Friedrich, April 22, 1993.

4. Ibid.

5. Interviews with Hawkins; with Charles B. Wright, March 22, 1993.

6. Interviews with Hawkins; with Lois de Menil, September 8, 1993.

7. Interview with James A. Fisher, May 5, 1993; with Edith Fisher, May 6, 1993.

8. Interview with Fisher.

9. Ibid.

10. Ibid.

11. Taylor, "Andy's Empire," p.36.

12. Interview with Wright.

13. Telephone interview with John R. Lane, September 16, 1993.

14. Interview with Robert C. Wilburn, April 8-9, 1993.

15. Interview with Wright.

16. Interview with Wilburn.

17. Interview with Phillip M. Johnston, May 7, 1993.

18. Telephone interview with Lane.

19. Interview with Wright.

20. Interview with Hawkins.

21. Interview with Wright.

22. Ibid.

23. Interview with Hungerman, May 5, 1993.

24. Ibid.

25. Ibid.

26. Interview with Wilburn.

27. Interviews with Hungerman; with Milton Fine, June 28, 1993.

28. Interview with Hungerman

29. Interviews with Frederick W. Hughes, March 25, 1993; with James A. Fisher.

30. Interview with Wilburn.

31. Interviews with William Penn Snyder III, June 29, 1993; with Wilburn.

32. Interviews with Hungerman, Fisher, and Wilburn.

33. Interview with Hungerman.

34. Interview with Wilburn.

35. Interview with Johnston.

36. Interview with Wilburn.

37. Ibid.

38. Ibid.

39. Agreement of the Establishment of The Andy Warhol Museum, By and Among Dia Art Foundation, Carnegie Institute, The Andy Warhol Foundation for the Visual Arts, September 29, 1989, director's files, The Andy Warhol Museum.

40. Ibid. p. 10.

41. Telephone interview with Lane.

42. H. John Heinz III, letter to Hughes, January 9, 1990, director's files, The Carnegie Museum of Art.

43. Ibid.

44. Telephone interview with Lane.

45. Interview with Johnston.

46. Interview with Archibald Gillies.

47. Ibid.

48. Interviews with Wilburn, Johnston, and Gillies.

49. Interview with Richard Gluckman, August 5, 1993; presentation notes for The Andy Warhol Museum, April 30, 1990, courtesy of Richard Gluckman.

50. Interviews with Vincent Fremont, April 19, 1993; with Hughes.

51. Interview with Gluckman.

52. Ibid.

53. Interviews with Mark Francis, July 14, 1993, and August 12, 1993; with Fisher.

54. Interview with Gluckman.

55. Interviews with Francis and Hungerman. If related but hidden costs, such as asbestos removal and operating expenses incurred before the museum opening, are added, the figure is about $150 per square foot. Nonetheless, compared with the going rate of $250-$350 per square foot that erecting a new structure entails, the Warhol Museum has controlled its construction costs.

56. Interview with Johnston.

57. Ibid.

58. Interview with Wilburn.

59. Interview with Gillies.

60. Interview with Wilburn.

61. Interview with Johnston.

62. Interview with Edith Fisher.

63. Interview with Francis, August 12, 1993.

64. Wright and Gillies, letter to Wilburn, November 13, 1990, director's files, The Carnegie Museum of Art.

65. Interview with Hawkins.

66. Interview with Wright.

67. Interview with Gillies.

Helen Searing

THE BRILLO BOX IN THE WAREHOUSE: MUSEUMS OF CONTEMPORARY ART AND INDUSTRIAL CONVERSIONS

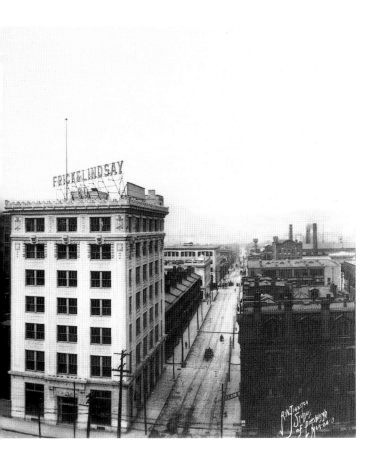

The Frick & Lindsay building
March 24, 1913

The new Andy Warhol Museum, architecturally no less than institutionally, is a unique and engaging hybrid that simultaneously represents the hottest trend in museum design — the conversion of industrial buildings into exhibition galleries — and reinvigorates the more venerable typologies of *Kunstkammer* and purpose-built ideal museum. Its architect, Richard Gluckman, has knowingly formed into a functional and expressive synthesis these divergent approaches to the display of, and instruction about, works of art.

That the museum has been established in the former Frick & Lindsay warehouse, built in 1911 as a distribution center for products sold to mills and mines,[1] is a spectacularly fitting trope. A setting that still bears the imprint of its industrial origins provides an ideal showcase for works by the artist who proclaimed one of his studios "the Factory" and exploited techniques of mass production in the service of his multifaceted art. Indeed, many of the objects made by Warhol and his cohorts have already been shown in comparable settings,[2] and they will reside familiarly, if provocatively, at 117 Sandusky Street, across the bridge from downtown Pittsburgh.

The Pittsburgh location seems preordained not only by its identification as Warhol's birthplace but by the city's emergence as a center for current cultural manifestations. Carnegie Institute, established in 1895, is one of the sponsors of the Warhol Museum, and its traditionally diverse programs and collections, which span science, music, and literature as well as art, adumbrated the tendencies seen since the 1950s in the practice of Warhol and many other artists, to break down or

transcend disciplinary barriers. Furthermore, held under the auspices of The Carnegie Museum of Art are the triannual Carnegie Internationals, which offer local and visiting audiences tantalizing encounters with the most recent artistic movements.[3]

Appropriate, too, is the circumstance that another sponsor is the pioneering Dia Center for the Arts, which perspicaciously demonstrated that converted factory and loft buildings can offer a sympathetic meeting ground for contemporary works of art and their viewers. It was Dia that selected Gluckman for its conversions, and he has gone on to establish a flourishing professional practice by specializing in precisely this mixed and marvelous architectural genre.[4]

Of course, conversion of existing spaces into exhibition areas where art collections could be viewed by people other than their owners has a very long history, but these spaces were initially found in domestic structures—city palaces and country houses, ecclesiastic and secular. From the sixteenth century onward, many residences were fitted out with cabinets and galleries where collections of marvelous objects could be shown to chosen guests. This practice was a precedent for the donation in 1753 of Montague House in London as the venue for the first British Museum, with its mixed contents of books, works of art, and scientific specimens. More focused collections of paintings, sculpture, graphic arts, and antiquities also were installed in grand domestic settings; thus, in the aftermath of the French Revolution, it seemed natural for the Louvre Palace, its Grand Galerie having welcomed the Academy's salons since 1699, to be formed into one of the first public art museums.

In the late eighteenth century, however, a generic building type was invented to serve specifically museological purposes—an invention coinciding with the emergence of art history as a discipline emphasizing the work of art as autonomous "masterpiece"—and professional architects were involved in providing appropriate designs. Once this type had been coined and minted, it was replicated throughout Europe and the Americas and admirably fulfilled its function for 150 years. Although houses continued to be turned into museums,[5] increasingly it was deemed mandatory for any metropolis worthy of the name to erect a monumental structure that clearly proclaimed its status as a treasure house, designed expressly to preserve and exhibit contents that were

considered works of art; the attitude persists to the present day. The notion of the museum as lofty temple of culture, located with other cultural institutions in a prestigious urban quarter or set apart in a specially designed park, a refuge from the quotidian, has survived almost intact. In this canonical museum, "masterpieces" were literally, as well as figuratively, placed on a pedestal, and the layman's contact with them was carefully guided and nurtured. Despite changes in material, spatial organization, lighting systems, and style, most museum buildings still speak forcefully of the power and prestige of nations, cities, and patrons, and of the elite nature of their treasures; more and more, too, they bear the signature of a renowned architect.

As long as there was general agreement among collectors, curators, and the lay public about what qualities defined "masterpieces," and as long as those self-contained works respected the established boundaries between the media, the purpose-built masonry museum with vaulted halls, internal light courts, and top-lighted galleries served its purpose well. But when modernist movements began to challenge the received wisdom about the nature of art and its relationship with the viewer, museums were put on the defensive architecturally as well as institutionally.

Thus there were calls for museum spaces that would restore historical context—and the period room was born. Then there were demands for galleries for the exclusive display of modernist art, resulting in designs that resembled office buildings or apartment houses rather than the hallowed marble halls.[6] However the strict typology that ruled museum architecture from 1780 until 1940 has broken apart, one aspect has held constant: almost without exception, purpose-built art museums make a strong aesthetic statement, often at the expense of the integrity of the works displayed therein. But now each museum makes a different statement, in order to distinguish the particular institution from its fellows on the next block or in the next city.

Architects bear a major share of responsibility for the posturing individuality of many postwar museum buildings. Desperately anxious to secure, or win in competition, what is arguably the most prestigious type of commission available, they flaunt their talent and produce eye-catching and costly designs. This is true for new museums of contemporary art no less than for the

traditional encyclopedic institutions; witness Arata Isozaki's Museum of Contemporary Art in Los Angeles, and the projected San Francisco Museum of Modern Art and Chicago's Museum of Contemporary Art, designed by Mario Botta and Josef Paul Kleihues respectively. But for many artists, the resultant buildings provide a setting that competes actively with their works and may even subvert their very intentions.[7]

In response, artists developed strategies to counter the perceived threat of the museum by creating objects that would deliberately evade its embrace. They fashioned works that were too big (interminable series; huge, factory-made pieces),[8] or too small and inexpensive (artists' books, musical notations), or too evanescent and immaterial (performance, light, unrealized conceptual paper projects), or deliberately unsuitable (earthworks, Walter de Maria's *Lightning Field*) for collection and display in the normative gallery space. Private collectors and public institutions reacted by turning to buildings devised for very different purposes as containers for the display of art.

Thus schools (P.S.1 in Long Island City, one of the first large-scale conversions), municipal offices (Clocktower Gallery in Manhattan),[9] banks (Jasper Johns' space on Manhattan's Lower East Side), hospitals (the Reina Sofia Museum in Madrid), and police and fire stations (the Boston ICA and Dia's outpost in Bridgehampton, Long Island) were pressed into service. But perhaps the most popular candidates for conversions were buildings that originally had been used for industrial and commercial functions—lofts, factories, power stations, and warehouses. These frequently contained expanses ideal for the display of work that had been liberated from the physical and conceptual framework that had hitherto controlled the art object. Lynne Cooke has summarized the issue brilliantly:

Once artists became engaged with process and materials in place of the outcome of their activity, the end product, and with the ways in which place and environment impinged on the perceptual and psychological comprehension of the object being viewed, the search for more flexible and more ideologically neutral sites than those conventionally provided by the museum and gallery quickened. Such "alternative" sites, it was hoped, would also permit artists to circumvent many of the economic and institutional factors that conditioned the making and marketing of the artwork as a commodity.[10]

The vogue for conversion of such structures gained momentum in the 1970s[11] and swelled significantly in the next decade; it had been anticipated by the artists themselves, who created studios in empty lofts, and by art dealers, who followed the artists to neglected warehouse districts like SoHo and Tribeca in New York City.[12] Eventually the commercial galleries were joined by institutional ones. Dia's first projects were displayed in spaces on Wooster Street (*The New York Earth Room* by Walter De Maria, 1977) and West Broadway (*The Broken Kilometer* by De Maria, 1979).[13] On lower Broadway one encounters in quick succession the Alternative Museum, the Museum for African Art, the New Museum of Contemporary Art,[14] and since 1992, the Guggenheim Museum SoHo. The phenomenon is represented in Pittsburgh by the Mattress Factory, established by Barbara Luderowski in 1977 on the North Side's Sampsonia Way. In addition to providing sites for artists in and around its six-story loft building, where mattresses were fabricated at the turn of the century, the organization is setting up satellite projects in abandoned buildings in the neighborhood; the first such satellite opened in 1986, around the corner on Montgomery Street.[15]

Today there are many examples of this appealing "mixed-media" building throughout Europe and the United States, serving institutions whose choice of setting accords well with their complex character. While sharing traits with traditional museums, institutes of contemporary art, and alternative spaces, they can readily be distinguished from them.[16] Unlike ICAs, they often own permanent collections or—as with the Liverpool Tate, the Temporary Contemporary in Los Angeles, and the Guggenheim Museum SoHo—are outposts of, or affiliated with, bodies that do. Unlike artist-run alternative spaces, they have professional administrators and curatorial personnel. Unlike conventional museums, even museums of modern art, they tend to focus on postwar art, particularly Minimal and Installation art, and are willing and able to devote much longer periods of time and much larger sections of gallery space to exhibitions by selected artists. Neither ICAs nor museums can keep on view for any considerable length of time representative portions of an artist's oeuvre. Typically in these hybrids, artists install their own work, and frequently configure it in tune with the allotted place for display.

And most important for the topic here examined, the structures which these new museums of contemporary art inhabit exude a very different aura from that we have come to expect from canonical art museums.

This hybrid architectural type seems to set up a unique alchemy with works of art that express the late-twentieth century sensibility shaped by industrialization and the machine. The former factories and warehouses resonate with memories of manual work performed there, and do not erect an elitist barrier between object and viewer; most frequently they are located in gritty urban quarters that were zoned for production and commerce rather than consumption of high fashion and high culture. Their characteristic spatial neutrality allows the artist to take on the role of architect and to fabricate an encompassing environment that is an integral part of the work. Sometimes that work incorporates recycled materials, thus complementing the restoration of the disused building to a new life.

There are practical reasons as well for the popularity of converted industrial structures. Not only is it less expensive to start with an existing building on its own site — even though renovation work that includes the creation of a climate-controlled environment especially geared to often fragile works of art can raise the budget substantially — but maintenance costs tend to be lower. These buildings were usually built tough and strong to withstand abuse from machines and sustain heavy loads. Many of them have structural skeletons of metal and/or reinforced concrete, which permitted generous spaces that once superbly accommodated manufacturing and warehouse functions and now can accommodate extensive installations. Many come already equipped with skylights, one of the distinguishing features of the classic museum building. Their outer walls are usually of brick or, as in the case of the Warhol Museum, glazed terra-cotta, materials that in our noxious environment can better withstand soot and smog than can the stone-clad walls that tend to come with the territory of much museum design, old and new.

Examination of a number of notably successful examples is now in order, to illuminate the power they possess to make the encounter between work of art and visitor particularly compelling. Such a discussion should also provide a context for understanding these converted spaces as catalysts for the unique achievement forged at the Warhol Museum.

Pride of place, perhaps, should be accorded the **Hallen für Neue Kunst**, because although this facility in Schaffhausen did not open until the mid 1980s, its origins go back a decade earlier. In 1974 (the same year that Dia was founded, for a very similar purpose), the Crex Collection, a vast private holding based in Zurich, was established by a group of wealthy individuals who wished to demonstrate engagement with their epoch by acquiring the art of their time. They set up the collection as a joint stock corporation and engaged the Zurich artist, Urs Raussmüller, to make purchases. At first inclusive in his acquisitions, Raussmüller subsequently adopted the policy — similar to that behind the founding of Dia — that it was important to fulfill a function that few museums were willing or able to: buy significant groups of works, by a few artists only, that might be too large or too numerous or too controversial for a single individual or art museum to exhibit and store. Among the artists favored were those who practiced Arte Povera, Conceptual art, and Minimalism: chiefly the Americans Donald Judd, Carl Andre, Robert Ryman, Robert Mangold, Dan Flavin, Sol LeWitt, and Bruce Nauman; the Europeans Mario Merz, Jannis Kounellis, and Joseph Beuys; and the Englishman Richard Long.[17]

When they were unable to find a permanent place in Zurich, the sponsors entered negotiations with the city of Schaffhausen, which in 1982 had acquired a disused textile factory constructed in 1913. The building, in sufficiently sound condition so that little renovation beyond cleaning and painting was necessary, has now been rented to a consortium that includes the City and Canton of Schaffhausen, representatives of the Crex Collection, and the Schaffhausen Museum and Art Alliance. Raussmüller, the director of the Hallen für Neue Kunst, invited artists whose works were owned by the Crex Collection to install their pieces in accordance with their own judgment and with the space at their disposal. In 1984 the Hallen opened to international acclaim.

The experience of visiting the Hallen is overwhelming. After a train or automobile trip along the Rhine in northern Switzerland, close to the dramatic Rheinfallen, one arrives at the dauntingly picturesque village of Schaffhausen, which dates back to the Middle Ages.

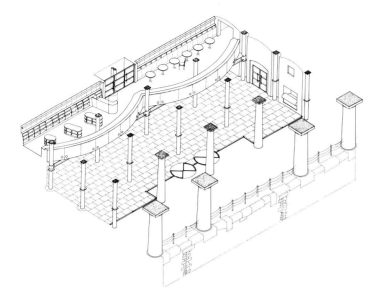

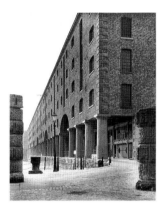

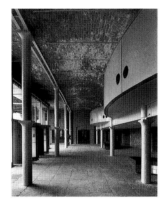

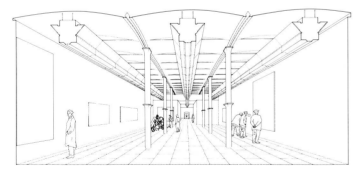

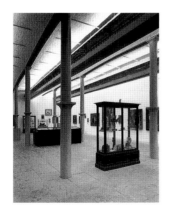

with "capitals" (flaring flanges) midway up to provide purchase for the mezzanine floor.

The mechanisms of modernization are quite obtrusive at the Tate Gallery Liverpool. A vertical core inserted in the center of the building longitudinally separates each level into "dockside" and "riverside"; it contains elevators and stairs, and distributes the electrical and ventilating services so necessary to the modern museum environment. In the galleries, three rows of the specially crafted horizontal duct units for lighting, smoke detection, and air-conditioning are suspended between the iron columns and the inner walls. Since the latter are independent of the bearing walls of the original structure, they offer flexibility in the hanging of art and in the concealment of services. Exactly parallel to the floor — stone at the ground level, wood above — these straight units offer a contrast with the gentle curves of the existing brick vaults and the metal beams, which deflect slightly.

The adjacent dock buildings shelter retail shops of the sort familiar to Americans at such places as South Street Seaport in New York and Quincy Market – Faneuil Hall in Boston; many firms have rented offices on the upper floors. As a result, the area has a strong commercial flavor and the Tate must compete for tourists' and shoppers' attention. All of the Doric columns, painted black in Hartley's time, have been given a coat of theme-park peach, which clashes somewhat with the more acid orange chosen by Stirling. While the vivid colors — meant to recall the Victorian love of polychromy[26] — may help the museum hold its own visually, the blankness of the ground-level screen exudes some of the chilliness associated with more traditional museum façades.[27]

The interiors too have the careful finish associated with purpose-built museums, including those by Stirling himself. This suits the program of the Tate Gallery Liverpool, which hosts exhibitions of early-twentieth-century art and therefore must accommodate framed pictures scaled to domestic spaces and elegant sculptures on pedestals. But more recent work appears there as well. In the summer of 1993, the work of Joseph Beuys was featured in one of the double-height galleries, and its stone floors provided a superb base for his mixed-media pieces.

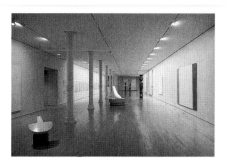

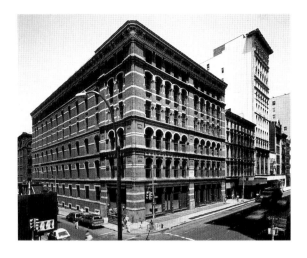

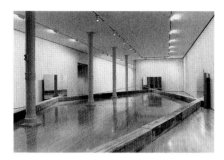

Very similar in program is the **Guggenheim Museum SoHo**, which opened in 1992. Located at 575 Broadway, the six-story building was designed by Thomas Stent in 1881–82 for John Jacob Astor III; its height, generous fenestration, and ample decorative embellishments reflect its use and date. It should be pointed out that architecturally, most of SoHo is extremely handsome. Dating from the years between the Civil War and World War I, the buildings, with fronts of cast iron or of brick or stone mixed with iron, and almost all enclosing beautifully detailed cast-iron columns, are lavishly ornamented, and each one is distinctive in appearance. The district is functionally and ethnically diverse, and even with so many galleries and museums, it has the liveliness customarily found in thriving commercial quarters.

The architect, Arata Isozaki, has been, like James Stirling, a familiar figure on the new museum circuit and, like him, has practiced in the postmodern manner, making frequent allusions to history and liberal use of traditional masonry. But unlike Stirling, he has scarcely tampered with the elaborate façade, and while Stirling sought a cacophonic combination of old and contemporary materials and took a tough approach well suited to the ambience of Liverpool, Isozaki strove instead for subtle elegance. In the purist galleries that he designed, there is little to recall the commercial uses — men's clothing store below, manufacturers and wholesalers of garments above — that the loft building once contained. Delicate new metallic detailing and finely rendered walls suggest that one has entered the restful and expensive precincts of the purpose-built museum.

Only two floors of the Guggenheim Museum SoHo are used for exhibition purposes (yielding about 30,000 square feet), and the ground-floor galleries share space with the large and well-stocked bookstore that serves as the entrance to the museum. As in the Tate Liverpool, a massive service core bisects the building, and while the display areas around the perimeter at the second level are not permanently divided by bearing walls, those on the north side seem squeezed between that core and the row of surviving cast-iron columns. Furthermore, a relatively large amount of the available space is taken up by dramatic double stairways that recall those typically found in conventional temples of art. Nothing could be more different from its expansive parent uptown, but the Guggenheim Museum SoHo will suffice for works of modest size. Perhaps the conventionality of Isozaki's design is meant to counter Frank Lloyd Wright's iconoclastic creation, which remains the venue for advanced contemporary art. The SoHo museum, in contrast, provides space for exhibitions drawn from the permanent collection and, on occasion, for temporary shows mounted by other institutions.

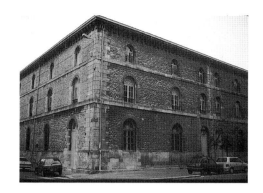

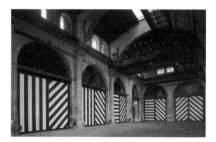

Unlike the Guggenheim and Tate outposts, the multilevel warehouse that since 1990 has been home to **capc Museum of Contemporary Art** in Bordeaux,[28] retains much of its original character, both inside and out. Completed in 1824, the building served as a customs storehouse for foodstuffs imported from French colonies in Africa and the West Indies; with the addition of an annex, it was used until 1960. The former Entrepôt Réel des Denrées Coloniales (also called the Entrepôt Lainé) near the quai Chartrons on the Garonne River was designed by Pierre Deschamps.[29] Austere and dignified, the warehouse resembles a fifteenth-century Florentine palazzo, at the time considered an ideal model for public buildings, utilitarian or cultural. The beautifully laid exterior walls of irregularly cut stone are pierced with round-arched windows and articulated with smooth stone string courses that offer a handsome contrast to the more roughly textured masonry of the bearing walls.

Erected before iron became a standard structural material, these exterior walls enclose a majestic series of brick and stone arcades that supported timber roofs; as part of the conversion, skylights were introduced over the central section, known as *les grandes nefs* (grand naves) because, soaring through the full three stories of the building, they have the grandeur and solemnity of the interiors of Gothic cathedrals. Groin-vaulted "aisles" and "galleries" (to continue the church analogy) surround this space and lead to rooms fitted out for a variety of functions that the museum sponsors. In addition to temporary and permanent exhibition galleries (including several for Arc et Rêve, the architectural branch of capc, which mounts shows of contemporary architecture and urbanism), the museum houses a research library, an auditorium, conference rooms, administrative offices, an atelier where children can learn about making art, and a bookstore. On the third story an elegant restaurant has been slipped in under arches of various diameters; on the terrace outside are installed works by Richard Long.

The architects, who have sensitively maintained the original character of this austere and impressive building, are Denis Valode and Jean Pistre; Andrée Putman and Bruno Moinard designed the restaurant and the furnishings of the museum. The *grandes nefs* offer an immense floor area for works that require it. In May 1990, Richard Serra's *Threats of Hell*, consisting of three huge steel plates each weighing 43 tons, was installed

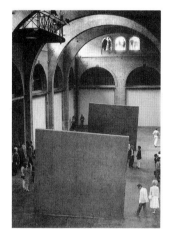

there with stunning effect. The architects comment that they looked

as though they had fallen out of the sky and been driven into the earth....[They] defined the spaces anew and were conceived both in relation to, and for, the great naves. At the same time, they can be perceived and read independently from the Entrepôt.[30]

The galleries around the nave are rather small, because the original structure forms modules of about 21 by 43 feet; here the strategy was to encase

within the architecture of the warehouse another architecture of museum spaces formed by walls — vertical and horizontal panels, which demarcate, divide, articulate, and define the exhibition space. The composition consists of a system of planes, centred and modelled on the dimensions of the building and dispersed according to a common rule.[31]

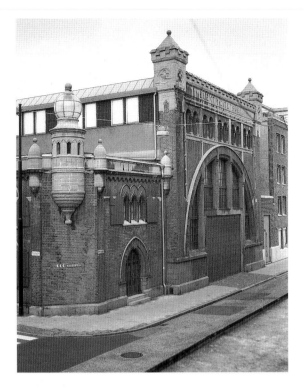

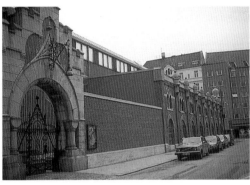

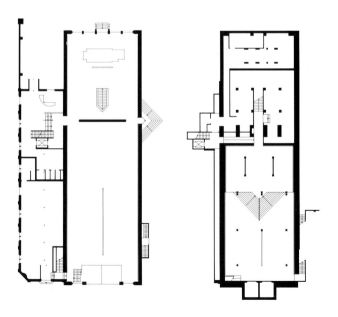

A very different type of industrial conversion, but one that also kept intact a soaring interior space tailor-made for the display of contemporary art, is that accomplished for the **Rooseum** in Malmö, a prosperous city in southern Sweden 45 minutes by boat from Copenhagen. The singular name honors the founder, Fredrik Roos, a banker and adventurous art patron, who died in 1991. Roos had for some time planned to set up a private *konsthal* in an older industrial building; his initial choice for a site had been London.[32] Happily, friends and advisers in Malmö showed him the complex of buildings that had once provided power to the municipality and that, in the late twentieth-century, awaited a new use. Renovated in 1987 – 88 by the local firm of White Arkitekter, the former *Elverket* (short for *Elektricitetsverk*) provides a spectacular setting for pieces from Roos's collection and for the imaginative exhibitions mounted by the Rooseum; it must be the most elaborate industrial building thus far to be converted into a museum.

Elverket was constructed in 1900 to replace the old gasworks of 1854. It was designed by John Smedberg in the Richardsonian Romanesque style, well known in Sweden, Denmark, and Finland.[33] Beautifully carved stone ornament is placed judiciously within its brick walls, and round and pointed arches of various widths give a striking rhythm to door and window openings. The neo-medieval forms and the abundant and beautifully carved stone ornament composed of sinuous, interlacing lines, adumbrating Art Nouveau decoration, were important features of Richardson's work that were adopted by his followers.

A very original touch is Smedberg's use of a preternaturally large globe that signaled the purpose of the building – to generate electricity for light and other services. The part of the building that housed the 220-kilowatt dynamo consists of a single large space, and that, too, is beautifully expressed on the exterior in a tremendous semicircular arch that springs directly from the base and allows for a huge window. The adjoining office building – now used in part for the administration of the museum – is linked with the electricity works by an ornate but graceful arched opening.

The exterior has been left virtually untouched, except for the garden façade, which is covered with

terra-cotta colored plaster. The garden contains one of
Dan Graham's pavilions, with transparent and reflective
panes rendering space and façades ambiguous; it can be
reached from the archway between the museum and the
office block, or from inside the museum via a triangular
set of steps that functions as a piece of sculpture in its
own right.

The handsome and evocative masonry walls conceal
a steel frame that was quite advanced for its time. This
permitted a clear span of about 48 feet in the turbine
hall, which is 36 feet high and about 158 feet long, and
which, abundantly endowed with natural light, offers a
majestic place for huge works of art. Its length has been
divided by a partition wall, behind which presides the old
dynamo. Below lies another gallery, lighted solely by
artificial light. This is accessible by two flights of inter-
estingly shaped sculptural stairs; the spatial play between
the two levels of the former turbine hall is very pleasing,
as are the buff and gray surfaces of patterned brickwork,
which the architects have let remain as a foil to the new
white walls.

Along the street and adjacent to the turbine hall is a
lower, two-story building with an entrance and smaller
galleries. All in all, the Rooseum is an extremely success-
ful conversion that maintains the charm of the original
power plant while it meets the needs of the museum's
collection and exhibitions. Although the architects have
changed a great deal on the interior, their interventions
are never obtrusive. The transformation has brought a
boost to the Rooseum's neighborhood; on the same block
are attractive new offices, and on the adjoining parcel
new housing has been constructed.

With its handsomely laid masonry walls and its
beautiful ornamentation, the Rooseum building looks to
the nineteenth-century traditions illustrated in the earlier
warehouses examined above. However, the steel frame
of the turbine hall, which permits the soaring generosity
of that space, introduces a new scale that locates the
building firmly in the modern era. Chronologically and
architecturally straddling two centuries, the Rooseum
provides an appropriate transition to three stellar exam-
ples of twentieth-century industrial structures converted
to the display of contemporary art.

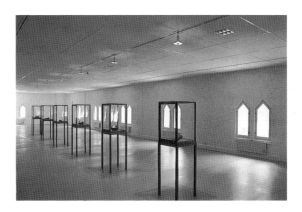

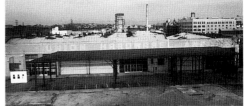

Two of these facilities, in Los Angeles and London, are remarkably comparable in architectural character. The first to open, in 1983, was the **Temporary Contemporary** in Los Angeles, so named because it was to be a provisional facility for its parent institution, the Museum of Contemporary Art, until MoCA's own new museum was ready. Frank Gehry, acquainted with many artists and collectors, and an experienced exhibition designer,[34] was chosen to effect the conversion of two adjoining, comparatively high one-story sheds — one a former police garage, the other used to store hardware.

First, the old warehouses needed upgrading and fitting out with improved services. Working with a relatively modest budget of $1.2 million, Gehry could make only limited architectural moves. But apart from that, he wanted "to let the character of the old warehouse exist; we tried not to change it and thus subordinate it but rather to work within it."[35] Platforms were constructed at various levels in order to use the tall spaces effectively, and freestanding partition walls were added to provide surfaces for hanging. Gehry turned the potentially problematic into the advantageous: the different roof systems of the two buildings, which are not

aligned along the same axis, became an opportunity for bringing variety into the vast spaces.

On the exterior, a large canopy was erected at the entrance to announce the presence of the museum and to offer shelter for outside installations. Its materials — Cor-ten steel and chain link — are longtime favorites of Gehry's, but they are, in addition, particularly apt here because they echo and reinforce the industrial character of the neighborhood and of the original sheds. Nor was it difficult to use the unfenestrated walls of low-cost brick as a site for Barbara Kruger's message of 1991. Although the Temporary Contemporary currently sits unused,[36] it was a great popular success and provided a desirable alternative — especially for large-scale installation pieces — to MoCA's new building by Arata Isozaki. The elaborate formal gestures, tortuous circulation patterns, conventionally sized galleries, and jewel-like preciousness of Isozaki's creation are not likely to enhance the kind of art that finds so comfortable a fit with Gehry's sheds. One could not point to two more extreme examples to represent the museological contrasts between expensive temple and straightforward container.

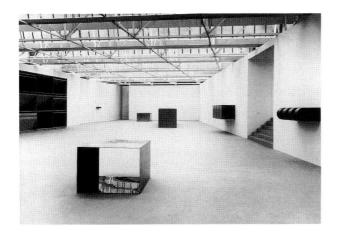 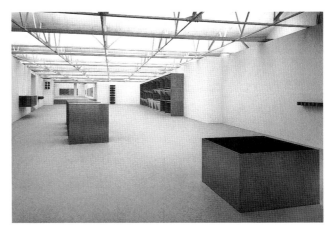

Conceptually and physically closest to the Temporary Contemporary is the building for the **Saatchi Collection** in London, completed in December 1984. The widely admired conversion at 98A Boundary Road was accomplished by Max Gordon, like Gehry a seasoned actor in the world of contemporary art.[37] The original building had been a motor repair shop, built in the 1920s; in the 1950s it was expanded with an addition to the north. The private museum, open to the public only two days a week, is not visible from the street and is surrounded by the walls of other buildings. An unobtrusive gate gives access to a courtyard through which one gains entry. Unimposing from the exterior, it is breathtaking within.

The space at 98A Boundary Road is used solely for temporary exhibitions; long-term storage is elsewhere. One story in height, the building offers 27,000 square feet of top-lighted display space in five galleries, each with its own configuration and ambience;[38] the reception area, the only one in which the skylights are concealed by a translucent ceiling, also is used for exhibition purposes. Gordon is known for his restraint and for the disciplined austerity of his detailing; his interventions are unobtrusive, even invisible in some instances. Wishing to "retain the anonymity of the industrial character of the roof structure,"[39] he had existing exposed wires and pipes removed, thus revealing the light elegance of the roofs, each of which has its own lighting system and silhouette.[40] Like Gehry but less dramatically, Gordon has varied the floor levels to animate the large spaces and to enhance the height of the walls. The versatility of Gordon's achievement is evident in the fact that widely divergent artistic trends have been comfortably accommodated in exhibitions held in these spaces over the years.

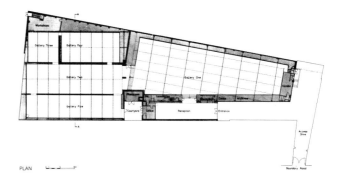

PLAN

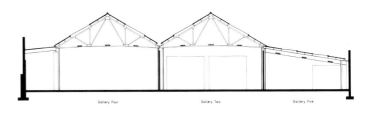

SECTION AA

Gallery Four Gallery Two Gallery Five

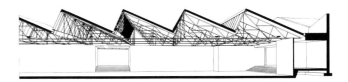

SECTION THROUGH GALLERY ONE TOWARDS RECEPTION

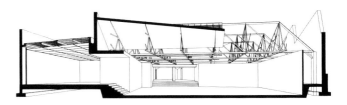

SECTION THROUGH RECEPTION AND GALLERY ONE TOWARDS GALLERY TWO

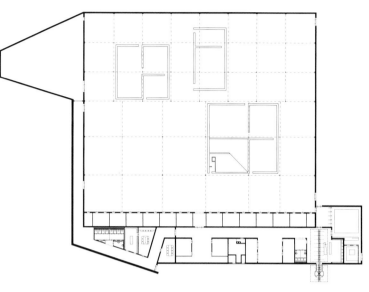

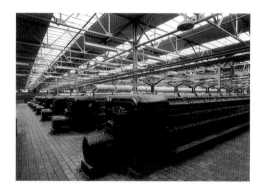

Similar in structure and typology to the Temporary Contemporary and the Saatchi Collection is the facility used by the **De Pont Foundation** in Tilburg, in the southern Netherlands,[41] which opened to the public in September 1992 in a renovated textile mill. Unlike the textile factory at Schaffhausen, the former Thomas de Beer wool-spinning plant consists of but a single story; here, an architectural firm, Bentham Crouwel of Amsterdam, was involved in the conversion. In both cases there was no need to tamper with the spatial and structural reality of the existing building; offering some 75,000 square feet of space, the de Beer plant was splendidly suited to its new purpose. Bentham Crouwel's main tasks were to clean the brick walls and the concrete floor, pour a new floor, and repaint the metal frame. A metallic entrance pavilion marked by a canopy was added, along with restaurant equipment.

One enters the reception area and proceeds down a narrow corridor with wall space for prints and drawings. Off this corridor are brick cells with metal doors and no direct natural light. They provide a pair of stunning rooms, (approximately 16 x 24 x 11 feet each), one of which houses a light piece by James Turrell and the other Richard Serra's lead *Gutter Splash Two Corner Cast*, fabricated in situ in 1992. Another pair of cells of slightly different proportions follows, and farther along the corridor is the library.

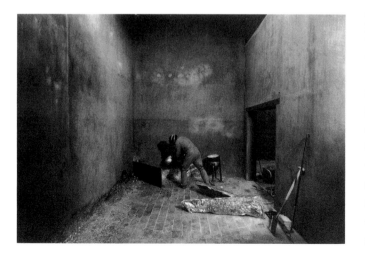

The main exhibition hall is awe-inspiring in its lateral expansiveness. Steel stanchions support the horizontal trusses, which in turn carry long pitched roofs equipped with glass skylights; the supports are very slender and scarcely take up floor space. Each artist has been given plenty of room, and enclosures have been made for some works. One of the delightful surprises inherent to the old mill is a series of small rooms on one side of the large gallery. (These originally provided storage for skeins of wool before they were woven into cloth on machines that stood in the vast skylighted space.) Small and cozy, with no daylight intruding, they make perfect display areas for small ceramic pieces, works on paper, and video installations.

The museum is situated away from the town center, in an area where other industrial buildings are located. The presence of the institution has stimulated new construction, and under Bentham Crouwel's master plan, residential and other buildings will eventually share the context of the De Pont collection.

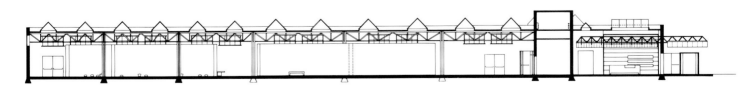

There is not room here for an extended description of some smaller, but also wonderful examples of the phenomenon under review; a citation must suffice. Zurich has two "alternative spaces" worthy of mention and a visit. One is the **Shedhalle**, located in an abandoned factory that has been taken over for radical cultural events of various types; its name, Rote Fabrik (Red Factory), may refer to the red brick of the exterior, which has a rather neo-medieval air not unlike that of the Rooseum, but political connotations may lurk in the designation as well. It lies at some distance east of the city center, in a mixed-use area that includes single-family houses and commercial structures, and a certain determination is required to enjoy its undeniable appeal. As at the Malmö and Tilburg facilities, old-fashioned walls enclose a steel frame supporting a spectacular system of skylights. From 1988 to 1993, exciting exhibitions of contemporary art were mounted in this impressive space.

In a frankly industrial section of the city — on the city map, the Industriequartier — one finds the **Kunsthalle Zürich**. Recently some private art galleries have made their appearance in the district, perhaps following the example of the Kunsthalle. Created in 1990, it is no larger than such galleries and has the simple white interior, set within a concrete frame visible above the walls, that since the 1960s has been de rigueur for the display of contemporary art. Although a modest new entrance has been introduced, the humble origins of the building speak clearly on the exterior through simple brick walls and shed roofs equipped with skylights.

An equally attractive pair of conversions on this side of the Atlantic should be noted. **The Isamu Noguchi Garden Museum** in Long Island City, New York, occupies an early twentieth-century photo-engraving plant which the artist purchased in 1974; it is located across from his studio, another former industrial space. Noguchi (1904–1988) was one of the first artists to move to Long Island City, a manufacturing area which has become something of a mecca for the arts.[42]

Used initially as a storage area for Noguchi's sculpture, the two-story building was extended in preparation for the installation of the museum, which opened in 1985. The 24,000 square feet, distributed among twelve galleries, present a magnificently sympathetic setting for the artist's varied oeuvre. Noguchi worked in stone, bronze, sheet metal, clay, wood, and plastic, and designed tiny objects as well as large landscapes and theater sets. This single-artist museum is further testimony to the importance of long-term display of a definitive body of major works for appreciation of an artist's contribution, yet no public institution was able or willing to make this possible.[43]

The industrial origin of the building has not been obliterated; plain brick walls, wood and metal beams, and industrial sash have been left exposed. The extension, designed by Noguchi in collaboration with the architect Shoji Sadao, is constructed of fine-grained concrete block; it forms a transition between the old building and the garden, which Noguchi also designed. Trees, shrubs, and water add a unique dimension, a synthesis of the natural and the man-made, to this immensely satisfying place. Tenants of local housing projects prize the museum as much as pilgrims from Manhattan.

While many of Long Island City's industrial structures maintain their original functions, others, such as the **Fisher Landau Center**, exemplify the trend under review. A private collection of contemporary American art, available for view by appointment, the Fisher Landau Center is located in its warehouse at 38–27 30th Street; at one time the facility was used to manufacture harnesses for parachutes. The conversion was designed by Max Gordon but completed only after his death. Nevertheless, his personal touch is readily visible in the austere and elegant minimalist design, which combines capacious galleries and intimate settings within the unobtrusive envelope.

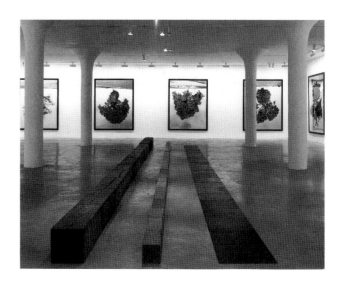

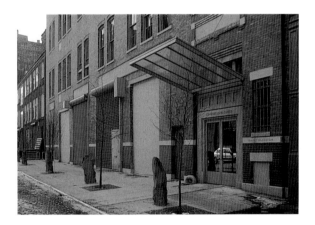

The only architect whose practice rivals Gordon's with regard to art-related conversions is Richard Gluckman. The Warhol Museum, his most ambitious American venture, is the largest yet realized among an expanding series of similar commissions, all influenced by his association with Dia.

Founded in 1974 and dedicated to contemporary art, the Dia Art Foundation has collected the work of individual artists in depth and presented it at various sites in New York and elsewhere.[44] In 1987, Gluckman completed a major project, the **Dia Center for the Arts**, a 40,000-square-foot space for changing exhibitions in a four-story warehouse at 548 West 22nd Street, within sight of the Hudson River. Unlike SoHo with its ubiquitous loft buildings, this area, in Chelsea, is characterized by attractive brownstones. It is only when one crosses Tenth Avenue that 22nd Street attains a quasi-industrial ambiance; the Arnulf Rainer Museum across the street alters the prospect somewhat.

The Dia Center building clearly reflects Gluckman's respectful approach to the original structure. At the ground level, new openings have been introduced, clad with materials such as corrugated metal and glass block, but above, Gluckman has retained the fenestration rhythm established by the segmentally arched windows. He also has kept the white panels that punctuate the tawny brick exterior walls and make an interesting pattern on the parapet. On the sidewalk, Dia's presence is announced by five basalt stones and five trees, a continuation of Joseph Beuys's 1982 *7000 Oaks* project.

Inside the building retains its blunt integrity. Surfaces have been cleaned and painted, but only on the fourth floor have new walls been inserted to cover windows and allow a larger area for hanging paintings. The concrete frame is for the most part visible; it aids in structuring the space and often provides a foil for the installations.

Zenithal lighting at the topmost story supplements the raking light from existing windows. Since 1991 the roof has supported the glass and metal structure that forms Dan Graham's "rooftop urban park project," as well as a small café. The roof also offers spectacular views of the Hudson.

While Gluckman's knowing hand is recognizable to those who have studied his work — and this Chelsea building has been honored by the New York chapter of

the American Institute of Architects and the International Association of Lighting Designers – his interventions are well concealed; as was intended, it is the art that dominates. At **The Andy Warhol Museum**, as elsewhere, the architecture is also at the service of the art, but Gluckman has had more opportunity to assert himself. He has made bold transformations within the existing 73,000 square foot, seven story building, and has designed a 15,000 square-foot, three-level addition at the rear.

In the Warhol Museum a balance has been achieved between the extremes of the well-nigh intact textile factory in Schaffhausen and the drastically remodeled Museum für Gegenwartskunst in Basel, with its dominating new construction. While the existing structure always makes its presence felt, it has been manipulated to provide a desirable variety of galleries for the diverse works that will be on display. Through the provision of new walls, exhibition spaces are given different proportions to maximize flexibility, and at the fifth level, floors have been partially removed to create double-height spaces. The unbroken, wall-to-wall galleries characteristic of the Dia Center's Chelsea space have been exchanged for more intimately scaled rooms, and large galleries on the second and seventh floors are 50 feet in width by 80 feet in length.

A richer palette of materials and hues also distinguishes the Warhol Museum from Gluckman's previous work. Buff colored fiber MDF board, cobalt-blue and cherry wood furniture, and gleaming aluminum play against the concrete frame and the white walls. Circulation spaces are set off by color and texture, and a sophisticated system of signage clearly identifies the various materials on display on each floor. There are no galleries at below ground level, where the coffee shop and education departments are located, or on the third floor, where visitors can consult the Warhol archives in a comfortable research and reading room. Not all of the furnishings are custom–made; classic chairs and tables from other eras intermingle with Gluckman's built-in pieces, contributing liveliness and informality to the ensemble and realizing Warhol's intuition that "department stores are kind of like museums."

A grand stairway has been inserted at the southern end of the building, and visitors are encouraged to take the elevator to the top story and walk down; there is a measured cadence to the experience. The stair has

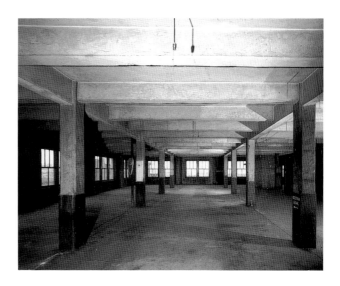

6th floor, before restoration

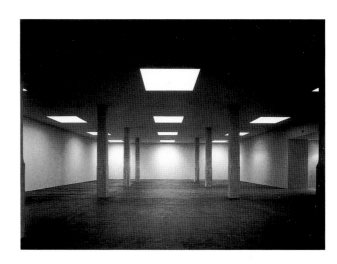

7th floor, after renovation, with skylights

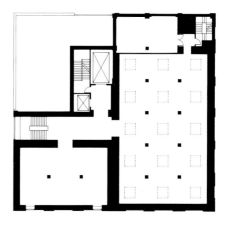

SOUTH ELEVATION

elegant metal railings and is lighted by a wide window that climbs the full height of the original structure and matches in detail the fenestration of the new addition at the rear.

The addition shelters the elevators, the theater — fitted out with tubular steel seats clad in brilliant green fabric, designed by Bauhaus-trained Marcel Breuer for a theater in France in 1931 — and the administrative offices. Gluckman's solution for the exterior was to pick up the materials and colors of the existing wings, which at the back and side are faced with brick in subtly varying blond hues. He has treated the surfaces in a frankly modernist way, so that while the new is sympathetic to the old, it is also distinguishable.

This is also true in his handling of the main façade and the ground floor behind the entrance. A clear boundary separates the exterior frame and the interior interventions, for Gluckman has excavated a two-story narrow volume immediately behind the street elevation. Although the original windows survive here, they do not give a view into a ground-floor commercial space, as formerly, but disclose a surface that carries museum messages for passersby. The public areas in the basement also benefit, as they receive light filtering down this slot. The entrance hall narrows as one penetrates the museum, all the more to dramatize the sudden release of space encountered in the first exhibition gallery, where Warhol's huge self-portraits are hung. This area thus becomes a memorial reminiscent of some nineteenth-century European single-artist museums that enshrine the dedicatee.[45]

Unlike the rather self-effacing brick warehouse in Chelsea, the Pittsburgh museum is garbed resplendently in cream-colored glazed terra-cotta on its two street façades. Terra-cotta as a facing material became very popular at the turn of the century, not only for its decorative beauty but for the possibilities of self-cleaning it offered; Pittsburgh is endowed with a number of buildings similarly clad. In these façades the structure is expressed but also framed at the sides and on the top, so that the open-ended character of the grid is repressed to suggest completeness and integrity; the composition is typical of Beaux Arts practice. Although little is known about the background of the original architect, W. G. Wilkens, he was responsible for a Beaux Arts office block

in Pittsburgh, the Maul Building at 1700 East Carson Street, on the South Side.[46]

The tripartite division of the façades can be likened to a classical column with base, shaft, and capital; this reflects the Beaux Arts sensibility, and was first codified by Louis Sullivan. That Chicago architect, who coined the misused phrase "Form follows function," was among the first to stress the height of "the tall building artistically considered"[47] by placing the vertical "pilasters" in front of the horizontal spandrels; he triumphantly concluded his compositions with a cornice reminiscent of those found on Renaissance palaces.

Sullivan's belief in the desirability of a definitive cornice was apparent in the Frick & Lindsay warehouse, which originally was topped off with an elaborate, five-foot high entablature (subsequently replaced by a bland parapet). In the interests of restoring the building exterior to its former elegance, it was decided to reproduce this striking feature, the details of which are gratifyingly appropriate to an art museum, consisting as they do of classical female heads and shields.[48] The replica is made of a versatile composite of concrete reinforced with glass fiber, which has the virtue of being far less weighty than the terra-cotta used in the original cornice while nevertheless resembling that material closely.

Sullivan also held that the cladding should be decorative to express its purpose and distinguish it from the bearing structure it clothes, and that tenet as well is reflected on the exterior of the Warhol Museum. All in all, the restored building represents a uniquely American solution to commercial and industrial design in a downtown area. Moreover, the architecture provides a fitting emblem of the uniquely American contribution of Warhol himself. One suspects that the artist would have appreciated the mingling of the commercial and the museological, the popular and the elite, the confrontation of the sturdy concrete frame with the exquisite façades, the maintenance of existing materials and spaces and the introduction of new ones.

The most recent, and thus far one of the largest, of the conversions here celebrated, the Warhol Museum will not be the last of these exciting hybrids. The administration and trustees of the Tate Gallery are eyeing the former Bankside power plant on the south bank of the Thames, opposite St. Paul's Cathedral, for

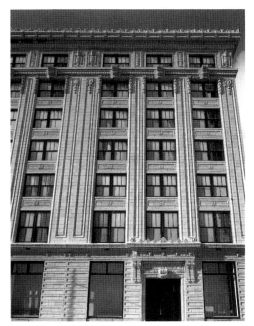

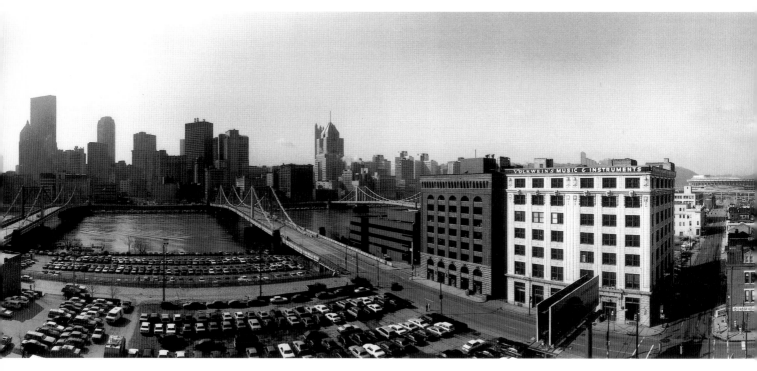

The Andy Warhol Museum before renovation, 1992

yet another annex.[49] And although plans to convert the monumental complex of mill buildings in North Adams, Massachusetts, into a "Mass MoCA" have been altered – exhibition spaces may constitute only part of a center for dance, music, theater, history, education, technology, and the visual arts – the precedents surveyed above make the inclusion of galleries for contemporary art an inevitable feature of this mammoth revitalization project.[50]

It is to be hoped that the designers of these future conversions will follow Gluckman's lead in attaining an equilibrium between the gutsy character of the original industrial and commercial buildings and the sophistication of the new construction. In this writer's experience, that character is essential to the experience of seeing and understanding much of the art that finds its home in these structures, and its retention is vital to sustain the enjoyment and insight that arises from the interplay of the building, the works of art, and the viewer.

Much can be learned from the architectural strategies that inform The Andy Warhol Museum, where differing functional typologies have been synthesized. The display of objects and written material from the Warhol Museum Archive suggests the intimate *Kunstkammer* with

its often eccentric curiosities, while the formal circulation patterns and the luminous galleries evoke the serene purpose-built museum with its reinforcement of the significance of art. Each of these traditions has been informed and revitalized by the worlds of work and commerce, production and consumption, utility and sensuality, that shaped the original warehouse, and the resulting architectural palimpsest is a consummate setting for ground-breaking creations that are themselves complex syntheses of age-old conventions and machine-age processes.

Early in this century, Marcel Duchamp demonstrated that the the hallowed precincts of a museum, gallery, or salon could confer artistic status on such ordinary consumer products as bottle racks and bicycle wheels. Andy Warhol extended and complicated this insight when he created his own "consumer products" in the form of the *Brillo Box* sculpture, which caused a sensation when shown at New York's Stable Gallery in 1964. Does not the phenomenon reviewed in this essay reveal the obverse of that coinage? If a museum can endow an object with artistic value, may not the presence of the acknowledged work of art transform a factory or warehouse into a museum?

NOTES

1. Later the building was sold to the Volkwein Music & Instruments Company, which used the premises to conduct its business of distributing sheet music and selling and repairing instruments. The W. G. Wilkens Company designed the original structure, which was six bays deep (on General Robinson Street) and three bays wide (on Sandusky). In 1918 three more bays were added to the left of the entrance on Sandusky that mirrored its façade; this was the work of O. M. Popp. The addition was shallower than the original warehouse, but in 1922 a three-story wooden extension was appended to the rear, filling in the block; this was too dilapidated to retain and has been replaced by a new three-story construction designed by Gluckman.

2. In the Museum für Gegenwartskunst in Basel, for example, and in the Dia Center exhibition space in New York's Chelsea.

3. At the 1991 Carnegie International, curators Lynne Cooke and Mark Francis extended the venue of the exhibition beyond the walls of the art museum, to the Mattress Factory and other places in the city. This was yet another signal that contemporary art thrives in environments alternative to those offered by the conventional museum building. See *Carnegie International*, 1991 (Pittsburgh: The Carnegie Museum of Art, and New York: Rizzoli, 1991).

4. Gluckman serendipitously arrived at his specialty when he was commissioned in 1977 to make ready a townhouse for Heiner Friedrich and Philippa de Menil, founders of Dia. He came to know and work with many of the artists sponsored by Dia. Gluckman was involved with Dia's site-specific installations in loft buildings in Manhattan, and in Bridgehampton, Long Island, where Dia has an outpost in another converted building. Gluckman has since designed galleries for Mary Boone, Larry Gagosian, and other dealers, and renovated spaces for the Boston Museum of Fine Arts and the Whitney Museum of American Art in New York. He is in the process of transforming a thirteenth-century shipyard in Seville into a museum of contemporary art, with specifically commissioned installations by an international cadre of artists.

5. And still are in the current era: Peggy Guggenheim opened the Palazzo Venier dei Leoni in Venice to the public in 1949 (today it is presided over by the Solomon R. Guggenheim Foundation); the Picasso Museum thrives in the converted eighteenth-century Hôtel Salé in Paris. The installation of the Thyssen-Bornemisza collection in the former palace of the Duc de Villahermosa in Madrid, converted for museological purposes by Rafael Moneo, has just been realized.

6. One recalls the sketches for New York City's fledgling Museum of Modern Art provided by George Howe and William Lescaze in the early 1930s, which perpetuated the commercial character of MoMA's first headquarters in the Heckscher Building at 730 Fifth Avenue. The executed design by Philip Goodwin and Edward Stone was less radical, but in height (five stories), plan of the galleries, and façade articulation, new parameters were set for museum architecture.

7. Thus Richard Serra described the recently constructed Neue Staatsgalerie in Stuttgart (1977–1982), designed by James Stirling and Michael Wilford, as "outdated and reactionary, because it reinforces the safe-deposit box mentality.... The architecture prescribes the presentation of the collection." (Lynne Cooke and Mark Francis, "A Conversation with Richard Serra and Alan Colquhoun," *Carnegie International I* (p.27). The interview presents provocative ideas about museum architecture. Despite such criticism, most of the museums erected over the last two years or so persist in this apparently enduring trend. See, for example, the Municipal Museum, Bonn, Germany, by Axel Schultes; the Municipal Museum, Yatushiro, Japan, by Toyo Ito; the Art Museum, Monterrey, Mexico, by Ricardo Legorreta; as well as the additions to the National Gallery, London, by Venturi, Scott Brown and Associates, and to the Brooklyn Museum by Arata Isozaki and James Stewart Polshek. The Getty Center in Los Angeles by Richard Meier, scheduled for completion in 1997, will be a veritable Acropolis.

8. In an illuminating interview, Count Giuseppe Panza di Biumo told of a temporary exhibition in which projects on paper by Robert Morris, Donald Judd, Robert Irwin, Sol LeWitt, Carl Andre, Richard Serra, and Bruce Nauman had been realized. "These were afterwards destroyed because it was too costly to ship tons of steel," he recounted. "It was cheaper to buy the steel and to realize the works again. For this reason they no longer exist. They have to be remade" (*Art & Design*, nos. 6, 8-9 [1990], p. 58).

9. P.S. 1 and the Clocktower Gallery are run by the Institute of Contemporary Art, formerly the Institute of Art and Urban Resources, founded by Alanna Heiss in 1971, which has sponsored important, culturally diverse exhibitions in these two remodeled spaces. P.S. 1, built in the 1890s in the late Victorian style known as Richardsonian Romanesque, with 30,000 square-feet of display space, is being renovated and expanded. In addition to holding temporary exhibitions the museum houses permanent installations by Dennis Oppenheim, Richard Serra, and James Turrell, among others. I am grateful to Anthony Vasconsellos for a tour of the existing facility and a preview of the forthcoming renovation. For descriptions of both venues, see Brendan Gill, "Manhattan's Arena for Aesthetic Melodrama," *Architectural Digest*, November 1990.

10. Lynne Cooke, "Essay," *The Mattress Factory: Installation and Performance* (Pittsburgh: The Mattress Factory, 1989), p. 19.

11. The first reuse of an industrial building for the display of art objects occurred probably in Victorian England. At the close of the Great Exposition of 1851, where works of art prophetically rubbed shoulders with commodities in Joseph Paxton's Crystal Palace, Prince Albert and his adviser Henry Cole decided to use the proceeds to establish two design schools (one for each gender) and a museum that would reinforce the art lessons taught in the school. Called variously the Museum of Science and Art and the South Kensington Museum, it displayed models of patented inventions, architectural casts, natural history specimens, and paintings. When the museum opened in 1856, it was installed in the iron and glass sheds affectionately known as the "Brompton Boilers," which served until 1864 as the home of the future Victoria and Albert Museum. After a new building was constructed on the site, sections of the "Boilers" were demounted and reused for the Bethnal Green Museum. See John Physick, *The Victoria and Albert Museum* (Oxford: Phaidon, 1982).

12. Mark Rothko, apparently, was the first artist to move to a loft in SoHo. The first galleries there were opened by Paula Cooper and Richard Feigen, in 1968; within about five years there were more than two hundred on the block between Spring and Prince streets alone. The entire issue of *Lotus*, vol. 66 (1990), is devoted to loft culture. The editor, Pierluigi Nicolin, sees loft living as a novel solution to the housing problem, but Germano Celant's thoughtful essay in the journal explores causes and consequences relating directly to art making and display. He writes: "Galleries no longer reflected the structure of an apartment....They became more ample, with an exhibition space that was on a scale with the large industrial lofts. The difference of 'sign' was very clear: it permitted a new reading of works of art as well as a re-interpretation of industrial architec-

ture. With regard to the first... one could say that the work of art was no longer thought of as part of the decor for a house or living room; it was now a large-scale 'product' that would disturb a 'household' environment and was therefore directed towards a more open environment. It is no coincidence that this shift took place at the same time as the advent of Minimal art in America and Arte Povera in Europe. As far as the second rereading is concerned... the discovery of the industrial areas of the inner city not only gave the elitist work of the artist an aura of 'real work,' [but] it also led to the reclamation of an abandoned area."

13. The ground floor at 383 West Broadway was originally the gallery of Dia's founder, Heiner Friedrich.

14. Founded in 1975, the Alternative Museum occupies part of one floor at 594 Broadway, which has a store at street level, and above, a mixed group of occupants including many art galleries. The Museum for African Art, at 593 Broadway, was beautifully reconfigured by Maya Lin; interestingly, the problems of appropriate display of its offerings parallel those encountered with much contemporary art. The New Museum of Contemporary Art moved to 583 Broadway in 1983, quadrupling its area to 23,000 sq. ft. All these loft interiors, like those run by Dia, are punctuated by decorative and functional cast-iron columns.

15. The mission statement of the Mattress Factory well describes its purpose: "A research and development lab for artists. As a museum of contemporary art, it commissions new site-specific works, presents them to the widest possible audience, and maintains selected individual installations in a growing permanent collection. The Mattress Factory's physical and organizational environments have grown out of, and in response to, a central focus on the process of creativity." The loft building itself has not been drastically changed; in that, it looks forward to several of the later buildings discussed in this essay.

16. Lynn Warren, *Alternative Spaces: A History in Chicago* (Chicago: Museum of Contemporary Art, 1984), defines "alternative space" as a "not-for-profit or noncommercial organization originated for and by artists that assures [them] a primary role in policy development and programming and which has continually operated a gallery space at some point for the purposes of exhibiting work by visual artists", and argues that they go back to the 1930s. Kay Larson, "Rooms with a Point of View," *ARTnews*, October 1977, sees them chiefly as a phenomenon of the 1970s, "arising in isolation out of the circumstances

of place and moment, the bare-walled, ripped-out 'alternative space' run by artists for artists and designed to fit the needs of post-studio art." See also Phil Patton, "Other Voices, Other Rooms: The Rise of the Alternative Space," *Art in America*, July/August 1977.

Institutes of contemporary art, also originating in the 1930s, similarly established themselves in available structures designed for very different uses. See Kay Larson, "Six Art Institutes: On the Long Lonesome Road of the Avant-Garde," *ARTnews*, December 1977, pp. 50-54.

17. This information comes from the author's interview with Hans Wyss; from a newspaper article in the *Zürcher Zeitung*, May 6, 1984; and from an article in *Museum*, 1987, pp. 68-73, by Christel Sauer-Raussmüller, curator of the Hallen.

18. The artist has supplemented the Crex holdings with long-term loans, so that some fifty works covering forty years of seeking perfection and meaning in the white square allow the visitor an unequaled opportunity to grasp the range and richness of Ryman's disciplined art.

19. The factory adjacent to the paper mill was in too poor a condition to be reused and was demolished in favor of the new structure.

20. The Kunstmuseum is an encyclopedic institution that continues to show work by artists who came of age in the 1940s and 1950s.

21. The Hoffman Foundation also donated funds for the restoration of the old mill. It is owned by the Christoph Merian Foundation, which contributed toward the new construction and maintenance of the facility.

22. Other critics have praised the richness of the spatial effects, the noble restraint in the use of materials, the mixing of natural light and halogen lamps, and the views through the windows of the cityscape, which create "a unique unity of interior space and urban exterior space: the museum is not a cut-off cabinet for initiates but is experienced as urbane, as a kind of arcade in the open air." ("Ein Neues Museum in Basel," *Du*, April 1980, p. 73). See also the positive comments published in *Casabella*, April/May 1980, p. 6.

23. Hartley lived from 1780 to 1860. See Henry-Russell Hitchcock, *Early Victorian Architecture in Britain* (New Haven, CT: Yale University Press, 1954).

24. The Greek Doric order, with its fluted and baseless columns, huge in circumference in relation to their height, had been rediscovered in the mid-eighteenth century, about the time that the public art museum was invented. If the more slender Ionic order was

the most popular choice for this building type (for example, the Glyptothek in Munich, the Altes and Neues museums in Berlin, and the British Museum in London), the imprimatur of ancient Greece gives the utilitarian Albert Docks a ready-made identification with high culture.

25. At this writing, the exhibition spaces on the first and second stories have been completed; the third floor serves staff. An auditorium, a restaurant, performance space, artists' studios, and a "warehouse gallery" will be installed in the remaining upper floors.

26. This was used by Stirling in all his museum designs, whether the immediate setting is Victorian, as is partly the case in the Sackler wing of the Fogg Art Museum at Harvard, or emphatically not, as at the Clore Gallery at the Tate in London and the Staatsgalerie in Stuttgart.

27. For a penetrating critique of this building, see Peter Buchanan, "Art Gallery, Liverpool," *Architectural Review*, July 1988, pp 18-27.

28. capc existed already in 1979 and, along with other cultural organizations, made temporary use of the still unrehabilitated Entrepôt. In 1984 it was established as a museum with a permanent collection.

29. Deschamps (1765-1834), Inspector General of Bridges and Roads, trained, in the best of contemporary French tradition, as an engineer. In 1971, the Entrepôt was put up for sale and probable demolition, but in 1973 the city of Bordeaux acquired it and made an agreement with the Ministry of Cultural Affairs to use it as a polyvalent cultural center. The Museum of Contemporary Art of Bordeaux was inaugurated in 1984 and in 1990 the rehabilitation was complete. See Pierre Veilletet and Georges Fessy, *L'Entrepôt Lainé à Bordeaux* (Paris: Les Éditions du Demi-Cercle, 1992).

30. "An Abstract Definition of Space" (text provided by Jean-Louis Froment compiled from writings by Valode and Pistre), *Art & Design*, 6, nos. 7/8, (1990), p. 71.

31. Ibid.

32. Although described in some literature (Helene Berge, *Konst i arbetets rum*, Lund University thesis, 1991) as a *konsthal*, the Rooseum has a permanent collection, left by Roos to what is now a generously endowed foundation. Much of his bequest is stored in Stockholm, but the Rooseum may use any part of it for exhibitions, which change about three times a year. I wish to thank Ulrika Levén of the Rooseum staff for her kindness and wisdom.

33. John or Johan Smedberg (1851-1913) studied at the Academy in Stockholm from

1868 to 1875, then spent the next three years in Paris at the École des Beaux-Arts, where he joined the ateliers of Charles Garnier and Charles-Auguste Questel. The Elverket is not at all French, but rather resembles the 1892 Stockholm Electric Works, designed by Ferdinand Boberg, the prime Swedish exponent of Richardsonian Romanesque. See Leonard Eaton, *American Architecture Comes of Age* (Cambridge, MA; MIT Press 1972), especially chapter 5.

34. Gehry has received commissions from numerous artists and collectors. He has also collaborated with several sculptors, and with dancer Lucinda Childs and composer John Adams on the occasion of the performance piece that inaugurated the Temporary Contemporary in 1983. See Mildred Friedman, ed., *The Architecture of Frank Gehry* (Minneapolis, Walker Art Center, 1986) and P. Arnell and Ted Bickford, eds., *Frank Gehry: Building and Projects* (New York: Rizzoli, 1985).

35. Friedman, p. 186.

36. It was necessary to close the museum to the public when the city of Los Angeles determined to renew the area – Little Tokyo. The Temporary Contemporary is scheduled to reopen in 1995.

37. Gordon (1931–1990) had a wide acquaintance among artists and gallery owners and was a master at turning existing buildings, or parts of them, into authoritative and sympathetic spaces for displaying contemporary art. Among the galleries he designed were Brooke Alexander, Maeght LeLong, Paula Cooper, and Richard Feigen in New York, and Anthony D'Offay, Mayfair Fine Art, and Waddington in London. Although little has been written on Max Gordon, Doris Lockheed Saatchi curated an important exhibition of his work, appropriately titled "No Trim," at the Architecture Foundation in London in 1992. A well-illustrated booklet, *98A Boundary Road: A Building by Max Gordon for the Saatchi Art Collection*, is available at the gallery.

38. Gallery One, 173 feet long, is tapered, its width diminishing from 59 to 34 feet; the floor was dropped 4 feet to allow for 14-foot vertical surfaces. The remaining galleries are rectangular; Gallery Two is 108 x 33 feet, Three and Four are each 34 x 33 feet. Gallery Five is 107 x 25 feet.

39. *98A Boundary Road*, p. 6.

40. Fluorescent tubes set in metal troughs under the roof structure supplement the natural light; the whole space is illuminated rather than having spots on individual works. The same strategy was initiated by Louis Kahn in the Kimbell Art Museum in Fort Worth, although there the ambient light is incandescent.

41. Jan de Pont, an attorney, businessman, and native of Tilburg, had a vision like the one that inspired the founders of the Crex Collection; he wished to make available to the public the visual art of his own day. As director of AGAM, a firm that imported Mercedes-Benz automobiles, he displayed art in the workplace. He also had owned and operated the textile factory from 1969 until his death in 1987. Shortly before he died, he arranged that part of his estate be used to encourage interest in contemporary art. (See *De Opening*, Amsterdam, 1992, pp. xvi-xvii).

42. Noguchi set up his studio there in 1961. Since then, not only have other artists – among them the sculptor Mark di Suvero and the painter Alfred Leslie – established themselves there, but institutions and facilities such as P.S. 1 (see note 9), Socrates Sculpture Park, the American Museum of the Moving Image, the International Design Center, and several performing arts centers have made Long Island City, in the borough of Queens, an important stop on the New York cultural loop.

43. The museum is supported by the Isamu Noguchi Foundation, which the artist established in 1981. The author is grateful to Lawre Stone for her insight and generosity.

44. In addition to the New York State installations mentioned in note 2, the foundation between 1979 and 1981 purchased a 300-acre deserted Army post outside Marfa, Texas, for the use of Donald Judd, who planned to turn it into a compound that included housing for artists and exhibition spaces for his and other artists' works.

45. For example, Bertil Thorvaldsen's museum in Copenhagen, which displays his sarcophagus in the courtyard.

46. Franklin Toker, *Pittsburgh: An Urban Portrait* (Pittsburgh: Pennsylvania State University, 1986), p. 148.

47. This was the title of one of Sullivan's seminal essays, first published in *Lippincott's* in March 1896, and reprinted in the collection *Kindergarten Chats* (New York: George Wittenborn, 1947); in it he set forth his theory "form follows function." He never intended the phrase as a slogan for modern functionalists, who have invoked it to justify their jettisoning of ornament and historical reference. Rather, Sullivan meant that formal strategies, including decoration, should be symbolically appropriate to the purpose of the building. He held that the tall office building or warehouse, as representative of "something new under the sun," should not be designed as a series of horizontal buildings piled atop one another, as most of the early skyscrapers had been, but should rise "without a single dissenting line." The architect of the Frick & Lindsay warehouse clearly adopted Sullivan's practice, which like his own was shaped by Beaux-Arts teaching. Sullivan had traveled to Paris to attend the École des Beaux Arts, but he never matriculated. However, his compositional and ornamental techniques show the influence of that institution, which had an important influence on American no less than on French architecture into the 1930s.

48. The heads resemble those found on Tyche figures, Hellenistic sculptures of city goddesses wearing castlelike crowns. Architectural Restoration Castings Co., of Ambridge, Pennsylvania, and the artist Ann Guip, of Sewickley, used old photographs and computer-generated drawings to fashion clay models of the original design.

49. *The Times* (London), June 29, 1993.

50. At this writing, Massachusetts governor William Weld has approved the release of $12.8 million in state bond money for the cultural center's first phase, subject to certain reasonable conditions. (*The Berkshire Eagle*, December 31, 1993.)

Richard Gluckman

ARCHITECT'S STATEMENT

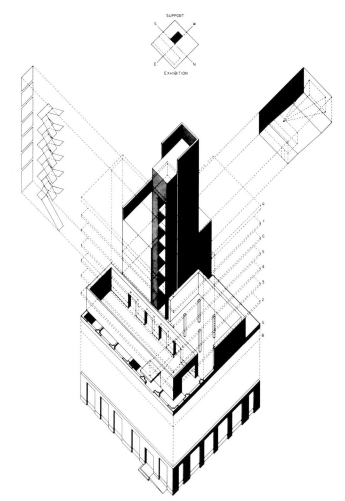

Situated near Pittsburgh's downtown business and cultural districts, The Andy Warhol Museum is housed in a renovated industrial warehouse built between 1911 and 1922. To accommodate the programs of The Andy Warhol Museum, the eight-floor, 73,000-square-foot building has been enlarged by a 15,000-square-foot addition to its southwest corner. The project contains 35,000-square-feet of exhibition space, a 110-seat theater, art storage facilities, an Archives Study Center and archives storage, an education department with space for art activities, a coffee shop, and a museum shop.

A rich palette of colors and materials was employed throughout the building to provide contrast with the white walls of the galleries. When entering the museum, the visitor moves into an entry characterized by its forced perspective, aluminum-leaf ceiling and deep blue plaster walls.

The museum-goer traverses a bridge marking the transition from the historic exterior to the renovated interior, allegorically connecting the museum's two functions: a permanent repository of the artist's works, and an active place to study his enduring influence on contemporary art.

Axonometric drawing of The Andy Warhol Museum

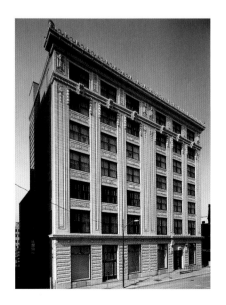

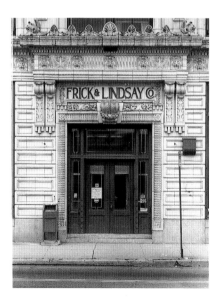

The restoration of the exterior of the existing building included replicating the original cornice in accordance with archival photographs and plans. The building addition is comprised of a simple group of rectangular volumes expressing, through their form and material, their interior function. The theater is located behind the walls of black glazed block. Above, the offices and archives storage are enclosed by walls of yellow brick, matching the secondary façades of the original building. The stair and elevator tower are clad with ground-face concrete block. The vertical bands of glazing, at the conference room and at the main stair, delineate the addition from the existing structure.

The north and east terra-cotta façades are left intact; a separation is created between the existing structure and the renovation in order to emphasize the contemporary intervention.

The eight levels of The Andy Warhol Museum present a different set of parameters than the typical museum; the ability of the visitor to remain oriented within the building was a major concern. The introduction of a strong vertical element, the main stair, and a strong horizontal element, the hallway which leads from the stair to the exhibition spaces, keep the visitor oriented within the museum. The repetitious experience of moving from floor to floor is punctuated by a series of architectural events; these coincide with curatorial requirements to create several spaces for specific works in the collection. The seventh-floor main gallery is top-lit by skylights and will be installed initially with works from the series of paintings titled *Shadows*. A two-story cubic space was created in the center of the building by removing sections of the existing floor and associated structure to accommodate large-scale works such as the *Skulls*. Similarly a narrow, double-height ecclesiastical space was made on the same floor to exhibit *Last Supper*.

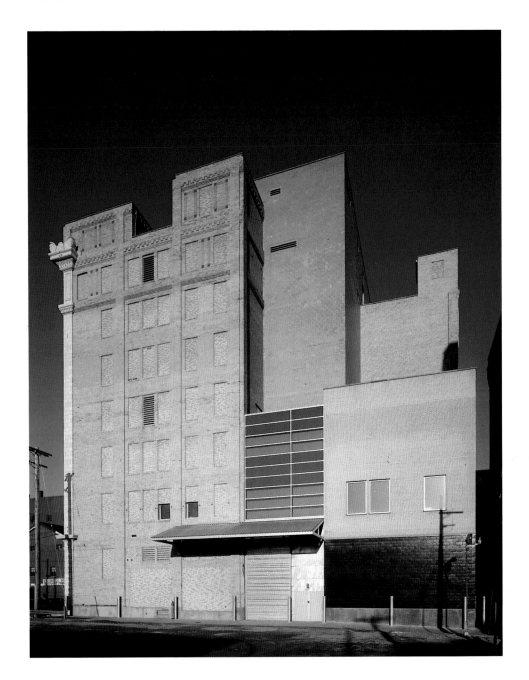

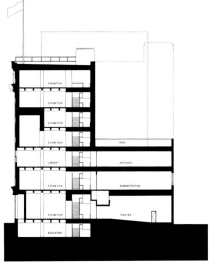

SECTION E-W LOOKING SOUTH

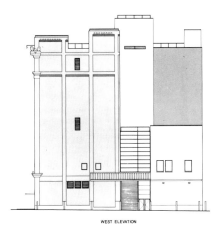

WEST ELEVATION

69

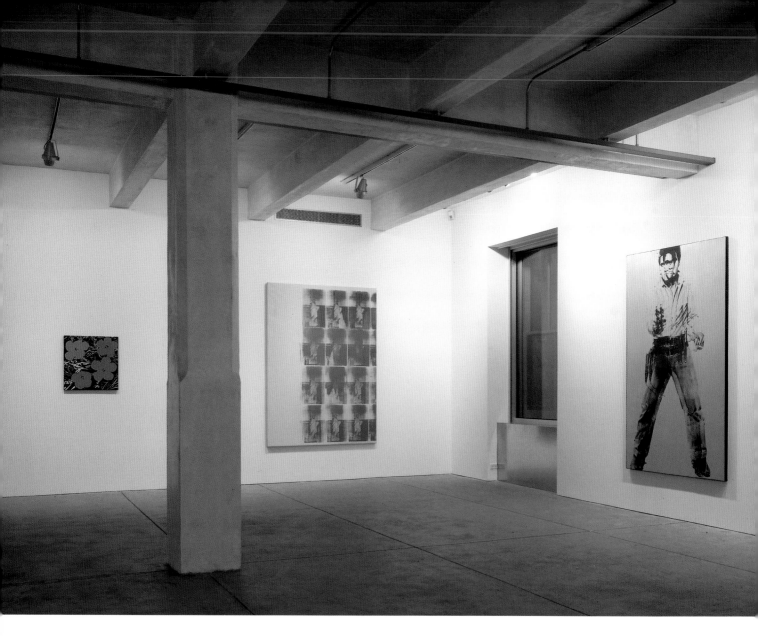

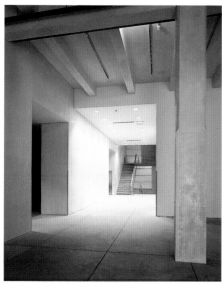

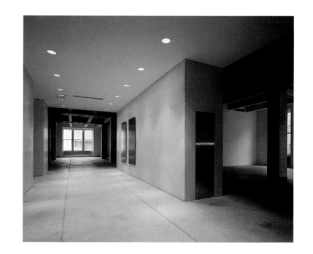

The entry, as well as the information area and shop are carved out of a box-like object inserted into the ground floor. This box is further delineated by the use of MDF panelling on the walls and cork flooring.

The theater space is defined by sculptural walls of brown MDF board; the dark blue-purple carpet and the green eisengarn fabric of the vintage 1931 Breuer chairs. The main staircase, backlit by a translucent glass window wall and with its aluminum and glass railing, uses materials long associated with Pittsburgh's industrial history. The space of the main stair and hallways are distinguished by a subtle, ochre-colored plaster which differentiates the circulation areas from the galleries.

A deliberate attempt was made to resist a literal re-creation of a Warhol-like aesthetic in the design of the building; this is tempered by references to Warhol's eclectic environments. The aluminum-leaf ceiling at the entry, the cowhide banquette in the coffee shop and the use of galvanized steel for sills and cabinetwork establishes juxtapositions of disparate materials in unaccustomed relationships. These references lend a material richness to an environment whose real focus is the art.

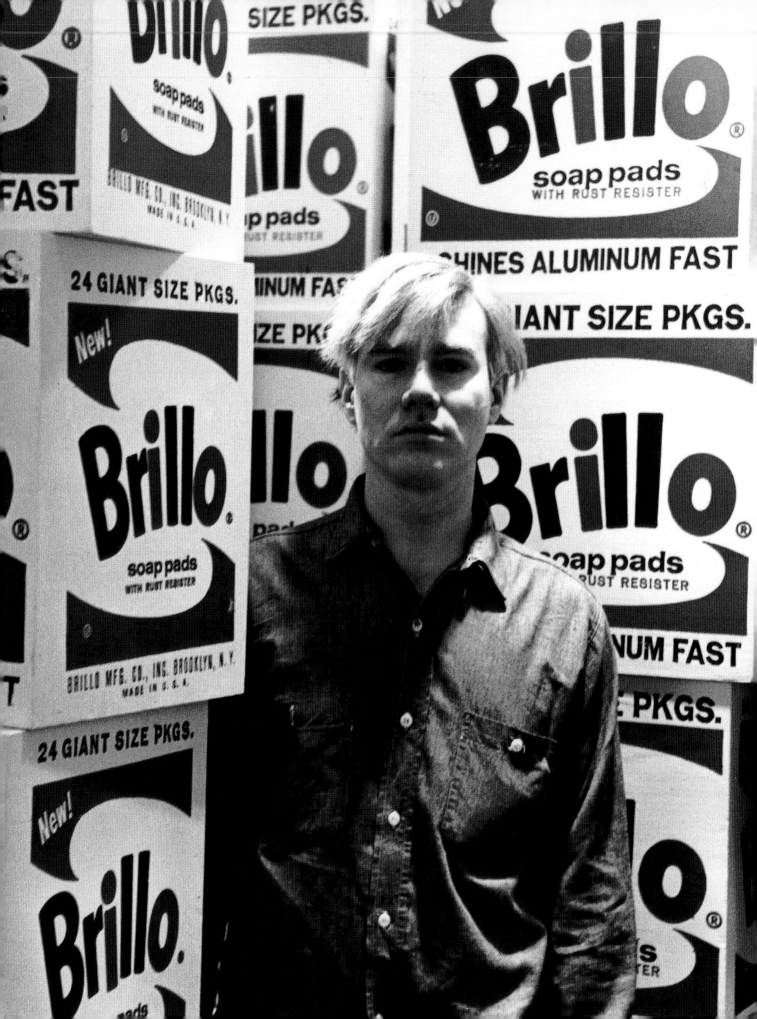

THE PHILOSOPHER AS ANDY WARHOL

"Warhol," Victoria said pompously, "the early Warhol,

before he was shot—"

"Where would America be without Andy Warhol?" I said.

"He put his stamp on American culture. He invented

superstars and all of that shit. It didn't quit with the Tomato

Soup Can. Andy Warhol was a genius. He—what he had,

was this great radio antenna. Picked up on all of the cosmic

vibrations. He just did it, I don't think he knew the half of it.

He was one of those idiot savants, I'm thinking. Your paintings

are too goddamn vague, Vick. I can't get a reading on them."

Thom Jones, *The Pugilist at Rest*

There is a penetrating passage in Virginia Woolf's *To the Lighthouse*, in which the philosopher, Mr. Ramsay, contemplates with a melancholy complacency the power and the limits of his mind. Construing thought as if it were organized in some order of profundity, and labeled with the letters of the alphabet, Mr. Ramsay reflects this way:

His splendid mind had no sort of difficulty in running over those letters one by one, firmly and accurately, until it had reached, say, the letter Q. He reached Q. Very few people in the whole of England ever reach Q.... But after Q? What comes next? After Q there are a number of letters the last of which is scarcely visible to mortal eyes, but glimmers red in the distance. Z is only reached once by one man in a generation. Still, if he could reach R it would be something. Here at least was Q. He dug his heels in at Q. Q he was sure of. Q he could demonstrate....He heard people saying— he was a failure— that R was beyond him. He would never reach R.

It is difficult to repress the speculation that Andy Warhol was alluding to this passage—he was, Barbara Rose once told me, a far more literate man than he cared to let on—in the title of his 1975 publication, *The Philosophy of Andy Warhol (From A to B and Back Again)*. A philosopher who makes it from A to B and has to begin all over again is scarcely a philosopher at all, one might think (though the founder of Phenomenology, Edmund Husserl, characterized himself as a perpetual beginner). "From A to B and back again" fits the image of a kind of fool which Warhol sought to project as one aspect of his persona—the image of one of those "pin-headed gum-

Andy Warhol, Stable Gallery, 1964
Photograph © Fred McDarrah

Film still from *Empire*, 1964

chewers," a critic unsympathetic with Pop called that generation of artists who had recently invaded gallery precincts in New York, heretofore dominated by the metaphysical heavyweights of Abstract Expressionism. But to put himself forward in the first instance as having a philosophy at all he must have intended to sound a note of comic incongruity with an artistic corpus which consisted of comic-strip heads, soup cans, Brillo cartons, and like images from what cultural critics were disposed to take as typifying the mindless, tasteless, thoughtless inanities of American popular culture, too sunk in banality to rise even to the level of Kitsch. For Kitsch at least has ambitions its audience misconstrues as classiness and artistic seriousness. In the scale of images, Warhol's remain at A: B must have seemed as much beyond his grasp as R was to Mr. Ramsay's "splendid mind."

Since at least Warhol's exhibition of Brillo (and other) cartons at the Stable Gallery on East 74th Street in Manhattan, in the spring of 1964, I have felt him to possess a philosophical intelligence of an intoxicatingly high order. He could not touch anything without at the same time touching the very boundaries of thought, at the very least thought about art. The 1975 text, as well as its pendant volume, *POPism: The Warhol '6os*, sparkle with conceptual observations and wit, put forth in the most piquant aphoristic language ("So full of thorns and secret spices, that you made me sneeze and laugh," Nietzsche says of his own "written and painted thoughts" in *Beyond Good and Evil*). But I refer to the very art that Warhol's critics saw as mindless and meretricious. Indeed, it is my thought that it was among Warhol's chief contributions to the history of art that he brought artistic practice to

a level of philosophical self-consciousness never before attained. Hegel had proposed that art and philosophy are two "moments," as he put it, of Absolute Spirit (religion was the third). In a certain sense, if he is right, there must be a basic identity between the two, and Hegel believed that art fulfills its historical and spiritual destiny when its practice is disclosed as a kind of philosophy in action.

That someone as astute as Warhol should have chosen to disguise his depth by what passed as motley in the 1960s has, in its own right, a certain allegorical appropriateness. In any case, I shall endeavor to reveal some fragments of the philosophical structure of Warhol's art. Along the way I shall try to relate it to certain of its art historical as well as cultural circumstances. But my essay differs from the standard art historical exercise in that I seek to identify the importance of the art I discuss not in terms of the art it influenced (or by which it was influenced) but in terms of the thought it brought to our awareness. Whatever he did, "he did it as a philosopher might," wrote Edmund White in a memorial tribute. Warhol violated every condition thought necessary to something being an artwork, but in so doing he disclosed the essence of art. And, as White goes on to say, all this was "performed under the guise of humor and self-advancing cynicism, as though a chemist were conducting the most delicate experiments at the target end of a shooting gallery."

I want to illustrate my claims with an initial example drawn from Warhol's films, which, whatever their standing in the history of cinema may prove to be, have an unparalleled contribution to make in our philosophical

understanding of the concept of film. I have in mind his *Empire* of 1964, which someone might just wander into under the misapprehension that its title promises one of those sagas of colonization or business in which a nation, or a mogul, builds up an empire. It is indeed of epic length, but it is marked by a total absence of incident, and its title is a pun on the Empire State Building, which is its only actor, doing what it always does, namely nothing.

Imagine that someone, inspired by Warhol, were to make a film titled *Either/Or* "based," as the title promises, on the masterpiece of the celebrated Danish philosopher, Søren Kierkegaard. Let the film be just as long as *Empire* (or longer, if you wish), and let it consist of nothing but the title page of the book, because the producer thinks that there might be an internal joke here for someone who is familiar with Kierkegaard's sly aphorisms. These aphorisms allow us to ponder the ambiguity in the concept of books, which exist as physical objects, of a certain color and size and weight, and as objects of meaning, which have a certain content and are in a certain language, and capable, as makes no sense with physical objects, of translation. That ambiguity immediately is transferred to the concept of being *based on*. Here is one of the aphorisms:

What the philosophers have to say about reality is often as disappointing as a sign you see in a shop window, which reads Pressing Done Here. If you brought your clothes in to be pressed, you would be fooled: for the sign is only for sale.

The two modes of being of a sign, as one might portentously say, are as a rectangle of plywood with paint and ink on its surface, which costs so many kröner at the store where signs are made and sold; and also as an emblem that gives information to potential customers. Information, for example, that they can have their clothes pressed in the place where the sign, by convention, means that that is the business of the place where the sign is.

These are also the two modes of being of a book — as something that takes up space and as something dense with wisdom. And it is this that makes the film *Either/Or* a kind of joke, or for that matter, makes *Empire* a kind of joke. The ambiguity that generates them in fact generates certain of Warhol's paradigmatic works of art such as, for signal example, the *Brillo Box* sculptures, which as works of art have all sorts of rights and privileges mere cartons of Brillo systematically lack, not being art. Here might be two Kierkegaardian–Warholian jokes:

A man sees what looks like an ordinary soap-pad carton in a shop window and, needing to ship some books, asks the shopkeeper whether he can have it. The shop turns out to be an art gallery and the shopkeeper a dealer who says: "That is a work of art, just now worth thirty thousand dollars."

A man sees what looks like Warhol's Brillo Box in what looks like an art gallery, and asks the dealer, who turns out to be a shopkeeper, how much it is. The latter says the man can have it, he was going to throw it away anyway, it was placed in the window temporarily after it was unpacked.

Henri Cartier-Bresson
Behind the Gare Saint Lazare, Paris, 1932

Perhaps half the visitors to the Stable Gallery were angry that something could be put forward as art that so verged on reality that no interesting perceptual difference distinguished them. And perhaps the other half were exultant that something could be put forward as art that so verged on reality that it was distinguished by no interesting perceptual difference. In the early 1960s it was universally assumed that art must be something exalted and arcane, which put one in touch with a reality no less arcane and exalted. The reality on which Warhol's art verged was neither arcane nor exalted: it was banal. And this was perceived as intoxicating or degrading, depending on where one stood on a number of issues having to do with American commercial reality, the values and virtues of the commonplace, the role and calling of the Artist, the point and purpose of art. For me, the interesting feature of the *Brillo Box*, was that it appropriated the philosophical question of the relationship between art and reality and incorporated it into the *Brillo Box* and in effect asks why, if it is art, the boxes of Brillo in the supermarket, which differ from it in no interesting perceptual way, are not. At the very least the *Brillo Box* made plain that one cannot any longer think of distinguishing art from reality on perceptual grounds, for those grounds have been cut away.

I shall return to this in a moment, but I want first to explain what makes *Empire* finally so philosophical a film. Philosophers from ancient times down have been concerned with framing definitions — definitions of justice, of truth, of knowledge, of art. This means in effect identifying the essential conditions for something to be an instance of art, of knowledge, of truth, of justice.

The first thing that might occur to anyone as obvious in framing a distinction between moving and still pictures is that the former do and the latter do not show things in motion. A still picture (let us restrict ourselves to photography) can show us things we know must be moving, as in a famous image by Cartier-Bresson of a man leaping over a puddle. But it cannot show them in motion. A motion picture of the same scene would show the trajectory the leaping man describes. And with this the hopeful philosopher of film might suppose something had been nailed down. What *Empire* demonstrates is that something can be a moving picture and not show movement. Nothing much in the film changes at all, in fact, even though, since the film was taken over an eight-hour stretch, something did change: a light in a window went on or off, a plane could have passed, the dusk in fact fell. But none of this is essential to the thought that the entire film could have been made in which nothing whatever changed or moved. And at once it must become clear that only moving pictures can show stillness, as well as motion.

A photograph by Ansel Adams of the Rockies, paradigmatically immobile to the point of being natural symbols for eternity, is a still picture of a still object. But even so, the photograph, we now realize, no more shows the stillness than Cartier-Bresson's shows the motion. Still pictures show neither stillness nor motion. Think, for comparison, of the difference between black-and-white photography and color photography. A black-and-white photograph may be taken of a black-and-white object — a zebra, say. But it does not show the blackness and the whiteness of that object, it merely shows the

Ansel Adams
Moon & Half Dome, Yosemite National Park, 1960

difference. For all we can tell from the photograph, what registers as black could be red and what registers as white could be pink. A *color* photograph of a black-and-white object actually shows the black and the white of the object. Black-and-white photography, like still photography, is essentially more abstract than its counterpart.

Warhol subtracted everything from the moving picture that might be mistaken for an essential property of film. What was left was pure film. What we learn is that in a moving picture it is the film itself that moves and not, necessarily, its object, which may remain still. Warhol's art, in film and elsewhere, goes immediately to the defining boundaries of the medium, and brings these boundaries to conceptual awareness. What makes him an artist, however, is that he actually makes the art and is not content with imagining it, after the manner of my *Either/Or*. To sit through an entire séance of *Empire*, all eight or so hours of it, in which nothing essentially happens but nothing, may have the collateral effect of making the experience of time palpable, almost as if in a sensory deprivation experiment. We do not become aware of time in ordinary cinema, because too much takes place in time for time itself to become the object of consciousness. Time ordinarily lies outside the experiences with which, as we say, we kill time, seeking distraction. Time is not killed but restored to awareness in *Empire*. And usually, in the ordinary moving picture, the time in the film is a kind of narrative time, so that a century may pass in the course of watching a two-hour film. In *Empire*, narrative time and real time are one. The time in and the time of the film are the same. There is, as

with the *Brillo Box* and the cartons of Brillo, no interesting perceptual difference.

Finally, with *Empire*, we become aware of the material properties of film, of the scratches, the grain, the accidental luminosities, and above all the passing before our eyes of the monotonous band. I think Warhol had an almost mystical attitude toward the world: everything in it had equal weight, it was all equally interesting. Or perhaps it says something about the human mind that under conditions of sensory deprivation it will find interest in the most marginal and unpromising differences. The film is made with the barest equipment, the zero degree of intervention, the null degree of editing. It was concerned, rather, with meaning, material and, finally, mystery. That the film, like the *Brillo Box* itself — like almost everything to which Warhol put his hand — should have the form of a philosophical joke bears out a conjecture of Wittgenstein's that it is conceivable that a philosophical work could be composed consisting solely of jokes. They have to be the right kinds, of course. There is an astronomical distance between Warholian jokes and the one-liners Richard Prince, for example, incorporates into his paintings.

For one thing, Warhol's jokes are not funny. There was, in my recollection of the Stable Gallery nearly thirty years ago, a spirit of play. But the boxes on display were not made in the spirit of play. Nor do I think Warhol capable of play. His seriousness seems almost otherworldly. There was a widely repeated story of a scolding given him at a Long Island party by Willem de Kooning. "You're a killer of art, you're a killer of beauty," de Kooning said, and it is clear that he hated Warhol for

Willem de Kooning
Marilyn Monroe, 1954, oil on canvas, 50 x 30 in. (127 x 76.2 cm)
The Neuberger Museum of Art, Purchase College
State University of New York, gift of Roy R. Neuberger

taking away from art everything that made art fun. So it is easy to understand why his indictment continued, "and you're even a killer of laughter." Who goes to the movies for philosophical instruction? Someday a gifted person should write a book about styles of artistic wit, comparing along the way de Kooning's with Warhol's. An incidental by-product of such an inquiry would be to illuminate the deep difference between de Kooning's *Woman* series and Warhol's *Marilyns*. The act of painting and the act of love were near affinities for de Kooning. Warhol, a far less primordial person, found the essence of women to consist in the images of women that form the common consciousness of sex. Their art and their wit are determined by this difference.

I want to pursue somewhat further the deep philosophical bearing of Warhol's central achievement as part of the classical phase of Pop art in the early 1960s. A great many questions must be answered before we have a full historical understanding of this extraordinary movement, and in particular of what it meant that imagery was appropriated from all across the face of commercial and mass culture. It was often suggested, even by some of the Pop artists themselves at the time, that their intentions were to blur, if not obliterate, the boundaries between high and low art, challenging, with commercial logos or panels from comic strips or advertisements from newspapers and magazines, distinctions assumed and reinforced by the institutions of the art world — the gallery, with especially its decor and the affected styles of its personnel; the collection; the carved and gilded frame; the romanticized myth of the artist.

Even then, differences among Pop artists must be made. In 1962, for example, Roy Lichtenstein painted a work which looked like a monumentalized composition book of the most familiar kind, with black-and-white mottling on the cover, and a label that says "Compositions." Iconographically, it looks as if it goes with the soup cans and the like that Warhol used, but in fact it has a really different meaning altogether. The word "compositions" is something of a pun, for it of course refers to the ways artists arrange forms in pictorial space. And the black-and-white mottling looks like the all-over composition for which Jackson Pollock earned high critical praise. The whole work makes a number of sly art-world allusions, and is in every sense a piece of "art about art," as such work came to be known. It is like the painting of large brushstrokes Lichtenstein made, lampooning the veneration of the heavy looped swirl of paint that emblemized Abstract Expressionism. Mockery is one of the armaments of civilized aggression, and Lichtenstein's work is filled with internal art-world barbs.

Warhol's jokes, I tend to think, were of another order altogether and had little to do with insider attacks on the pretensions of the art world. Rather, he was asking where the distinction is to be sited between art high or low on the one side, and reality on the other. This in a way was a question that had driven philosophy from Plato onward, and while it would be preposterous to pretend that Warhol generated the kind of systematic metaphysics that seeks to define the place of art in the totality of things, he did, in a way I think had never before been achieved, demonstrate what the *form* of the philosophical question must be. And in doing this he invalidated some

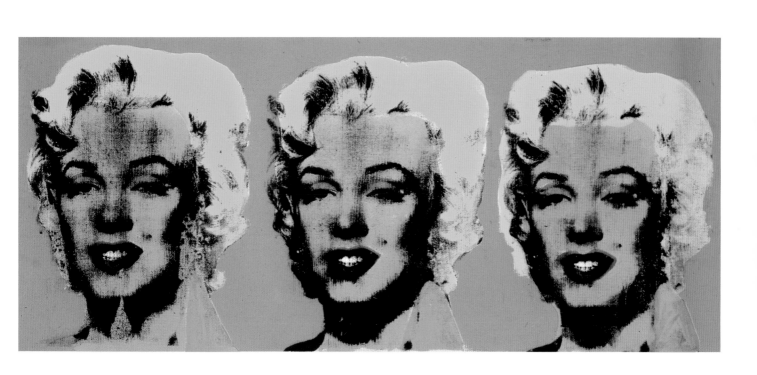

Marilyn (Three Times), 1962
Synthetic polymer paint and silkscreen on canvas, 15 x 33 1/2 in. (38.1 x 85.1 cm)
Founding Collection, Contribution The Andy Warhol Foundation for the Visual Arts, Inc.

Roy Lichtenstein
Composition II, 1964
Magna on canvas, 56 x 48 in. (142.2 x 122 cm)
Collection Ileana Sonnabend

two millennia of misdirected investigation. One thing I
want to propose is that the imagery of Pop enabled him
to do this.

There is a famous section of *Philosophical Investigations*
in which Wittgenstein seeks to call into question the idea
of philosophical definitions, asking whether they can be
achieved and whether there is any point in achieving
them. Wittgenstein uses the example of *games*, and asks
us to try to imagine what a definition of "game" would
look like. He asks us to "look and see," and then, when
we have complied, we will see that there are no overar-
ching properties shared by all the games and only the
games. Rather, games form a kind of "family," the
members of which share some but by no means all prop-
erties. And yet, Wittgenstein says, we all know what a
game is and have no difficulty in recognizing something
as one without benefit of a definition. So what's the point
of pursuing it? His followers not long afterward applied
this strategy to art, where similar reasoning suggested
that artworks form a family rather than a homogenous
class, that there are thus no properties common and
peculiar to works of arts, and that anyway we all know
which are the works of art without benefit of such a defi-
nition. The upshot, these philosophers argued, is that
the long search for definitions was misguided.

It is against this background that Warhol's *Brillo Box*
seem to me to have something significant to say. A pho-
tograph of Warhol among his boxes looks indiscernible
from a photograph of a stockroom clerk among the boxes
in the supermarket. With what license can we pretend
to tell the work of art from the mere utilitarian object?
One is made of plywood, the other of corrugated card-

board, but can the difference between art and reality rest
on a difference that could have gone the other way? In
the end, there seems to be a "family resemblance" far
more marked between *Brillo Boxes* and the Brillo boxes
than between the former and, say, any paradigm work
of art you choose – *The Night Watch*, say – which in fact
seems to have exactly as many resemblances to the Brillo
cartons as to *Brillo Box*. And after all, experts in the art
world at the time were quite ready to consign Warhol's
Brillo boxes to some less exalted category than sculpture,
making them subject to customs duties when a gallery
sought to import them into Canada. The point is that
the difference between art and reality is not like the dif-
ference between camels and dromedaries, where we can
count humps. Something cannot be a camel that looks
like a dromedary, but something can be an artwork
which looks just like a real thing. What makes the one
art may be something quite invisible, perhaps how it
arrived in the world and what someone intended it to be.

Brillo Box does for art what *Empire* does for film. It
forces reflection on what makes it art, when that is not
something that is obvious, just as the film demonstrates
how little is required for something to be a film. To see
Empire as film is to shelve as inessential a lot of what the-
orists have supposed central to film, all of which Warhol
unerringly subtracted. Edmund White puts it perfectly:

*Andy took every conceivable definition of the word art and
challenged it. Art reveals the trace of the artist's hand:
Andy resorted to silk-screening. A work of art is a unique object:
Andy came up with multiples. A painter paints: Andy made
movies. Art is divorced from the commercial and the utilitarian:*

Marcel Duchamp
In Advance of the Broken Arm, original 1915
Wood and metal, "Ready Made" snow shovel, 47 3/4 in. (121.3 cm) high
Yale University Art Gallery: Gift of Collection Société Anonyme

Andy specialized in Campbell's soup cans and dollar bills. Painting can be defined in contrast to photography: Andy recycles snapshots. A work of art is what an artist signs, proof of his creative choice, his intentions: for a small fee, Andy signed any object whatever.

This list could be protracted indefinitely. To be sure, Warhol made his point in a clearly negative way. He did not tell us what art was. But by his framing the question, those whose business it is to provide positive philosophical theories could at last address the subject. It is difficult to pretend that Warhol's intention was to clear the underbrush and make room for a finally adequate theory of art. In some ways it is perhaps inscrutable what his intentions ever were. White, perhaps for effect, called him "a brilliant dumbbell." The speaker in Thom Jones's story says, "I don't think he knew the half of it." Warhol's name is associated with frivolity, glamour, publicity, and making it big. The awesomeness of his achievement is that under the guise of the simple son of the fairy tale, seemingly no match for his daunting siblings, Warhol made the most profound conceptual discoveries, and produced examples of pure art which appear uncannily to look like examples of pure reality.

The question inevitably arises of the extent of Warhol's originality in this matter, inasmuch as the precedent of Marcel Duchamp casts a certain shadow over all subsequent efforts to draw the boundaries of art. In writing about Warhol, one cannot evade the question of the relationship between what he had done in the *Brillo Box*, and what had been achieved with the Readymades of Duchamp. "Aesthetic delectation is the enemy to be defeated," Duchamp had said in connection with this genre of work, and the Readymades, according to him, were selected precisely for their lack of visual interest. And for the most part Duchamp did not endeavor to exhibit them (with of course one notorious exception). Thus one snowy night he walked into the Arensbergs' apartment in New York carrying a snow shovel, which was the work *In Advance of the Broken Arm*, and my sense is that this was a relatively private performance for a small and extremely sophisticated group whose members appreciated and perhaps venerated Duchamp as a novel kind of artist and thinker. The "notorious exception," of course, is the case of *Fountain*, which Duchamp tried to exhibit in 1917 with the Society of Independent Artists at Grand Central Palace. The show was to have been a kind of Salon des Indépendants, hence was to have no jury and award no prizes. Nonetheless *Fountain* was rejected by the hanging committee on the grounds that while any work of art was acceptable, this was not a work of art. And the "work" was hustled out and taken to Alfred Stieglitz's "291" gallery, where it was photographed by the master (with what appears to be an entry card wired to one of the bolt holes).

Stieglitz was particularly sensitive to the issue of something not being art, inasmuch as one of his main struggles was to get *photography* accepted as art. It is certainly true that Duchamp was pressing against the Independents' conception of art, but my sense remains that this, too, was a precocious performance, inasmuch as *Fountain* itself disappeared when "291" closed, the

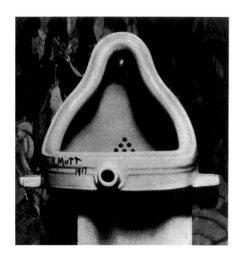

Marcel Duchamp
Fountain, 1917 (not extant)
Photograph by Alfred Steiglitz, from the second issue of
The Blind Man, published May 1917, by Marcel Duchamp,
Beatrice Wood, H.P. Roche

month it was photographed. Evidently nobody came to pick it up, and in my imagined scenario, the workmen threw it out as so much detached plumbing. Its point had been made, and was underlined with the issue of Duchamp's ephemeral magazine, *The Blind Man*, devoted to "the case of R. Mutt" – that being the name with which Duchamp signed it. (Perhaps Duchamp thought he could pick up another urinal at need, which proved false: the particular line of urinal disappeared, and not even The Museum of Modern Art in New York, with all its resources, was able to find an exact duplicate for its High & Low show of 1990.)

Duchamp perhaps felt that, except for the specific occasion of the Independents' exhibition, exhibiting the Readymades would be inconsistent with his anti-aesthetic agenda. Not even the Arensberg group was indifferent to aesthetic considerations, and they tended to think that what Duchamp was bent on was defamiliarizing the urinal, revealing its inherent aesthetic merits and even its formal parallels with the sculpture of Brancusi, which they so admired. Oddly, this may not have been altogether remote from Warhol's intention, just because of his propensity not so much to find beauty in the banal but the banal as beautiful. There is a sense in which he really was moved by the everydayness of everyday things, and this is central to his artistic projects. Whereas Duchamp, so far as one can rely on anything he wrote for *The Blind Man*, claimed that R. Mutt was seeking only to put in place "a new piece of thought" for the object. Perhaps among other things, Duchamp was using the banal as a kind of battering ram against the fortified concept of art which the Independents thought they were

democratizing by waiving admissions criteria, never thinking that "work of art" was as elastic a concept as Duchamp demonstrated it to be.

Still, Duchamp did not raise the question in its vivid Warholian form. Perhaps he made the point that a urinal can be work of art, anticipating the dictum ascribed to Warhol that "anything can be work of art." Duchamp did not raise the other part of the question, namely, why were all the other urinals not works of art? But that was Warhol's marvelous question: Why was *Brillo Box* a work of art when the ordinary boxes of Brillo were merely boxes of Brillo? (As an ironic footnote, the actual Brillo box was designed by Steve Harvey, a second-generation Abstract Expressionist who had turned his hand to commercial design.)

Moreover, the urinal is a highly charged object, associated with some of the most heavily defended boundaries in modern society, namely the differences between the sexes, the segregation of the processes of elimination from the rest of life, and a whole host of associations having to do with privacy, sanitation, and the like. The *Brillo Box* by contrast has no such traffic with the forbidden and the imperative. It is public, bland, obvious, and uninteresting. It was part of Warhol's personality, not merely as an artist, to find the uninteresting interesting and the ordinary extraordinary. "Isn't this a wonderful world?" was something Roy Lichtenstein told me Andy used to say. What he liked about the world was the way it was, exactly in the form in which aesthetes might have found it offensive. Philosophy, Wittgenstein once said, leaves the world exactly as it found it. Warhol, in his uninflected way,

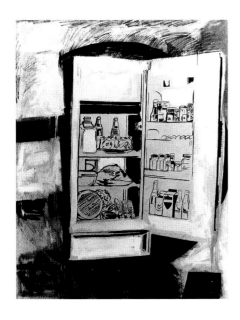

Icebox, 1960
Synthetic polymer paint, ink, and pencil on canvas
67 x 53 1/8 in. (170.2 x 134.9 cm)
The Menil Collection, Houston

did slightly more than leave the world alone. He celebrated the way it was. "The Pop Artist did images that anyone walking down Broadway could recognize in a second – comics, picnic tables, men's trousers, celebrities, shower curtains, refrigerators, Coke bottles – all the great modern things the Abstract Expressionists tried so hard not to notice at all." Elsewhere he once said, "Pop art is a way of liking things." So it was not just the ordinariness of ordinary things that came to constitute his subject matter. His art was an effort to change people's attitudes toward their world. It might almost be said, paraphrasing Milton, that Warhol sought to reconcile the ways of commerce to those who lived in the world it created. It just happened that in so doing, he made a philosophical breakthrough of almost unparalleled dimension in the history of reflection on the essence of art. In fact, the thesis this essay seeks to advance is that he could not have made the breakthrough had he not been as involved as he was with just those objects the "Abstract Expressionists tried so hard not to notice."

This is connected with a further point. Only when someone thinks enough of the most ordinary objects – objects in fact "despised and rejected" by anyone with taste, anyone interested in "higher things," anyone interested in art as high culture – only when someone who thinks these things in fact wonderful, in fact equal to any artwork in existence, only then could that person have put these things forward as art. Still, however greatly one is moved by the ordinary objects Warhol so clearly was moved by, the thought could not have been available that they might be turned into art until that had become an actualizable possibility within the history of art. He

had to have been able to do this. "Not everything is possible at every time" is the great empowering thought of Heinrich Wölfflin. We must then ask what it was that made *Brillo Box* possible, in 1964, when it was actually made and exhibited. It was always possible for such an object to exist. The question is what did it take to make it possible for that object to be *art?*

I begin by considering the negative dimension of Pop: what the movement was *against.* The immediate target was the pretensions of what in New York had taken upon itself the mantle of high art, namely Abstract Expressionism, with its celebration of the self, of the inner states painting allegedly made objective, and of paint itself as the medium par excellence through which these inner states were externally transcribed. In a certain sense, Abstract Expressionist painting was a kind of private pictorial language, a turning away from the public and the political in the interest of producing an art that was, in the words of Robert Motherwell, "plastic, mysterious, and sublime." Motherwell, whose sympathies were inherently European, felt that in achieving this, the New York School (the label was his) had gone well beyond whatever had been attained by the School of Paris, not one of whose painters "is a sublime painter, nor a monumental one, not even Miro." In a famous letter to *The New York Times* (June 7, 1943), Adolph Gottlieb and Mark Rothko wrote: "To us, art is an adventure into an unknown world....The world of the imagination is fancy-free and violently opposed to common sense." The "unknown world" was of course the sphere of the Unconscious, which artists then sought

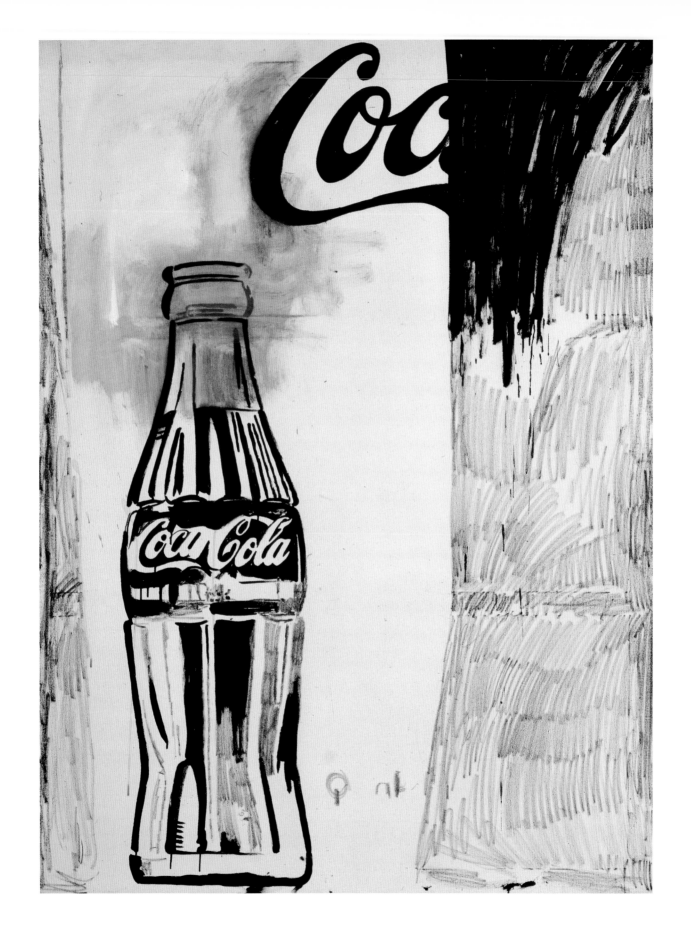

Coca-Cola, 1960
Synthetic polymer paint and crayon on canvas, 72 x 54 in. (183 x 137 cm)
Founding Collection, Contribution Dia Center for the Arts

access to through one or another device of automatism.

Dore Ashton, whose authoritative text on the New York School articulates superbly the canonical artistic mentality of those years, cites a passage from Jung, whose ideas had had a considerable impact on the reflections of the New York painters, preeminently, of course, Jackson Pollock:

Recoiling from the unsatisfactory present, the yearning of the artist reaches out to that primordial image in the unconscious which is best suited to compensate the insufficiency and one-sidedness of the spirit of the age. The artist seizes the image and in the work of raising it from the deepest unconscious he brings it into relation with conscious values, thereby transforming its shape until it can be accepted by his contemporaries according to their powers.

Gottlieb and Rothko wrote: "Only that subject matter is valid which is tragic and timeless. That is why we profess spiritual kinship with primitives and archaic art." The New York painter, in brief, sought to escape the "insufficiency and one-sidedness of the spirit of the age" and to help his contemporaries do so as well. This was to be achieved by connecting them to the powerful contents of the unconscious mind, where they will touch something universal and "tragic." These artists were readers of Freud and Jung, and of the anthropologists; and their reading lists were given them by the Surrealists, who had fled a continent at war to form an encapsulated community in New York. So powerful was the impact of Surrealism on the small circle of original painters in New York that Motherwell, at one point, proposed naming their collective style "Abstract Surrealism."

In turning against Abstract Expressionism's self-proclaimed heroism, almost with a sense of revulsion, in the early 1960s, artists along a wide spectrum that included Pop, Minimalism, and Fluxus were not simply opposing a formal agenda having to do with the way to paint and the meaning of the painterly gesture. They were taking a stand against a certain philosophy of the artist, a certain philosophy of mind, a certain view of society, and in certain cases they found themselves not uncomfortable in "the unsatisfactory present" in which members of the New York School felt themselves so altogether alien. Abstract Expressionism, if we accept the formulation of Gottlieb and Rothko, was in fact a form of cultural criticism, which in particular meant an indictment of the values of a commercialized, "capitalist" society in favor of one more primitive, and more true to human nature as embodied in the symbolic contents of the unconscious mind.

The Expressionists sought to live amid the "great modern things" much as the Surrealists lived in American society, not bothering even to learn the language. To the degree that they paid attention at all to the culture of the world they turned their back to, it was to dismiss it as "Kitsch," to use the word Greenberg gave currency in his great essay of 1939, "Avant Garde and Kitsch." And while Minimalism and Fluxus went their own somewhat different reductionist ways, Pop — and with Pop, Warhol particularly — affirmed everything for which the older movement stood: the ordinary world as against the "unknown world"; the objects everyone knew and recognized in "a split second" as opposed to objects pulled out from the dark depths of the unconscious

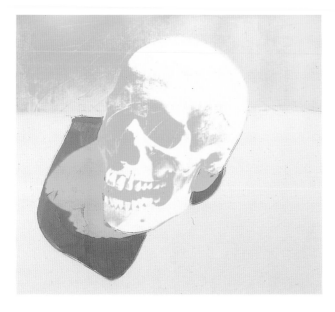

Skull, 1976
Synthetic polymer paint and silkscreen on canvas
72 x 80 1/8 in. (182.9 x 203.5 cm)
Founding Collection, Contribution Dia Center for the Arts

which can only be made present in strange and distorted forms; the comic as opposed to the tragic; the actual world as opposed to something timeless, primordial, and universal. And this meant that Pop affirmed the reliable symbols of everyday life as against the magical, the shamanistic, and the arcane. The Pop artists cherished the things the Abstract Expressionists found crass beyond endurance.

Since we are speaking of "the spirit of the age," it is perhaps of value to pause and reflect on some parallels between what Warhol was doing and what some of the advanced philosophers of the time were doing. The latter, largely under the influence of the late philosophy of Wittgenstein, were making a certain return to ordinary language the center of their thought: precisely, the language of the marketplace, the nursery, and the street, the language everybody knows how to use in the commonplace situations that define the common life. This requires some explanation.

In the period up to and after World War II, philosophical attitudes toward common sense and common speech were by and large contemptuous — neither of them was deemed adequate for the exalted purposes of philosophy. Common sense gave no adequate reading of the way the world really is, as we know it through the discoveries of science. Science, especially modern physics, tells us things inconsistent with common sense that must, accordingly, be false. But ordinary language, as modern logic has revealed, is prone to paradox and hence inadequate to serve the descriptive purposes of science. (Even Freud credited himself, through his discovery of the unconscious, to have dealt a blow to common

sense.) The task of philosophy was to construct an impeccable ideal language suited to house the truths of science, and mathematical logic offered a magnificent tool for this rational reconstruction. Wittgenstein's early masterpiece, the *Tractatus Logico-Philosophicus*, was precisely an effort at designing an ideal language in which whatever was legitimately sayable could be said.

All this changed abruptly in the 1950s in a shift as dramatic and climactic as the shift later in the decade from Abstract Expressionism to Pop, and as unimaginable in its way as it would have been to suppose that serious artists would one day paint uninflected pictures of Donald Duck or Mickey Mouse. There was nothing internal to either art or philosophy that explains the shift — it seems to have come from outside, from exactly "the spirit of the times." All at once the project of an ideal language seemed as preposterous as the claims of the New York School seemed pretentious. Here is a pertinent observation by one of the leaders of the so-called Ordinary Language movement, the Oxford University professor J. L. Austin.

Our common stock of words embodies all the distinctions men have found worth drawing, and the connexions they have found worth making, in the lifetimes of many generations: these surely are likely to be more numerous, more sound, since they have stood up to the long test of the survival of the fittest, and more subtle, at least in all ordinary and reasonably practical matters, than any that you or I are likely to think up in our arm-chairs of an afternoon.

One might substitute "psychoanalyst's couch" for "armchair" and come up with a formulation of the

Ethel Scull, 1963
Synthetic polymer paint and silkscreen on canvas, 4 panels, 20 x 16 in. (50.8 x 40.6 cm) each
Founding Collection, Contribution The Andy Warhol Foundation for the Visual Arts, Inc.

position of the Pop artist against that of the Abstract Expressionist. The Abstract Expressionists, of course, insisted that their paintings were not without content, but in fact had the deepest possible content. But as David Hockney somewhere remarked, the surface is deep enough. Nothing could be deeper or more meaningful than the objects that surround us, which are "more numerous, more sound, and more subtle" than all the portentous symbols dredged up in sessions of Jungian analysis, about which ordinary people know nothing, and regarding which artists may be deluding themselves in supposing they know more.

The terms of the discussion have of course changed, in philosophy no less than in art, since the late 1950s and early 1960s. Today the controversy in philosophy has to do with whether our ordinary explanation of human conduct – what is derogatorily termed "folk psychology" – does not constitute a leaky theoretical vessel for deep understanding of ourselves, and whether it must not be replaced with the language of neuro-computationalism. The transformations in the terms of art world controversy are no less striking. As the 1960s wore on, the world Warhol rhapsodized in his flat descriptive way, like the form of society it embodied, came under intense and various forms of cultural criticism. There was a resurgence of left-wing radicalism stimulated by the Vietnam War, and then a search for alternative life-styles remote indeed from the refrigerators, the storm doors, shining sinks, warm yummy soups, and the pantry stocked with catsup and canned goods, of high Pop. Warhol was shot in 1968, by which time his own aesthetic had undergone a certain evolution. "The early Warhol, before he was

shot" was the transfigurationist of the commonplace. As the 1970s wore on, he became a different kind of artist, more obsessed with glamour, nightlife, and the darker dimensions of gay culture.

But I am ahead of my story. I had intended to give some explanation of how the exaltation of the ordinary helped raise art to a consciousness of its philosophical nature. The Abstract Expressionists certainly regarded themselves as metaphysicians in paint, and believed their art to connect with an array of meanings to which they had access through the unconscious. They used with flourish the language of philosophy and spoke with familiarity of the self, the noumenon, the *Ding an sich*. The ordinary world was, as in a great tradition beginning at least with Plato, misprized as inferior, as mere, as alien in relationship to the reality they believed themselves in touch with. The relationship between art and reality could not be framed in the structures they allowed themselves. It could be framed only when it became possible to accept the ordinary, and to see that something could be art and yet look as much like an ordinary object as one ordinary object looks like another – the way *Brillo Box* resembles Brillo boxes as much as they resemble one another. Once that was seen as possible, it became instantly clear that art was not the way Abstract Expressionist theory required it to be, and could not be philosophically grasped as long as it was conceived that way. Philosophical understanding begins when it is appreciated that no observable properties need distinguish reality from art at all. And this was something Warhol at last demonstrated.

I often have found myself struck by the irony that

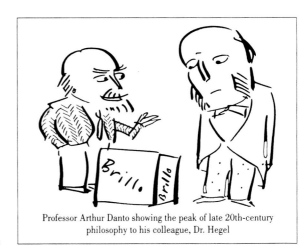

Professor Arthur Danto showing the peak of late 20th-century
philosophy to his colleague, Dr. Hegel

someone so outwardly unlikely as Warhol, who seemed
to the art world so little possessed of intellectual gifts
and powers, so cool, so caught up in low culture — *in
Kitsch!* — should in fact have displayed philosophical
intuitions quite beyond those of his peers who read Kant
and spouted Existentialism and cited Kierkegaard and
used the heaviest and most highfalutin vocabularies.
When I claimed, in an essay I published at the time of
his posthumous retrospective exhibition at The Museum
of Modern Art, that Warhol was the nearest to a philo-
sophical genius that twentieth-century art had brought
forth, I was looked on with some incredulity by a good
many of my friends, who held him in very low intellectu-
al esteem. Motherwell insisted that all Warhol ever said
in front of art was, "Wow." But the genius lay in the
work and in the conceptual intuitions to which the work
was a response.

It is true that one of Warhol's contributions to cul-
ture was a certain sort of look — that of the leather-clad
pale lank night child, monosyllabic and cool, unmoved
by "art, beauty, and laughter," to cite de Kooning's
trinity. But that persona was itself among his works,
a certain embodiment of "the artist of modern times."
He achieved something at the very antipodes of the
paint-smeared proletarian persona of the Cedar Bar: he
became what he did. In an interview published in the
month of her death, Eva Hesse expressed her unqualified
admiration for Warhol because his art and his life were
one. That was the way to be, she felt, and she aspired to
that unity herself. It is in any case not necessary, in
order to display the utmost philosophical acuity, to wear
tweeds and elbow patches and peer out at the world
through pipe smoke.

Warhol's work and life were one because he trans-
formed his life into the image of an artist's life, and
was able to join the images that composed the substance
of art. Unlike Duchamp, Warhol did not seek to set up
a resonance between art and real objects so much as
between art and images, it having been his insight, as
my aphorism from Kierkegaard implies, that our signs
and images are our reality. We live in an atmosphere
of images, and these define the reality of our existences.
Whoever and whatever Marilyn Monroe actually was is
hardly as important as her images are in defining a cer-
tain female essence which, when it was vital, condensed
men's attitudes toward women and women's attitudes
toward themselves. She was her images, on screens and
in magazines, and it was in this form that she entered
common life. She became part of our own being because
she occupied the shared consciousness of modern men
and women the world around. Nothing could be hauled
up out of the depths of the unconscious that could possi-
bly have the magic and power of Marilyn.

Warhol's art gave objectivity to the common cultural
mind. To participate in that mind is to know, immediate-
ly, the meaning and identity of certain images: to know,
without having to ask, who are Marilyn and Elvis, Liz
and Jackie, Campbell's soup and Brillo, or today, after
his death, Madonna and Bart Simpson. To have to ask
who these images belong to is to declare one's distance
from the culture. This made Warhol an utterly public
artist, at one with the culture he made objective. There
are connected with this two forms of death — the cessa-
tion of life and the obsolescence of one's images. When
no one recognizes whose photograph they are looking at,

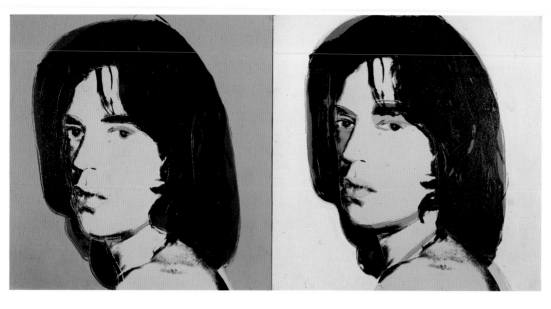

Mick Jagger, 1975
Synthetic polymer paint and
silkscreen on canvas
40 x 40 in. (101.6 x 101.6 cm) each
Founding Collection, Contribution
Dia Center for the Arts

then is the subject of that photograph irrecoverably dead. True fame in the modern world is to have one's image recognized by persons who never knew anything but the image. True immortality is to achieve an image that outlasts oneself and that continues to be part of the common mind indefinitely. Like Charlie Chaplin, or JFK, or Warhol himself. His self-portraits are portraits of his image, and hence as much and as little him as his portraits of Marilyn are "really" her.

To have one's image make it into the common culture is to be a star, in Warhol's system of the world: a movie star, a rock star, a political star, a star of the supermarket shelf, or fairly rare, an art star. Jackson Pollock became an art star, perhaps the first in America, through a *Life* magazine article devoted to him in 1949. Everyone stored Pollock's glowering face, but more important, everyone, everywhere, could recognize, instantly a Pollock. De Kooning, far more highly regarded in some critical circles than Pollock, never became a star. Picasso's great face made him a star somehow, but Braque, far more handsome, never became one. There are no art stars among our contemporaries, no one everyone knows, except perhaps Cindy Sherman. In Clement Greenberg's celebrated taxonomy, stars are Kitsch because their place of being is the common mind. This makes art stars Kitsch, even if their art is avant-garde. This mixing of categories doubtless contributed to Warhol's being held with suspicion if not disdain in high critical circles in America, which found it hard to accept a contribution that was to make Kitsch avant-garde.

Warhol invented a form of portraiture that henceforward specified the way stars would appear. Everyone he portrayed became instantly glamorous through being transformed into the unmistakable Warholesque image: Liza Minnelli, Albert Einstein, Mick Jagger, Leo Castelli. The dealer Holly Solomon commissioned her portrait and exclaimed over how Warhol had turned her into "this Hollywood starlet." But in an odd way there was a certain equality in the subjects, in just the way the Coca-Cola drunk by Liz Taylor is no better than the one drunk by the bum on the corner, Chairman Mao is no more a star than Bianca Jagger, and the black and Latino transvestites of *Ladies and Gentlemen* no less glamorous than Truman Capote or Lana Turner. Or the death star, the human skull. This is how one looks in one's fifteen minutes of world fame. "If you want to know all about Andy Warhol," he said in an interview in 1967, "just look at the surface."

There is more to it than that. He turned the world we share into art, and turned himself into part of that world, and because we ourselves are the images we hold in common with everyone else he became part of us. So he might have said: If you want to know who Andy Warhol is, look within. Or, for that matter, look without. You, I, the world, we are all of a piece.

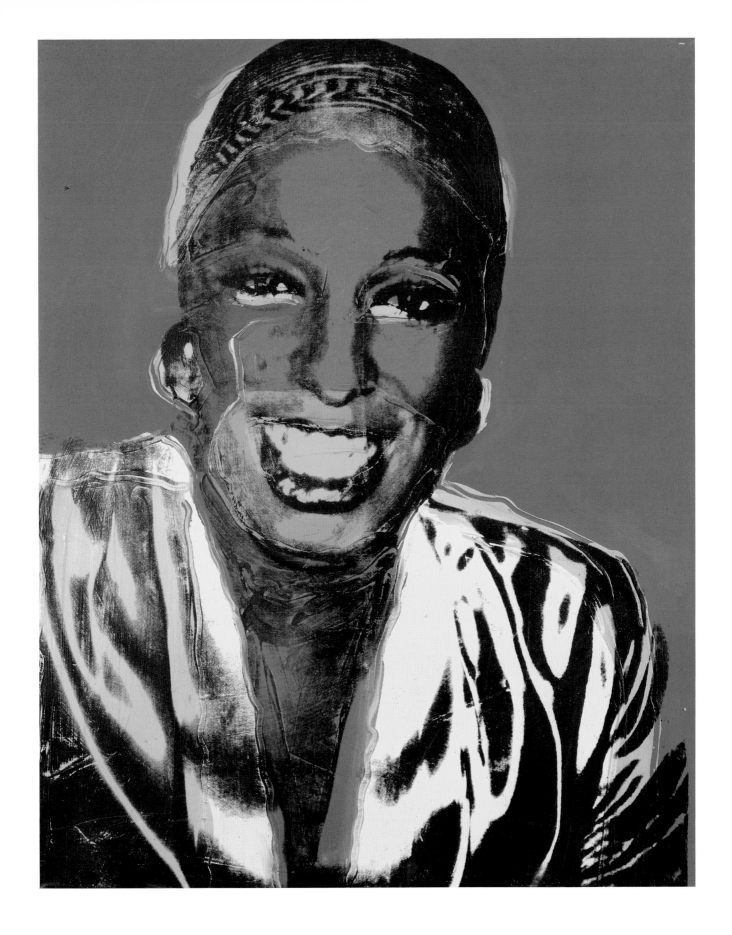

Ladies and Gentlemen, 1975
Synthetic polymer paint and silkscreen on canvas, 49 7/8 x 40 1/8 in. (126.7 x 101.9 cm)
Founding Collection, Contribution Dia Center for the Arts

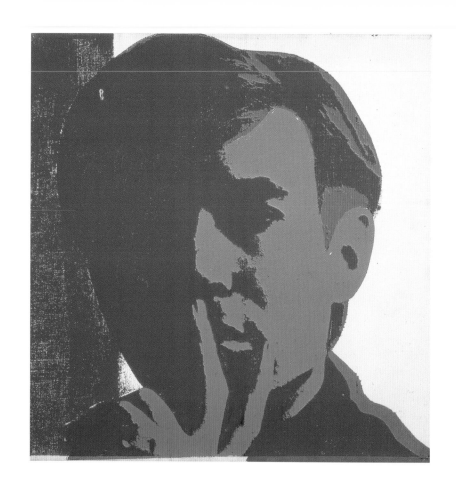

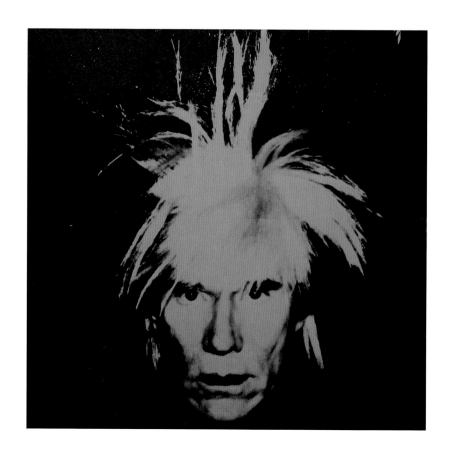

Mark Francis

THE DEMOCRACY OF BEAUTY:
AN INTRODUCTION TO THE COLLECTIONS OF
THE ANDY WARHOL MUSEUM

For what is beautiful to the artist, becomes beautiful.

What is poetical to the poet, becomes poetical.

So let's visit museums with poets and artists.

Dominique de Menil[1]

Self-Portrait, 1966-67
Synthetic polymer paint and silkscreen on canvas
22 x 22 in. (55.9 x 55.9 cm)
Founding Collection, Contribution
The Andy Warhol Foundation for the Visual Arts, Inc

Self-Portrait, 1986
Synthetic polymer paint and silkscreen on canvas
108 x 108 in. (274.3 x 274.3 cm)
Founding Collection, Contribution
The Andy Warhol Foundation for the Visual Arts, Inc.

The concept of a single-artist museum is not as familiar in the United States as it is in Europe, and there are very few examples of such a museum here, despite the extraordinary burst of cultural activity that has occurred in this country during the twentieth century. It is appropriate that it has been left to Andy Warhol, one of the most prolific and influential artists of our time, and one whose work traversed many different forms and media, to be the progenitor of what is, and will likely remain, the most comprehensive single-artist museum in the United States. The collections of his work which are to be given to The Andy Warhol Museum are overwhelmingly the contributions of two sources, Dia Center for the Arts and The Andy Warhol Foundation for the Visual Arts, Inc. In essence, the museum is able to represent thoroughly every aspect of Warhol's work through the combined efforts of the devoted and visionary collectors, Philippa de Menil and Heiner Friedrich, and the artist's estate, of which The Andy Warhol Foundation became the principal beneficiary.

The size of the collection is itself extraordinary, amounting to some 900 paintings and 1,500 drawings, prints of all of Warhol's films as they are preserved and made available, almost all of his published prints on paper and in books, and many hundreds of photographs and Polaroids in varying formats. Warhol often worked in series and in sequences where variation, repetition, and a cumulative effect were fundamental to his purposes, and so it is fortunate that the museum can exhibit his work in such strength and depth, thereby properly and fully representing his contributions to cultural life. Warhol was principally a visual artist, yet one who was

never bound by medium or convention. He not only made paintings, drawings, prints, photographs, wallpaper, sculpture, ephemeral and environmental works, but was also a filmmaker and video artist, a diarist, aphorist, editor, and publisher of books and magazines, a stage designer for dance and theater productions, and an entrepreneur and producer of multimedia events. The title "artist" gave him the license to engage in, and indulge in, all of these various activities.

From the 1970s, when Philippa de Menil and Heiner Friedrich first conceived their plans for permanent installations of Warhol's (and other artists') work, they collected paintings and drawings with the aim of a museum in mind. Consequently they were able to accumulate remarkable examples of Warhol's work, most notably of early 1960s hand-painted consumer images, disaster and car crash paintings from the mid–1960s, the *Skull* series from 1976, and the *Shadows* of 1978.

After Warhol's death in February 1987, his executors were left with a staggering array of his works, papers, source materials, collections, and other assets, and the responsibility of disposing of these materials in a manner of which he would have approved. As the museum has achieved a broad and deep overview of Warhol's work through our research of the last four years, we have become indebted to the grand and generous foresight of Warhol's principal colleague, Fred Hughes, and his associates at the Warhol Foundation for advice and access to the collections.

Andy Warhol was exceptionally prolific and hardworking from his student years in the late 1940s to his death. Although he was highly successful as an artist and sold a great deal of his production even from the early days of his career, he managed to preserve an extraordinarily large number of works at every stage, from drawings and sketchbooks of the 1950s to film reels, photographs, audio- and videotapes, and large paintings, especially from the later periods. All of these were made available to us for our selection of the museum's collections, and we were thus able to study the artist's work with a concentration previously impossible, and to establish hitherto unexplored connections both within his work, and with the work of other artists. The Andy Warhol Museum will be able to exhibit more than 500 of his works at any one time, many more than have been shown together in any previous exhibition. Moreover, the museum will present his work complete and integrated for the first time. Prints, photographs, and archival items will be displayed in galleries together with paintings, and the film theater and film gallery will be adjacent to those exhibition spaces, so that the building will be permeated with the spirit of the artist and the activities of his Factory. Because of Warhol's working methods and techniques, which included the repetitive use of silkscreens, and his hoarding of his own work from almost every phase, the museum has been able to take ownership of what might be considered some of his greatest works, from *Elvis (Eleven Times)* of 1963 to four of the *Last Supper* series of paintings of 1986. In terms of their quality, cultural and historical significance, scale, and value, the donations to The Andy Warhol Museum are among the greatest gifts made to an American museum.

Andy Warhol's work was about beauty. As a young man, he captured the lineaments of beauty in drawings of boys, feet, flowers, and shoes. He recognized a permanent beauty in the iconic images of modern life, which he preserved and embalmed in paintings of *Marilyn* and *Elvis*, *Jackie* and *Liz*, and in his later years he manufactured beauty in the pages of *Interview* magazine and, on commission, in the celebrity portraits he painted and printed. Nor was his representation of youth and beauty detached from the constant sight of death, as many of his works show. His paintings of car crashes and electric chairs, his film *Sleep* (1963), his environments of silver clouds, and his *Shadow* paintings (1978) – done at widely separate moments in his career of more than thirty highly productive years – all reinforce a sense of his constant recognition of the ubiquity of death and the fragility and impermanence of life. His work was principally one of commemoration; his subjects mortality, beauty, and the passage of time itself.

Warhol's paintings and prints of Marilyn Monroe (taken from Hollywood publicity photos of the 1950s) were done just after her death in 1962, as were his later paintings of his own mother, Julia Warhola, with whom he had lived and worked almost all his life. The first significant instances of Warhol's commemorative intent were the sketches of a male head in profile with a schematic outline of a tree and a car crashing into a wall, which referred to James Dean's violent death in 1956; one of these is in the museum's collection. The fetishistic relationship of glamour and death was, and is still, fed and maintained by tabloid newspapers and fan magazines, which were a constant interest of Warhol's from his childhood throughout his adult life.

Shadow, 1978
Synthetic polymer paint and silkscreen on canvas
78 x 138 in. (198.1 x 350.5 cm)
Founding Collection, Contribution
The Andy Warhol Foundation for the Visual Arts, Inc.

In The Andy Warhol Museum these strands in
Warhol's work can be traced and connected across a
period of four decades, from his student drawings done
at Carnegie Tech in Pittsburgh in the 1940s to his last
paintings, made in his studio at 22 East 33rd Street in
New York. The connections also run across the com-
plete range of media he put at his disposal, not only pen-
cil on paper and silkscreen ink on canvas, but film, video
and television, room environments, accumulations of
ephemera in a sculptural sequence (the Time Capsules),
magazines and books, prints, photographs, and Polaroids.
Warhol worked on so many projects simultaneously that
much of his production had to be made in collaboration
with friends, associates, and colleagues. Indeed, his
openness to suggestion from others was notorious.
Although he constantly asked the opinion of those
around him, the large number of drawings, layouts,
printer's proofs, and Polaroids in the Warhol Museum
demonstrate overwhelmingly that he was not — contrary
to the mythology which has developed — disengaged or
uninvolved in decisions, or simply a sponge for other
people's ideas. In fact, he experimented with new tech-
niques, many of them evolving from the wide-ranging
training he received in Pittsburgh. He was historically
innovative, most notably with his application of

silkscreens to paintings on canvas,[2] and there is little
evidence remaining in his studio that he discarded or
put aside paintings or other works as failures. Rather,
the real collective achievements of the Factory were con-
cealed by the glare of over-exposure. Now, in the varied
spaces, both grand and intimate, and in continuing pro-
grams and activities, the interdisciplinary character of his
work will be experienced in an integrated fashion. These
presentations will demonstrate the abundance produced
by Warhol's obsessive work habits, and the multiple
ways in which each medium he touched informs each
of the others.

When he first screened the still image of Elvis Presley
onto a silver-painted canvas in 1963, for instance, the
intimate relations between film and art became
visible. Warhol used a common film still of Presley, the
star of *Flaming Star*, had it enlarged and silkscreened to
human scale and cinema-screen size, and multiplied the
image sequentially on canvas, leaving an impression of
movement. The museum has the largest extant painting
of the series, a canvas that was still in Warhol's studio at
the time of his death. In 1963, at the time that this group
of paintings was made and exhibited in Los Angeles,
Warhol moved on from his meditations on Hollywood
film stars, such as Liz Taylor, Marilyn Monroe, and
Natalie Wood, to making films in his own Factory and
transforming himself and his own crowd into Superstars.
He made art a form of industry, a performative one in
which everybody in his circle collaborated with him in
the nonchalant transformation of images. His collabora-
tions became a form of spiritual ministry in which he
remained at the center of all the activity, goading his dis-
ciples to stay productive. In this way, Warhol turned his
studio into a factory, and that Factory subsequently
turned into a corporation and then a foundation.

In the crucial years of the early 1960s, Warhol's
work grafted together four (apparently) mutually exclu-
sive methodologies of production in a spirit of parody,
play, and implicit respect. First, the industrial and
assembly-line production methods and supermarket dis-
plays of American companies such as Coca-Cola, Heinz,
or Ford were depicted in paintings and sculptures and
imitated in studio fabrication in the silver Factory and
in gallery displays at the Ferus, Stable, Castelli, and
Sonnabend galleries. The Warhol Museum has fifty

Julia Warhola, 1974
Synthetic polymer paint and silkscreen on canvas
40 x 40 in. (101.6 x 101.6 cm)
Founding Collection, Contribution
The Andy Warhol Foundation for the Visual Arts, Inc.

Heinz Boxes, 1964
Synthetic polymer paint and silkscreen on wood
8 1/2 x 15 1/2 x 10 1/2 in. (21.6 x 39.4 x 26.7 cm) each
Founding Collection, Contribution
The Andy Warhol Foundation for the Visual Arts, Inc.

Dance Diagram, 1962
Synthetic polymer paint on canvas, 71 1/4 x 52 in. (181 x 132.1 cm)
Founding Collection, Contribution
The Andy Warhol Foundation for the Visual Arts, Inc.

Heinz Box sculptures as well as a selection of other box sculptures.

The second model of production for the Factory was the Hollywood studio, where an omnipotent impresario could oversee the intense and creative ferment of actors, directors, cameramen, set designers, and others. Warhol could reproduce works according to demand with his silkscreen technique, producing multiple copies of paintings and prints, for example the *Flowers* of 1964, and thus making works available cheaply. Yet at the same time he created an impression of scarcity and demand by stating that he was giving up painting. He understood that the Hollywood machine was fueled by publicity and hype.

Warhol's two other models were smaller in scale, more revolutionary than populist, and emergent from different subcultures rather than ubiquitous. In 1963 he started attending dance events at the Judson Church in Greenwich Village; there he saw, among others, James Waring's dance company, in which Fred Herko and Yvonne Rainer had performed. The "ordinary" movements and untrained performers were influential in Warhol's adoption of unconventional performers and personalities in his Factory crowd. At the same time, Warhol became close to the filmmakers Jack Smith and Jonas Mekas, thereby exchanging the swish uptown gay world associated with the Serendipity café for the "mouldy glamour" and outrageous camp characterized by Smith's films *Flaming Creatures* and *Normal Love*.[3]

With these four disparate worlds to play with, Warhol was able at this period to diversify his activities, previously restricted in large part to fashion and magazine commissions and shop-window displays, and establish patterns for the constant carnival, the cool and enigmatic masquerade, that his operation was to remain for the next twenty-five years.

Quite how productive Warhol's life was (matched among artists in this century perhaps only by Picasso's) can now be seen in its richness, detail, and interrelatedness in The Andy Warhol Museum. It no longer makes any sense to departmentalize his work by medium, as it needs to be seen as a unified whole, a modern *Wunderkammer* in which each seemingly insignificant Polaroid, drawing, press clipping, or film can become the source for a major painting, while a large room environment such as the *Shadows* installation takes on the evanescent, flickering quality of a film strip.

No part of life was irrelevant to Warhol, and each
medium could transmute into another: his techniques of
transformation remained constant throughout his work,
even as technologies evolved. In the museum, film and
video will be shown in close proximity with paintings,
prints, and drawings. Archival items will be integrated
with art objects in ways that may well be unprecedented.
In recent years, archival items have been introduced into
temporary exhibitions, but rarely in the displays of per-
manent collections.[4] The nuances of distinction among
these categories and media are a fundamental aspect of
the richness of experience revealed through Warhol's life
and work. Since Toulouse-Lautrec and Oscar Wilde
in the late nineteenth century, he is possibly the first
artist whose work has become celebrated simultaneously
in elite and popular cultures, in critical studies and the
tabloid press, in the high life of the academy and the low
life of the nightclub.[5]

Warhol earned his living through the 1950s as a
commercial artist, drawing and designing printed ads,
fashion illustrations, and record and book covers. Almost
immediately after his arrival in New York from Pitts-
burgh in 1949, he became highly productive and success-
ful, and his life was transformed from the deprivations
that he had known in childhood. His second career as
an artist took off in 1962–63, after his first gallery exhibi-
tions in Los Angeles and, later, in New York, of
consumer images – soup cans, dollar bills, and so on.
Even now, thirty years later, most critical attention is
paid to this "classic" period, thereby missing the continu-
ities in Warhol's work over a forty-year period and its
developing reach and spread into film, TV and video,
magazines, rock music, and interior design.

Alone among the artists of his generation, Warhol
really participated in, and became an element of, the
popular culture of his time. Paradoxically, however, it is
not as active celebrant, passive voyeur, or detached critic
of consumer culture – as his *Campbell's Soup Can* paint-
ings, *Heinz* and *Brillo* sculptures, and the late *Ads* are
variously supposed to show – that he is implicated in the
spectacle of everyday contemporary life. Rather, it is
his attitude to time, beauty, and personality – in effect,
the relations between the human body and face and
how they are recorded by different mechanisms – which
plunges Warhol's work into both the mainstreams and

Oscar Wilde on couch, 1880s Andy Warhol on couch, 1964–66

Be a Somebody with a Body/Jesus Christ (Last Supper Detail), 1986
Synthetic polymer paint on canvas
50 x 56 in. (127 x 142.2 cm)
Founding Collection, Contribution
The Andy Warhol Foundation for the Visual Arts, Inc.

99

Before and After, c. 1961
Pencil on paper
10 3/4 x 14 3/4 in. (27.3 x 37.5 cm)
Founding Collection, Contribution
The Andy Warhol Foundation for the Visual Arts, Inc.

the subcultures of contemporary existence. John Yau has recently argued, in a subtle analysis of Warhol's work, that the artist's attempt to arrest time, his fear of aging and death, his depiction of the "before and after" of plastic surgery, his repetition of images, all connect him to commercial culture through a shared negation of experience.[6] The simultaneous idealization of and distancing from the subject is at the heart and on the surface of all Warhol's work. By tracing certain pervasive strands in different media, we can see his extraordinary capacity to anticipate, select, and define many of the images which define postwar life.

Warhol's work, however, cannot be confined to the role it is sometimes assigned, that of a social chronicle of its period. It has been claimed that Warhol trivialized the deepest traditions of art by reducing them to the depiction of mundane consumer disposables or the brutal, ephemeral facts of contemporary life. His *Campbell's Soup Can* paintings and *Brillo Box* sculptures can be seen as subversions of the genre of still life, updating the bourgeois tradition of a cornucopia — in which a table is seen piled high with luscious food or spectacular flower arrangements — and transforming it to the modest expectations of the industrial working class from which Warhol escaped. But the ideas with which Warhol was certainly engaged must be measured against the actuality of the paintings and sculptures themselves, and the ways in which they have been exhibited. The museum's own *Campbell's Soup Can (Pepper Pot)* (1962), one of four major soup-can paintings in the collection, monumentalizes the humble can by enlarging it to human scale, but also presents it as romantically decayed, the label peeling off, the metal surface of the can rusting and as pitted as an ancient classical column. The point is not so much what the images Warhol chose represent — in this case a kind of modern democratic sacrament — as the treatment he gave these images. Although Warhol often made images of food and drink — the illustrations for *Wild Raspberries*, the *Campbell's Soup Can* paintings, the film *Eat* (which shows Robert Indiana eating a mushroom), the Velvet Underground and Nico album cover, prints of grapes, ads for Absolut Vodka — they have an anomalous character within his work as a whole, unless they are charged with erotic subtexts or a sacramental aspect. As he did with *Marilyn* and *Jackie*, Warhol selected images already in the public domain — though overlooked as trivial film

Velvet Underground and Nico, 1966
Album cover

Campbell's Soup Can (Pepper Pot), 1962
Synthetic polymer paint on canvas, 71 3/4 x 51 3/4 in. (182.2 x 131.4 cm)
Founding Collection, Contribution The Andy Warhol Foundation for the Visual Arts, Inc.

Philip's Skull (CAT Scan), 1985
Synthetic polymer paint, silkscreen, and urine on canvas
40 x 40 in. (101.6 x 101.6 cm) each
Founding Collection, Contribution
The Andy Warhol Foundation for the Visual Arts, Inc.

stills or press photos — and subjected them to a process which gave them iconic status, and at the same time acknowledged a tragic and allegorical dimension of life and death.

One of the earliest drawings in the collection is an anatomical study of a male torso, done while Warhol was still a student at Carnegie Tech. While it attests to Warhol's technical training and his academic study of the human body, and thereby links him with a Western artistic tradition dating back to Dürer and Leonardo in the sixteenth century, it also prefigures Warhol's abiding interest in the representation of the body, visible in his 1950s drawings and much later in his *Torso* (1977) and *Body Parts* (1985) series, the *Philip's Skull* paintings (1985), derived from a CAT scan image, and paintings and drawings with sources in commercial ads. Along the way, Warhol discarded the principle underlying such drawing studies — that the truth or essence can be revealed by penetrating below the skin to the tendons, skeleton, or character beneath. His great contribution to the history of portraiture was his acceptance and understanding of the photographic trace as the basis

for the construction of identity and personality, and therefore of light and shadow as the means of revelation, rather than touch.

At first, throughout the 1950s, Warhol made many hundreds of life drawings of friends, acquaintances, and dancers posing or performing. The drawings concentrate on heads, torsos, lips, and feet. Many of the sketchbooks in the museum's collection indicate that Warhol produced dozens of drawings in rapid sequence at a single sitting. The contrast between the languor, pleasure, and desire displayed in the poses and the repetitive labor demanded of the artist to depict them became characteristic of Warhol, as his work and play become one and the same. Later, he found simpler ways to make portraits, by having his subjects pose in automatic photobooth machines, making short "screen tests" of them, and taking Polaroids, which could be silkscreened and turned into paintings. In the 1970s, when Warhol had supposedly given up art for a life of socializing, he kept photographing and tape-recording every possible moment, even when he was apparently relaxing amid friends at the nightclub Studio 54.

In all of these media, as in the "monoprints," the unique impressions on paper that Warhol made of some of his 1970s portrait subjects, the façade and the reality are identical, just as the grain and the inflections of the voices on his audiotapes represent the disembodied character of the speaker. In this sense, Warhol made no distinction between documentary and fiction. In lieu of the classical perspectival sense of space, or the cubist fragmentation of planes, representations in which distances in *space* can be described, in Warhol's work difference and change are recognized through *time* and sequentiality. This radical contribution to the history of art also explains Warhol's attraction to dance, film, and publications, rather than to the usually three-dimensional world of theater.[7] Even the many drawings of shoes that he made on commission for *Glamour* magazine and later for I. Miller, Fleming Joffe (an exotic-leather supplier), and other companies are presented only in profile or head-on. There are only rare examples of a three-quarter view or a use of perspective, the latter usually transferred from a photographic source.

Taylor Mead, c. 1963
Photobooth photograph
8 x 1 3/4 in. (20.3 x 4.4 cm)
Founding Collection, Contribution
The Andy Warhol Foundation for the Visual Arts, Inc.

Barbara Allen, c. 1977
Polaroid photograph
4 1/4 x 3 3/8 in. (10.8 x 8.6 cm)
Founding Collection, Contribution
The Andy Warhol Foundation for the Visual Arts, Inc.

Warhol's blotted-line technique, which he had discovered as a student (learned from the graphic works of Paul Klee and Ben Shahn, to which he was exposed at college), was used extensively throughout his most prolific period as a commercial artist during the 1950s, when it corresponded successfully with the letterpress and web-offset printing techniques of the books, magazines, and newspapers in which his work appeared. The starkness of black lines and solid shapes was later modulated with pure color washes, introduced in the Christmas cards he produced for Tiffany's (beginning in 1956); in his Bonwit Teller window displays (1961); and in his own printed books, among them *25 Cats Name Sam and One Blue Pussy*, *A la Recherche du Shoe Perdue* (1954), *A Gold Book* (1957), and *Wild Raspberries* (1959). His use of flat color became more pronounced in the consumer product and soup-can paintings of the early 1960s. His rococo drawing style, and the folksy lettering his mother, Julia Warhola, added to many drawings, were replaced by a harder, more modern style, while the subjects changed from shoes, pastries, angels, cats, and boys, to canned and boxed merchandise, movie stars, and newspaper photographs. But the principles of repetition, derivation from photographs or multiple stamped sources, and flat color remained consistent from one period to the next.[8]

In the later 1950s, Warhol returned to painting on canvas for the first time since his student days. In 1956 he traveled around the world with Charles Lisanby (who worked for the photographer Cecil Beaton), and during the trip reportedly said that he wanted "to be Matisse." There is a formal similarity between Matisse's and Warhol's figure drawings (and also Jean Cocteau's), but further, it is possible that Warhol appreciated the decorative richness and coloration of Matisse's paintings, which he may have seen at The Museum of Modern Art's great exhibition in 1951, soon after his arrival in New York. (His sketches of boys could as appropriately be compared with the contemporaneous drawings and photographs of boys on Fire Island by Paul Cadmus.) It may also be that Warhol recognized the impact of the new fashion photography of the period, especially that of Richard Avedon and Irving Penn, beside which his own line illustrations might seem quaint, and so he decided he wanted to be known as an artist rather than a fashion illustrator.

Two Men (Decorative Background), c. 1950s
Oil, spray paint, and ink on linen
42 x 47 3/4 in. (106.7 x 121.3 cm)
Founding Collection, Contribution
The Andy Warhol Foundation for the Visual Arts, Inc.

Rorschach, 1984
Synthetic polymer paint on canvas, 164 x 115 in. (416.6 x 292.1 cm)
Founding Collection, Contribution The Andy Warhol Foundation for the Visual Arts, Inc.

Elizabeth Taylor in *Butterfield 8*, 1960

Andy Warhol on the telephone, 1964

The American art world was also changing. Jackson Pollock's death in a car crash was announced the very day Warhol returned from his world tour, August 11, 1956. Robert Rauschenberg, Jasper Johns, John Cage, and Merce Cunningham were becoming the leading artistic innovators in New York. At this time, and before the famous Castelli Gallery exhibitions of Johns' flag paintings and Rauschenberg's combines, Warhol began to make midsize paintings with painterly color washes and linear figures, derived and traced from photographic and magazine sources. These can be seen as transitional works, heralding the well-known hand-painted consumer images he began to produce around 1960.

From early in the 1950s, Warhol had taken on assistants (including his mother) to do much of his work, and this "industrial" studio practice makes it difficult to identify which sheets, especially those featuring the blotted-line technique, are by his hand and which by that of, say, Nathan Gluck. The willingness to delegate left Warhol freer to experiment with spray cans, stencils, rubber stamps, marbleized washes, and transfers — techniques which recur, transformed and greatly enlarged, in the later series of *Rorschachs*, *Camouflages*, and *Shadows*. These late abstract paintings are almost always the result of applying printing or reproduction techniques which Warhol learned and put to use long before serious consideration was paid him as an artist. His systematic and exhaustive repertoire of flowers, insects, animals, children, angels, women, and men (almost never a landscape, except when he was a tourist) began to seem formulaic, insignificant, and without symbolic resonance once he started to paint such works as *Bathtub*, *Toilet*, and *Telephone* (all from 1960), and *Dance Diagram* (1962). The images in these works are all emblematic of the human body. The telephone, for instance, can be read against the erotic implications of the telephone in the 1960 film *Butterfield 8*, in which Elizabeth Taylor plays a callgirl whose business depends on that machine.

Even a *Dollar Bill* (1962) is a portrait of the president (like Warhol's later images of Kennedy and Nixon), as well as an index of exchange. Drawings of front pages and headlines from newspapers not only conflate text and image but expect viewers to spend the same amount of time looking at the drawings in a museum or gallery as they would spend reading a newspaper on the subway, so that the experiences would be equalized in value. The

Warhol Museum's collection is extraordinarily strong in paintings and drawings of this critical period in Warhol's development as an artist, so that each step of the way can be traced, from his early drawing of a road sign reading "dead stop" to the disaster and car crash paintings of the mid-1960s, to the images of the stilled and empty chambers of the *Electric Chair* paintings and the *Suicide* prints. Although Warhol's new reputation and notoriety were associated with his use of supposedly mundane and banal subjects such as soup cans and Hollywood film stars, a gravitas underlying the deadpan flippancy began to emerge, and serious criticism could align Warhol's work with that of John Cage or Samuel Beckett as an innovative, unsparing examination of the human condition. The apparently affectless look that has characterized much art over the subsequent thirty years only masked more existential expressions.

While Warhol and other artists — Rauschenberg, Johns, Oldenburg, for instance — began to receive popular acclaim in the news media, their work emerged from an avant-garde milieu that was itself hardly populist. The dance and theater events held at Judson Memorial Church were a crucible in which the importance of the body — its movements, gestures, and silences — was communicated by artists in open and unexpected ways. The secular body was consecrated and privileged over the tradition of the word.[10]

The dramatic change in scale — from intimate drawings and commercial illustrations to monumental canvases — was symptomatic of Warhol's emergence from his safe uptown milieu of Serendipity, fashion magazines, and opera subscriptions. By 1962–63, his love of dance, old movies, comic strips, folk art, and Art Nouveau (and later, Art Deco) had become a public celebration of camp rather than a domestic enthusiasm.

Warhol's success as a commercial artist gave him the security he required as an outsider in the art world, and at the same time enabled him to use his established skills to subvert accepted standards of quality and taste within a supportive avant-garde community. Between 1960 and 1964, he introduced one provocation after another, recognizing that each would reinforce his position as a radical innovator. His *Elvis* paintings were sent to Los Angeles in rolls, cut into saleable sizes, and hung edge to edge like a frieze around the gallery. The Warhol Museum's *Elvis (Eleven Times)* is the last remaining roll

Dead Stop, c. 1953
Ink on paper
19 1/8 x 23 in. (43.6 x 58.4 cm)
Founding Collection, Contribution
The Andy Warhol Foundation for the Visual Arts, Inc.

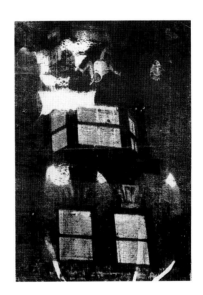

Suicide, 1963
Silkscreen ink on paper
24 x 18 5/8 in. (61 x 47.3 cm)
Founding Collection, Contribution
The Andy Warhol Foundation for the Visual Arts, Inc.

Electric Chair, 1965
Synthetic polymer paint and
silkscreen on canvas
22 x 28 in. (55.9 x 71.1 cm)
Founding Collection, Contribution
The Andy Warhol Foundation
for the Visual Arts, Inc.

Installation view *Andy Warhol*
Whitney Museum of American Art, 1971

from this series. The scale of the painting is not intended
as that of a mural but rather to parody the industrial
production line. Already Warhol was indicating clearly
his calculated use of his studio as a factory, the gallery as
a shop, the painting as wallpaper or film — all elements
which he later carried to their logical ends. His use of
large-scale silkscreens and, later, acetates on paintings
was the final step in his technical experimentation, a
step that allowed him an exceptional and unprecedented
production, including dozens of *Heinz* and *Brillo Box*
sculptures, hundreds of *Jackie* paintings, hours of film.

As his production of objects and films increased,
Warhol merged and overlapped the different media,
creating environments out of museum exhibitions such as
his first retrospective, which traveled from the Pasadena
Art Museum to the Whitney Museum of American Art
in New York in 1971. Paintings were hung close together
so they could not be seen in isolation, and were further
"impurified" by being superimposed on *Cow* wallpaper.
The intended effects were akin to the heightened sensory
overload of the Velvet Underground concerts in which
Warhol projected films and lights over the band, creating
constantly moving shadows.

Warhol's great achievements in 1966 and 1967 had
the casual finality of a poker player's royal flush. All the
characteristics of his later work were there: the frontality
of the images, the replacement of nuance and shading
with the imprints of misregistration and signs of slippage

on the canvas surface. As Warhol perfected his tech-
niques he transferred the viewer's emphasis to the power
or glamour of the subject itself. From a distance of thirty
years, for example, one can acknowledge more readily
how much more powerful and auratic the images of
Marilyn, Liz, and Elvis remain, compared with those
of Natalie Wood, Tuesday Weld, and others of the
same period. It is tantalizing to imagine what kind of
paintings Warhol might have made of those who were
closest to him at that time, like Fred Herko and later
Edie Sedgwick. Their presence and personality survive
only in his films, the sole medium in which Warhol's
capacity to distance himself from personal involvement
did not work.

In his paintings and works on paper of this period,
before he supposedly gave up painting in 1965, Warhol's
role became more that of a public reporter; he edited the
images from newspapers, magazines, or news agencies
and presented them at face value, though enlarged, for
maximum aesthetic impact. Even in the *Flower* paintings
started in 1964 — with a heightened range of colors and
fluorescent paints — there is no spatial depth. They were
designed to be seen en masse in regimented rows on the
walls of galleries, rather than singly. Warhol removed
images from one context — the supermarket or news
media — to another, the gallery, where they would be
seen as another form of the public spectacle of which his
work, and Warhol himself, were becoming a part.

The *Crowd* drawings, which are related to a commis-
sion from *ARTnews* magazine for artists to design posters
for the 1964 New York World's Fair, were derived from
a news photograph of a mass of supplicants being addres-
sed by the pope in St. Peter's Square in Rome, multi-
plied into anonymity, and imaginatively transported to
New York, as if they were tourists at Coney Island or vis-
itors to the World's Fair itself. Warhol recorded every-
thing voraciously, as it happened, with a camera or tape
recorder, so that the parade of exhibitionism was endless
and self-perpetuated. Even automatic photobooths on
the street became an intimate arena where Warhol and
friends or clients could play and invent personae. He
never threw any of these ephemeral objects away, and
despite their fugitive materials and the chaotic storage
conditions in which they have remained for many years,
many of the photobooth strips and early Polaroids
remain in good condition. Some images — those of Ethel

Tuesday Weld, 1962
Silkscreen on paper
29 x 23 in. (73.7 x 58.4 cm) each
Founding Collection, Contribution
The Andy Warhol Foundation for the Visual Arts, Inc.

Most Wanted Men No. 12, Frank B., 1964
Synthetic polymer paint and silkscreen on canvas
48 x 39 in. (121.9 x 99 cm) each
Founding Collection, Contribution
The Andy Warhol Foundation for the Visual Arts, Inc.

Scull and Holly Solomon, for instance — were the sources for commissioned paintings, while many others were put aside. In a sense, they took the place of Warhol's earlier sketchbooks as instant records in sequential time of Warhol and his friends having fun and showing off.

As Warhol's fame spread and his opportunities for exhibition became more extensive, he was able to produce work (as indeed he always had) for specific occasions and commissions. One such assignment came from the architect Philip Johnson, for paintings to be shown on the exterior of his New York State pavilion at the 1964 World's Fair. This series, the *13 Most Wanted Men*, was painted over by the authorities. Later, in 1967, he exhibited large self-portraits at the Montreal World's Fair. As part of the Experiments in Art and Technology at Expo '70 in Osaka, Warhol made *Rain Machine*, an unusual construction that became the first major gift to the Warhol Museum from a donor other than Dia and the Warhol Foundation.[11]

After his first museum exhibition at the Institute of Contemporary Art in Philadelphia in 1965, Warhol was reported to have given up painting, although in fact his production continued unabated and on demand at the

Factory. He began to realize that all the media he was using – silkscreen, film, and audiotape – could be extended into spatial environments which would re-create the permanent day-and-night social space into which his studio had already been transformed. His exhibition at the Castelli Gallery in 1966 consisted solely of *Cow* wallpaper and helium-filled *Silver Clouds* in which the spectators were reflected. Just as Warhol had earlier brought the atmosphere of the supermarket into the rarefied environment of the art gallery when he first exhibited his *Campbell's Soup Cans* on shelves at the Ferus Gallery in Los Angeles, so now he transformed the Castelli Gallery into the equivalent of a nightclub, an artificial interior activated by the presence of the audience. Simultaneously with this remarkable exhibit uptown – which has been reconstructed in the museum – Warhol the entrepreneur was promoting the Velvet Underground and Nico at the Dom, an old Polish social club on St. Mark's Place in the East Village, in a series of concerts that the museum can only document through film and photographs. Transitory though these multimedia concerts were, they nevertheless represent the realization of Warhol's long-held aim of generating a permanent creative atmosphere, a secular communion – glamorous and anonymous.

One means of preventing Warhol's work from being seen merely as an ephemeral form of social commentary is to consider it within the terms and traditions of Catholic iconography. Warhol was brought up in the Eastern Rite Catholic Church, and he remained a practicing communicant in his later years. In the 1960s, however, he publicly signaled how much of his work was fueled by amphetamines and other controlled drugs, and his gay sexuality and amused tolerance of license and excess in his films were not hidden, and Warhol put a distance between his lapsarian world and that of organized religion. His *Marilyn* paintings have been viewed as the equivalent of icons, and it could be argued that his *Jackie* paintings are images of a mourning Madonna, the *Electric Chairs* a crucifixion scene, the *Skulls* his version of *vanitas*, the *Last Suppers* a superimposition of his collaborative work practice on Leonardo's image of Christ and his disciples. Many of Warhol's closest associates were Catholic, including Billy Name, "Pope" Ondine, and Fred Hughes. Seen in this light, Warhol's spectacular productions of music, film, and dance become a kind of epiphany. The heightened spiritual and Dionysiac expe-

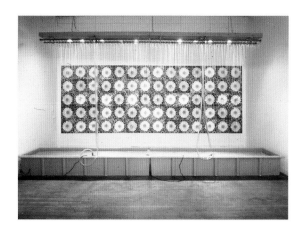

Rain Machine, 1970
Mixed media
132 x 240 x 96 in. (335.2 x 609.6 x 43.8 cm)
Anonymous Gift

Velvet Underground Concert at the Dom, 1966

Last Supper, 1986
Synthetic polymer paint on canvas
116 x 390 in. (294.6 x 990.6 cm)
Founding Collection, Contribution
The Andy Warhol Foundation for the Visual Arts, Inc.

Leonardo da Vinci
Last Supper, c. 1495-98
Oil, tempera and varnish on wall
168 x 346 1/2 in. (427 x 880 cm)
Refectory, Santa Maria delle Grazie, Milan

rience was recognized as such at the time by no less an observer than Barnett Newman, who characterized the multimedia concert he attended as "the greatest spectacle of piety I've ever seen....It seems like a holy place to the people there; they sit and stand as if they were in a church. Their behavior is exemplary. Everyone is involved in quiet courtesy. Instead of the organ a rock-and-roll combo plays; instead of the ritual of sacrament, there's a continuous flashing of images on a screen and everybody is happy."[12]

But the idyll did not last. It began to unravel even in the comedy of films such as *Lonesome Cowboys* and *The Nude Restaurant*, which Warhol made in 1967, and then spun out of control when Valerie Solanas, the founder of S.C.U.M. (Society for Cutting Up Men), shot and seriously wounded him in 1968. As Warhol recovered from his injuries, he started work on portraits of Nelson and Happy Rockefeller and Dominique de Menil, the first in an extensive series of "celebrity" portrait paintings, which preoccupied him and were a staple of his production for the next decade. Instead of the publicity shots and printed sources he had used previously, Warhol derived silkscreens from Polaroids he took. The process can be compared to cosmetic surgery or the

facelift, as he applied himself to images of Mick Jagger, Liza Minnelli, Dennis Hopper, Grace Jones, and other entertainers. Each portrait took on a hieratic aspect as the subjects, now personally known to the artist (as Marilyn and Elvis had not been), were preserved and embalmed looking their best. Warhol took a large number of Polaroids of each portrait subject, trying to get the right pose, and to see the caked white face makeup applied so that imperfections could be bleached out for the enlarged silkscreen, is to realize the close relations between the ideals of cosmetic surgery and the preservative purposes of the death mask.

In this series, Warhol went beyond the "swagger" portrait (the tradition of noble and bourgeois portraiture which stems from the culture of the European courts in the seventeenth century) and the recording of his social milieu, in order to disguise his fear of aging and death. In counterpoint to the ideal of glamorous youth and fame, he also painted a small number of portraits of his closest family, friends, and associates, including his mother, who died in 1972, Henry Geldzahler, Truman Capote, and Leo Castelli. These images, by contrast, make little effort to obscure the depredations of aging and experience. A third type of portraiture emerged in Warhol's portraits of fellow artists such as Jean-Michel

Edouard Manet
A Bar at the Folies-Bergère, 1881-82
Oil on canvas
37 3/4 x 51 1/4 in. (96 x 130 cm)
Courtauld Institute Galleries, Home House Trustees, London

Viva in *The Nude Restaurant*, 1967
Film still

Vincent Van Gogh,
Self-Portrait, 1889
Oil on canvas
25 1/2 x 21 1/4 in. (65 x 54 cm)
Musée D'Orsay, Paris
Gift of Paul and Marguerite Gachet

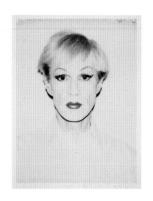

Self-Portrait, c. 1981-1982
Polaroid photograph
4 1/4 x 3 3/8 in. (10.8 x 8.6 cm)
Founding Collection, Contribution
The Andy Warhol Foundation for the
Visual Arts, Inc.

Basquiat, Francesco Clemente, and Joseph Beuys, of a sort of pantheon of creative figures with whom Warhol wished to associate himself. That Warhol spared no one is most evident in his self-portraits, a subject he took up again in 1978 at age fifty. His last self-portraits, done in 1986, are extraordinarily haunting, matching those by Munch and van Gogh in their combination of despair and self-dramatization.

During the 1970s, and almost until his unexpected death in 1987, it was widely assumed — except among younger artists — that Warhol had given up "serious" or "ambitious" art for a life of socializing, in a Faustian pact with celebrity and fame. In fact, just as Warhol had never before distinguished work, play, and private life from one another, he continued to produce extraordinary works, often on a monumental scale. The Warhol Museum has created gallery spaces to accommodate some of his largest, yet subtlest later works.

In 1971 and 1974 he played with, and subverted, the sanctity of the modernist museum's white walls, first by plastering his *Cow* wallpaper on every wall for his retrospective at the Whitney Museum in New York, and then by transforming the Musée Galliera in Paris into an environment with *Mao* paintings, some sixteen feet tall, prints and drawings, shown on top of purple and white *Mao* wallpaper. The Warhol Museum holds an extensive group of the *Mao* series, and the portraits of black drag queens known as *Ladies and Gentlemen* (1975), a subject which was not only close to Warhol's sympathies,[13] but politically charged, just as his last really significant film, *Women in Revolt* (1970–72), had been. The paintings and prints, which have not been widely seen, have some technical similarities to the contemporaneous series of images of Mick Jagger, in their use of collage, linear overlays, and Color-Aid backgrounds.[14]

From the mid-1970s a working pattern emerged at Andy Warhol Enterprises that allowed an even broader range of activities than before. Portrait commissions were constant; *Interview* magazine was issued regularly in increasingly glamorous and colorful formats; books of *pensées*, reminiscences, and photographs were published under the artist's name, starting with *The Philosophy of Andy Warhol (From A to B and Back Again)*, in 1975, which parodied Mao's *Little Red Book* and reinforced Warhol's reputation as an *idiot savant*. Almost everything he touched turned to gold; the only exceptions included the later print

portfolios *Endangered Species*, *Space Fruit*, *Myths*, and *History of Television*, whose subjects were, in the main, too obvious to engage his or others' imagination.

It has gone largely unremarked that Warhol's artistic energies in his last decade were invested not only in his monumental paintings, but also in a considerable number and variety of uncommissioned pencil drawings and screened "monoprints" on paper, which he made for his own interests. His *Diaries* often attest to his obsessive need to return to the studio to make drawings "after hours" and on Sundays. Without exaggeration one might draw a parallel here between Warhol's and Picasso's last years, as both created dozens of drawings, tracing and altering lines of a sketchbook page on the sheet below.[15] Some of Warhol's loveliest images are the unique prints with no background colors and the subjects' lips outlined in red only. These works were never shown during the artist's lifetime, and an extraordinary selection of them is now in the collection of the Warhol Museum.

The crowning glory of the museum's collections, however, is the depth in which his great late series of paintings is represented. From 1978, when the *Shadows* installation, surely one of Warhol's masterpieces, was conceived, he made an extraordinary number of huge and dramatic paintings – the *Oxidations*, *Rorschachs*, *Collaborations*, *Body Parts*, *Medical Diagrams*, *Ads*, *Camouflages*, *Self-Portraits*, and *Last Suppers*, each of which extended his range and yet, in the context of his earlier work, continued to refer to his preoccupations with the human body, the exchange of value between money and objects, and what can only be described as a religious desire for communion and human interaction.

Torso (1977), one of a series of simple and multiple paintings derived from photographs, abstracts the profile of a human body so that, if turned on its side, it would resemble a landscape. (In fact, Warhol ironically referred to the more overtly sexual of his *Body Part* and *Sex Part* series as "landscapes.") In this and similar works personality or character was of no interest to the artist: the figures are anonymous and shown without faces or distinguishing features. They are a translation into another medium of the fetishistic interest Warhol earlier displayed in John Giorno, the subject of his film *Sleep* (1963), and the many sleeping boys he drew in the 1950s. The horizontal faces were then often turned upright

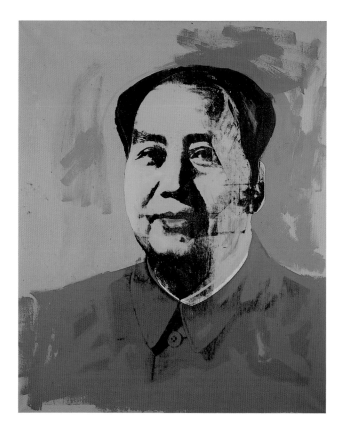

Mao, 1972
Synthetic polymer paint and silkscreen on canvas
82 x 68 in. (208 x 172.5 cm)
Founding Collection, Contribution Dia Center for the Arts

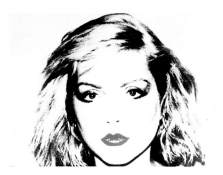

Debbie Harry, 1980
Silkscreen and diamond dust on paper
40 x 60 in. (101.6 x 152.4 cm)
Founding Collection, Contribution
The Andy Warhol Foundation for the Visual Arts, Inc.

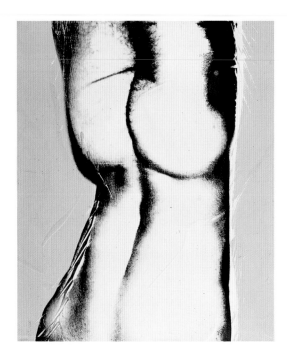

Torso, 1977
Synthetic polymer paint and silkscreen on canvas
50 x 42 in. (127 x 106.7 cm)
Founding Collection, Contribution
The Andy Warhol Foundation for the Visual Arts, Inc.

ninety degrees so that the boys appeared to be in the throes of intense ecstasy, as does the star of the film *Blow Job* (1964).

It would have been easy for an artist as comfortably established as Andy Warhol to disdain the energies and ambitions of younger artists. He not only competed with them but collaborated with them, most closely with Jean-Michel Basquiat and Francesco Clemente, each of whom might be thought to be his polar opposite. In fact, Warhol recognized and encouraged the complementarity of their work with his own. They shared a sense, as did Joseph Beuys, Warhol's great European contemporary, that social and political life, music and dance, producing television and magazines, making record covers and paintings are all part of an interconnected web of private and public activities.

Many of Warhol's later paintings are on such a scale, six or eight feet high and thirty or forty feet long, that they transgress the limits of domestic space and seem destined for the grander public spaces of museums. Nevertheless the viewer can scan the surfaces and be enveloped by an optical and spatial environment, to whose conditions Warhol had been devoted since he first exhibited sprayed and crumpled sheets of paper at the Loft Gallery in New York in 1954. Unfortunately, no documentation survives of Warhol's first installation, yet all his final groups of work strive toward the same ends, which were wholly realized in January 1979, when the *Shadows* were exhibited. In these paintings, among the artist's most enigmatic, an unidentifiable trace of an image, possibly the corner of a room, is repeated 102 times, unfolding like a film strip as the paintings are shown edge to edge, and embodying the colorful, nocturnal, dreamlike world that Warhol himself inhabited, and which he associated with the cinema and the discotheque.

Warhol kept as much of his life as could be recorded in any medium. He never threw anything away. As the myriad materials are identified and brought into the light, the working process and endlessly prolific production of this exceptional artist will been seen in their full complexity, from modest Polaroids, to drawings, to finished prints. A single-artist museum has the unique privilege and responsibility — denied those obligated to isolate single works in a historically significant narrative — not only of presenting an artist's most important contri-

Oxidation Painting, 1978
Synthetic polymer paint and urine on canvas, 12 panels, 16 x 12 in. (40.6 x 30.5 cm) each
48 x 49 in. (121.9 x 124.5 cm) overall
Founding Collection, Contribution The Andy Warhol Foundation for the Visual Arts, Inc.

Raid the Icebox I with Andy Warhol
Installation view at Rhode Island School of Design,
Museum of Art, 1969

Joseph Beuys
Vitrines in the Beuys-Block, 1970
Hessisches Landesmuseum, Darmstadt

butions but also of exploring every vein and capillary of creativity, insofar as they can be drawn from the density and flux of the artist's studio.

None of the critics of Andy Warhol's work have considered its complete scope and range, except those who dismiss his later work as a mere rehearsal of his radical innovations of the early 1960s. Even those most disposed to take Warhol's work as seriously as it deserves, and who acknowledge its enduring impact on art and popular culture, have nevertheless concentrated on its art-historical importance, leaving aside its ramifications as popular culture, and its influence in many fields and subcultures.[6] Warhol is the signal example of an artist who propelled himself from the folk culture of a poor, protective, immigrant Carpatho-Rusyn family into an absorbing immersion in twentieth-century popular culture — a phenomenon with largely American roots which has now become international and all-pervasive. Warhol's work is fundamental to any understanding of these developments. In passing from folk through fine art to popular culture, Warhol learned from industrial production methods and the catalytic revelation of the exceptional license and freedoms granted those in the world of art. Warhol himself, like the shy and modest Clark Kent turning into Superman, or the orphaned Norma Jean Baker becoming the Hollywood goddess Marilyn Monroe, was transformed and consumed by this process. He maintained a certain invulnerable innocence in a world of venal ambition, manipulation, and destruction, and he was able to bring the cultures of fashion, folk art, design, publishing, and high art together and immerse them in the democratic and volatile turmoil of popular culture.

Just as Andy Warhol broke taboos and subverted expectations in his life and work, time and time again, let us hope that the museum devoted to his work, its collections, and programs, will be open to the radicality and vitality that were his constant achievements. His critics have claimed that moral passivity, and a retreat from the high point of his first successes, marred the overall trajectory of Warhol's career; now the extent of his influence and the number of unseen works make it clear that much remains to be discovered. As the artist himself remarked: "They always say that time changes things, but you actually have to change them yourself."

NOTES

1. *Raid the Icebox with Andy Warhol*, catalogue, Museum of Art, Rhode Island School of Design, Providence, 1969.

2. Warhol's first silkscreen paintings, done in 1962, predate Robert Rauschenberg's.

3. See Peter Wollen, "Notes from the Underground," in *Raiding the Icebox: Reflections on Twentieth-Century Culture* (Bloomington: Indiana University Press, 1993), p. 172: "He [Warhol] was the revenge of camp on high seriousness and of the underground on the overground.... The potential of the other dimensions – the underground, the camp, the Velvets – is still available. It left its trace on punk and on the emergence of militantly gay art. In the last analysis, it may be...that he will be remembered not as the artist of the 'copy,' but, more subversely, as the artist of distraction whose Chelsea Girls rampage through the perverse aesthetic realms of the underground imagination."

4. A notable example of new attitudes to the integration of various categories of objects can be seen in the rehanging of the twentieth-century galleries at the Art Institute of Chicago by Charles Stuckey.

5. See Richard Ellmann, *Oscar Wilde*, (New York: Oxford University Press, 1987): "Wilde succeeded in naturalizing the word 'aesthetic.'...From now on the conception of artist was to take on heroic properties." (p. 205). "We inherit his [Wilde's] struggle to achieve supreme fictions in art, to associate art with social change, to bring together individual and social impulse, to save what is eccentric and singular from being sanitized and standardized, to replace a morality of severity by one of sympathy." (p. 589).

6. John Yau, *In the Realm of Appearances: The Art of Andy Warhol*, (Hopewell, NJ: The Ecco Press, 1993), pp. 38-45.

7. Warhol's one attempt at theater was the orgiastic *Pork* (1971), which, unfortunately, has become as underrated as his novel, *a*.

8. See Trevor Fairbrother, "Tomorrow's Man," in Donna De Salvo, ed., *Success Is a Job in New York* (New York: Grey Art Gallery, 1989).

9. The museum lacks only "comic strip" and "do-it-yourself" images among the major subjects of the early 1960s.

10. See Sally Banes, *Greenwich Village 1963: Avant-Garde Performance and the Effervescent Body* (Durham, NC: Duke University Press, 1993), pp. 251-54, for an analysis of the ways in which the church, and its ministers Howard Moody and Al Carmines, opened

Jean-Michel Basquiat, Francesco Clemente, Andy Warhol
Collaboration, 1984
Synthetic polymer paint on canvas, 112 x 80 in. (284.5 x 203.2 cm)
Founding Collection, Contribution
The Andy Warhol Foundation for the Visual Arts, Inc.

themselves to the activities of the avant-garde.

11. Maurice Tuchman was the curator, with Jane Livingston, of the Osaka exhibit.

12. Barnett Newman, *Revolution, Place and Symbol* (New York: Journal of the First International Congress on Religion, Architecture and the Visual Arts, 1967), pp. 129-34.

13. "It's hard to look like the complete opposite of what nature made you and then to be an imitation woman of what was only a fantasy woman in the first place." Andy Warhol, *The Philosophy of Andy Warhol* (New York: Harcourt Brace Jovanovich, 1975), p. 54.

14. The probable origin of these stylistic innovations was a grotesque photographic collage portrait of Warhol by Arnold Newman done in 1973-74.

15. See Rosalind Krauss, *The Optical Unconscious* (Cambridge, MA: MIT Press, 1993), pp. 225-30, for an analysis of the ways in which Picasso's sketchbooks, far from being spontaneous, are related to the mechanical, serial, and erotic sequence of flip-books.

16. See Thomas Crow, "Saturday Disasters: Trace and Reference in Early Warhol," *Art in America*, May 1987.

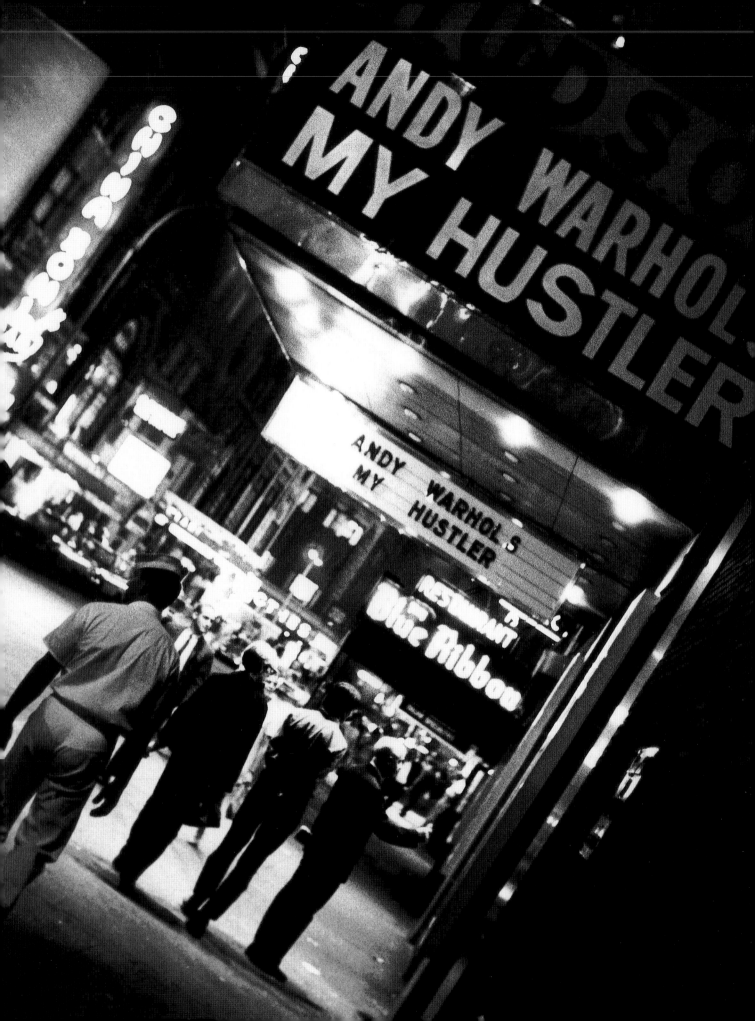

Callie Angell

ANDY WARHOL, FILMMAKER

I.

I have in mind the image of a film I've never seen...

Paul Arthur on *Empire*[1]

Paul Taylor: And there's going to be a retrospective

of your films at the Whitney Museum.

Andy Warhol: Maybe, yes.

Paul Taylor: Are you excited about that?

Andy Warhol: No.

Paul Taylor: Why not?

Andy Warhol: They're better talked about than seen.

From Warhol's last interview[2]

Andy Warhol under the marquee
of the Hudson Theater, 1967

The films of Andy Warhol have inhabited a legendary realm since their very beginnings. Warhol's early series of silent minimalist films, such as the 5-hour, 21-minute **Sleep** (1963), showing a man sleeping, and **Empire** (1964), an 8-hour shot of the Empire State Building, which were seldom shown and at any rate widely considered unwatchable, nevertheless achieved instant fame for their extraordinary length and unprecedented lack of action. To a certain degree, the notoriety of these early films can be seen as a deliberate strategy on Warhol's part, who, as a Pop Artist producing *Campbell's Soup Can* paintings and *Brillo Box* sculptures, was already demonstrating his genius for working in publicity as if it were simply another art medium. As the fame (and reputed length) of the early films accrued over the years, their aura adhered not only to the works themselves, but to Warhol as well, where it enhanced the mystique surrounding his image as an artist.

In 1972, at a time when Warhol and Paul Morrissey were seeking financial backing for their commercial film productions, Warhol withdrew his 1960s films — by then numbering nearly sixty released titles — from public circulation. Hundreds of other films, shot between 1963 and 1968 and never distributed, remained inaccessible in storage at Warhol's Factory. With few exceptions, therefore, the great majority of Warhol's films have not been seen for the past twenty years. As Warhol understood, the absence of his films, whether physically unwatchable or simply unavailable, has consistently worked to increase their value in the marketplace of cultural discourse, where a growing body of recollections, descriptions, and interpretations, projected on the often

blank screens of Warhol's cinema, has come to replace direct experience of the films themselves.[3]

This phenomenon is rare in the popular and easily reproduced medium of film; it is even rarer, perhaps, that a major body of work by such an important contemporary artist should remain so widely unseen even seven years after his death. A multiyear project to research, preserve, and release all of Warhol's films is now well under way; it will be interesting to see what happens as the films return to public view and encounter the discourses that have grown up about them in their absence. But before this process is completed, the withdrawn films are due at least passing recognition as possibly the most Warholian of all the artist's works. Complex and multifaceted as the 1960s, remote and infinitely interpretable as the figure of Warhol himself, these invisible films have occupied a unique place in our cultural imagination for the last twenty years.

The current project to research, preserve, exhibit, and distribute the films of Andy Warhol, now proceeding as a joint effort between the Whitney Museum of American Art and The Museum of Modern Art in New York, with the cooperation and support of The Andy Warhol Foundation for the Visual Arts, has begun the lengthy process of returning Warhol's cinema, work by work, to its proper place in the public sphere; as of this writing, twenty-four titles have been preserved and released.[4] The preservation of the films is the first and most necessary step in reconstructing the history of Warhol's cinema and reassessing his role as filmmaker, a practice as consistently elusive and complex as the films themselves.

The key to both projects is access to the complete Warhol Film Collection, an extraordinary inventory of materials that seems to include nearly every piece of film Warhol generated during his filmmaking years.[5] This collection comprises over 4,000 reels of film: 500 original 1,200-foot reels, 2,800 reels of outtakes and prints, and nearly 800 rolls of original silent film, 500 of which are **Screen Tests** shot between 1964 and 1966, and the rest footage shot for Warhol's other silent films.[6] Included within this massive accumulation of physical materials are many detailed clues to Warhol's filmmaking practice: hand-written notes found on the original boxes containing 100-foot silent rolls; unused 33-minute reels shot for films such as **My Hustler** (1965); prints of films existing in

different versions; unreleased features; uncompleted film series; and other unfinished works.

Inspection of the films is yielding not only firsthand information about their contents, but also a wealth of technical data on the kinds of soundtracks, film stocks, and editing and printing techniques employed by Warhol at different times. Such detailed physical evidence is a valuable tool in the reconstruction of Warhol's activities as a filmmaker, and provides an antidote to the sometimes mythic lore which has informed previous histories of his cinema.

What is beginning to emerge from this new body of evidence is a more specific picture of the remarkable scope of Warhol's film practice – the many different directions in which he moved, often simultaneously, and the extraordinary efficiency with which he worked to realize his ideas in film. Warhol's rapidly shifting interests are apparent in the complex history of his film production, which can be roughly outlined as a number of distinct film series: the minimalist films of 1963-64; early experimental narratives such as **Tarzan and Jane Regained ...Sort of** (1963) and the unfinished **Batman**, **Dracula**, and **Soap Opera** (all three from 1964); the **Screen Tests** and other portrait films shot from 1964 through 1966; the scripted sound films made in collaboration with Ronald Tavel in 1965 and 1966; the Edie Sedgwick films; experiments in multiscreen projection, including the successful commercial release of **The Chelsea Girls** in 1966-67; the rapidly produced series of 1967 "sexploitation" features, which were included in the 25-hour double projection of ★★★★ (**Four Stars**); the on-location features **Lonesome Cowboys** and **San Diego Surf**, shot in 1967 and 1968; and, beginning with **Flesh** in 1968, the series of films produced by Warhol and directed by Paul Morrissey.

In the course of this astoundingly prolific production, Warhol redefined both the filmgoing experience and the practice of filmmaking itself on his own terms, turning out apparently endless movies, or endless series of movies, which seemed to arise from a radical fantasy of film as an omnipresent medium that could literally last forever, a medium that could, furthermore, ultimately reveal everything about its subjects. Warhol's fascination with the mysteries of personality as revealed (and concealed) on screen is a consistent theme through all his movies, which collectively constructed a new definition of film performance as an ongoing dialectic between

Andy Warhol at the rewinds in the Factory, 1964

personality and persona, documentary and drama, reality and illusion.

Warhol's biography and interests are inscribed in his movies on a more personal level than in most of his other artworks – his location as an artist within the avant-garde, his personal and professional relationships, his identity as a homosexual within the various worlds of gay culture in the 1960s, his interest in pornography[7] – all have left explicit traces in the content of his films. Yet Warhol's films are as artistically rigorous as his other artworks, and on terms specific to the medium, from the formal investigations of his structural works, to the experiments in new projection formats, to the parodies and imitations of Hollywood enacted both in individual films and in the Factory's production methods.

Like his other artwork, Warhol's cinema raises difficult questions about perceived boundaries between high and low in cultural production. The trajectory of his film career, moving in less than five years from avant-garde art films to feature-length movies intended for commercial release, mirrors in reverse Warhol's previous move from commercial art into fine art production, and has proved just as problematic for critical discourse, often polarizing opinions about his films into opposing

camps of "art" versus "entertainment."[8] While Warhol's stature as an artist consistently helped to legitimize cinema as an art form, the peculiarities of his practice have complicated efforts to think about his films as works of art in most conventional senses. For example, Warhol's many collaborations with other people, especially Paul Morrissey, have raised confusing questions about the authorship of his films. The fluidity of his filmmaking practice, which was often serial in nature and structured around the full-length reel as the basic unit of production, has in some cases made it impossible to categorize his films in standard filmographic terms, or evaluate them as unique art objects.[9]

There is little evidence that such issues were of much concern to Warhol himself, who from the beginning drew freely from both Hollywood and the avant-garde in the content and practice of his cinema and, in any case, always enjoyed confounding his critics. But it seems likely that a full history of Warhol's career as a filmmaker – a history which comprehends how Warhol himself thought about film – will eventually require some reconceptualization of the traditional ways in which we understand the production of both art and film.

II.

I like photography and cinematography more than

painting now. It's because you can show more in it.

There are more images, more pictures that can be created.

No one can show anything in painting any more,

at least not like they can in movies.

I knew that I would have to move on from painting.

I knew I'd have to find new and different things. Lots of stuff

bores me.

Andy Warhol [10]

"Storyboard" drawings for **Sleep** by Sarah Dalton, 1963

Andy Warhol entered filmmaking with full awareness of recent developments in American avant-garde cinema. Before he started making films in the summer of 1963, he had been regularly attending screenings of underground films organized by Jonas Mekas, who would open the Film-Makers' Cinematheque, an informal avant-garde film theater, in 1964. Warhol's first films not only were intended for underground film audiences, but reflected the influence of other filmmakers whose work he had seen.[11] However, his sphere of reference as a filmmaker also included the related and much larger world of avant-garde art practice in the early 1960s, an explosive period of cross-fertilization and redefinition in the arts to which he was already making major contributions as a Pop Artist.[12] This was the milieu in which Warhol moved, and its pervasive influence can be found in many of his early films, such as the casual appearance of Claes and Pat Oldenburg in **Tarzan and Jane Regained... Sort of** (1963) or the unreleased **Dinner at Daley's** (1964), a documentation of a performance by the Fluxus artist Daniel Spoerri. To a certain extent, Warhol's minimal films can be seen as the successful translation of formal issues current in avant-garde practice in other media into the medium of film. Elements of duration and stillness developed in the music of John Cage and La Monte Young and the repetitive, reductive use of everyday gesture found in performances by dancers such as Steve Paxton and Yvonne Rainer, for example, are apparent in the endlessness of **Empire** and in the sustained and simple actions of **Kiss**, **Eat**, and **Haircut**.[13]

The first major achievement of Warhol's filmmaking career was this group of minimalist films, the notoriously long and static silent movies made in 1963 and 1964 by which he first became widely known as a filmmaker: **Sleep**, **Kiss**, **Haircut**, **Blow Job**, **Eat**, **Empire**, and **Henry Geldzahler**. These works have become so strongly identified with Warhol's origins as a filmmaker that their style—the single unedited reel-long shot recorded on an unmoving tripod-mounted camera—is usually taken literally to represent how Warhol first began to make movies, a technologically "primitive" approach which, supposedly, he only gradually overcame with the help of others – when, as one story goes, Paul Morrissey finally convinced him to move his camera for the first time in 1965.[14] Such a historical view not only overlooks the

wide range of experimental techniques to be found in many of Warhol's early films (which do indeed include such un-Warhol-like elements as hand-held camera, various camera movements, single framing, editing, color, narrative, and even sound[15]), but also tends to obscure the formal sophistication of the minimalist films, a substantial artistic achievement which Warhol gradually perfected during a period of careful experimentation and conceptualization.

Warhol's minimalist films began and ended with the idea of an 8-hour film, which he initially conceived of as a film of a man sleeping. In July 1963, shortly after he had bought his first movie camera, he asked his friend, the poet John Giorno, if he could film him sleeping, and began shooting roll after roll of **Sleep** in Giorno's apartment that summer. Warhol's efforts to complete this film as planned were greatly complicated by the limitations of his equipment, a silent 16mm Bolex which could only shoot 4-minute lengths of film.[16] Early rolls shot for **Sleep** indicate that Warhol experimented with several different techniques, including a moving hand-held camera and multiple shots. "Storyboard" drawings discovered on the boxes of many of the original **Sleep** rolls suggest an elaborate editing scheme which involved cutting short individual shots out of separate rolls and splicing them together (see illustration).[17]

The finished film is a complex montage of different shots of portions of the sleeper's body; these shots vary in length from a few feet to full-length 100-foot camera rolls, with each shot appearing a number of times. Reel Five, for example, which contains 133 splices, is constructed from short sections of film varying in length from 10 to 20 feet, each repeated ten to twenty times. In spite of these efforts, the finished film was not 8 hours long as planned, but only 5 hours and 21 minutes, even when projected, as all of Warhol's silent films, at the slow motion speed of 16 frames per second.[18] It seems likely that Warhol's early experience with the editing of **Sleep** in the fall of 1963 was at least partly responsible for his later avoidance of editing and the adoption of the full-length camera roll as the basic unit of his filmmaking.

It is possible to follow the evolution of Warhol's minimalist technique through **Sleep**, **Kiss** (1963-64), and the three versions of **Haircut** (1963-64), as he gradually eliminated his hand-held camera, internal editing, multi-

Frame sequence from **Sleep**, 1963, with John Giorno

ple camera setups, and other experiments (such as the repeated, reversed film images that appear in **Sleep** as well as in one version of **Haircut**) to arrive at the purist style found in **Blow Job**, **Eat**, **Empire**, and **Henry Geldzahler** (all 1964): a single shot on an entirely stationary camera continued over multiple assembled rolls to record a single preconceived action. By reducing his film production to these basic elements of the medium, Warhol was able to transcend the limitations of his equipment and accomplish the paradoxical effect of stillness and monumental duration in his moving images. The apotheosis of this minimalist style is **Empire**, Warhol's successful realization of the 8-hour film he had tried to make in **Sleep**. By selecting a nonmoving object, the Empire State Building, as his subject, and by renting an Auricon camera which could hold 50-minute, 1,200-foot film cartridges specifically for this shooting, Warhol was able to achieve unprecedented duration and nearly total immobility in this film. After the dramatic first 50-minute reel, in which the sun sets and the exterior floodlights on the building are suddenly turned on, the only action in the film is the occasional blinking of lights until, 6 hours later, in the next to last reel, the floodlights are suddenly turned off again.[19] The utter stillness of this image, immobilized within the stationary frame of the film screen, makes the film equivalent in physical presence to a painting on the wall. The day after shooting **Empire**, Warhol used two leftover reels of film and the rented Auricon to shoot **Henry Geldzahler**, a 99-minute portrait of his friend, the curator and art critic; he then went on to concentrate on other kinds of films.

The artistic success of **Empire** and its predecessors has somewhat overshadowed the continuous nature of Warhol's other, and very different, early explorations in filmmaking. This is especially true of the parodistic experimental narratives he began in 1963 with **Tarzan and Jane Regained...Sort of** — shot in California and starring Taylor Mead and Naomi Levine — and then continued through 1964 in such unfinished works as **Batman** and **Dracula**, made in collaboration with Jack Smith,[20] and **Soap Opera**, an episodic narrative film interrupted, like a television show, by a number of sound commercials made by Lester Persky. The filmmaker Jack Smith, whose **Flaming Creatures** (1963) was seized by the New York City police in 1964 because of the nudity and sexual antics of its transvestite actors, was one of the most

Reel One of **Empire**, 1964

Beverly Grant and Jack Smith during the making of **Dracula** at the Factory, 1964

important early influences on Warhol. Their collaborations spanned a period of almost three years, beginning in 1963 with **Andy Warhol Films Jack Smith Filming "Normal Love,"** Warhol's short "newsreel" film of that event, and continuing through **Batman** and **Dracula** (1964), and Smith's performances in **Camp** (1965) and **Hedy** (1966). For Warhol, Jack Smith served as an early model of how to be a filmmaker — not necessarily in practical terms (Smith's production methods were notoriously disorganized and lengthy) — but on an artistic and political level, especially in Smith's uncompromising commitment to a difficult, even doomed, aesthetic. Like Smith, Warhol would continue to draw upon the mythologies of Hollywood and the underworlds of drag queens and gay camp for the subject matter for a number of his films. Over the years, Warhol used actors who had worked with Jack Smith, including Naomi Levine, Mario Montez, Beverly Grant, and Frances Francine, and traces of Smith's transgressive aesthetic can be found in many of Warhol's films, from **Mario Banana** and **Harlot** (1964) to **Lonesome Cowboys** (1967-68).

Beverly Grant with unidentified young man and Billy Name's cat, Lace, during the making of **Dracula** at the Factory, 1964

By 1964, Warhol's filmmaking had become central-
ized in the Factory, the studio on East 47th Street into
which he had moved at the end of the previous year. At
the Factory, Warhol's cinema production – the shooting
and screening of movies – became the main attraction in
an extraordinary social scene that grew up around the
artist and his art-making activities, as increasing numbers
of visitors from an expanding network of overlapping art
worlds dropped by to see Warhol and, in many cases,
appear in his films. The newly silvered Factory became,
in part, a functioning film studio, with camera, lights,
and backdrops set up for the filming of **Screen Tests**, shot
on the spot with a minimum of preparation, and with an
expanding population of visiting celebrities, potential
actors, technicians, and assistants available for more
elaborate productions.[21] The 500 individual **Screen Tests**
Warhol shot from 1964 through 1966 provide a kind of
filmed guest book for the Factory, including artists, film-
makers, writers and critics, gallery owners, actors,
dancers, socialites, pop music stars, poets, and, of course,
Factory regulars and Superstars.[22] Once preserved, this
collection of formal film portraits will undoubtedly con-
stitute a unique documentation of the New York arts
scene during this period.

These 100-foot silent films have been called both
Screen Tests and Portrait Films, a dual terminology that
suggests their double significance in relation both to
Warhol's cinema and to his lifelong work in portraiture
in other media.[23] For most **Screen Tests**, the subjects
were asked to sit in a chair illuminated by a light and
facing a stationary camera mounted on a tripod; for the
three minutes of filming that followed, they were often
instructed to be as motionless as possible, thus creating
the illusion of a still photograph in the moving medium
of film.[24] These films bear a direct relation to other non-
film works by Warhol, such as the "Photobooth Pictures"
from the same years, 1964-66, which are also portraits
created over time in serial photographic imagery.[25] In
fact, by the fall of 1964, Warhol was considering selling
the **Screen Tests** as individual art objects called "Living
Portrait Boxes," tabletop boxes within which individual
films mounted on 8mm loop cartridges would be project-
ed on small rear screens.[26] Once they are preserved, the
Screen Tests – and what Warhol learned from them about

the posing, framing, and lighting of his subjects[27] — will most likely be seen as important precursors of the later painted and silkscreened portraits Warhol made from his own photographs in the 1970s and 1980s.

But the **Screen Tests** were also central to the development of Warhol's cinema, not only in the attraction and selection of people to star in his movies, but in the expansion of his film practice into a continuous, cumulative mode of serial production. During 1964, Warhol worked simultaneously on a number of other on-going series, including **Batman**, **Dracula**, **Kiss**, the pornographic **Couch**, and **Banana** (a series of short films of people eating bananas). A reporter who visited the Factory one afternoon in November 1964 described Warhol efficiently taking advantage of the presence of John Palmer and Ivy Nicholson to quickly film them in reels of **Couch** and **Kiss**, as well as in individual **Screen Tests**.[28]

Warhol would use and reuse individual **Screen Tests** over the years, recycling the films under a variety of different formats and titles. Some **Screen Tests** were shot or selected for ongoing, conceptual projects such as **The Thirteen Most Beautiful Women**, **The Thirteen Most Beautiful Boys**, and **Fifty Fantastics and Fifty Personalities**; other **Screen Tests** were included in films like **Batman** and **Dracula**, or assembled into omnibus reels for projection in double screen behind performances of the Velvet Underground,[29] or behind poetry readings by Gerard Malanga.[30] They also formed the basis of *Screen Tests: A Diary*, a collaborative publication by Warhol and Malanga which apposed double-frame images from the **Screen Tests** with Malanga's poems about their subjects.[31] In the next few years, Warhol extended this flexible, recombinant mode of production into his narrative films, especially in the making of **The Chelsea Girls** (1966), and in the numerous reels and multiple feature films included in the 25-hour, 94-reel ★★★★ **(Four Stars)** (1967).

From left:
Ray Johnson and Andy Warhol
(with hand-held Bolex) filming
Jill Johnston dancing at the Factory, 1964

Ivy Nicholson prepares for the shooting of her **Screen Test** at the Factory, 1966, with Andy Warhol in the background

II.

Something that I look for in an associate is a certain

amount of misunderstanding of what I'm trying to do.

Not a fundamental misunderstanding;

just minor misunderstandings here and there....

If people never misunderstand you, and if they

do everything exactly the way you tell them to,

they're just transmitters of your ideas,

and you get bored with that.

But when you work with people who misunderstand you,

instead of getting transmissions you get transmutations,

and that's much more interesting in the long run.

Andy Warhol[32]

At the end of 1964, Warhol bought his first sound camera, a single-system 16mm Auricon like the one he had rented for the shooting of **Empire** in July, and made his first sound film, the 70-minute black-and-white **Harlot**, starring Mario Montez. The idea for **Harlot** seems to have originated in a film called **Mario Banana** (1964), a 100-foot black-and-white silent roll which shows the actor Mario Montez, dressed in full drag as Jean Harlow, suggestively eating a banana. **Mario Banana** is not only part of the **Banana** series (other reels of which ended up in **Couch**), but a good example of a successful **Screen Test**, an experimental filming of a particular performer that led directly to a starring role. Montez's performance in **Mario Banana** becomes, in **Harlot**, the centerpiece of a larger staging in which Montez, in blonde wig, white dress, gloves, and pearls, lolls on the Factory couch, eating, and eventually pretending to masturbate with, a series of bananas. Arranged around the couch in formal clothing and generally static poses are Gerard Malanga, Philip Fagan, and Carol Koshinskie holding a white cat. The soundtrack is an off-screen dialogue improvised by Billy Name, the poet Harry Fainlight, and Ronald Tavel, a young playwright whom Warhol had enlisted as screenwriter.[33]

With the acquisition of his Auricon, Warhol was now able to shoot an uninterrupted 33 minutes of film at a time; throughout 1965 he would produce a number of films consisting of full-length unedited reels, often shot with an unmoving camera (which he considered his "contribution" to the art of film).[34] In spite of the addition of sound, dialogue, and the more elaborate narrative situations made possible by the use of 33-minute film cartridges, Warhol continued to use the full-length reel and stationary camera to explore a radical new conception of film not as constructed, "finished" product, but as a kind of delineated performance space, a specific temporal and physical framing within which planned or unplanned actions might or might not unfold. In this approach, a certain number of decisions about a particular film would be made beforehand — a preliminary concept, the occasional writing of a script, selection of the stars, setup of the camera, framing and lighting of the action, the number of reels to be shot — but the filming itself would be left free enough to be affected by a wide variety of chance factors, including the actors' improvisations, forgotten lines and other mistakes, technical prob-

lems, interpersonal tensions, and, increasingly, Warhol's deliberate introduction of destabilizing elements into the film's action. Under these calculatedly chaotic conditions, the "acting" and filming of each movie could become, in the tradition of avant-garde performance, a task performed under difficulties; whatever happened would be recorded on film, and that record, however it turned out, would become the "finished" film itself.

This methodology is particularly noticeable in the series of films Warhol produced with Ronald Tavel, who had a strong artistic sensibility of his own as a writer.[35] In their collaborations, Tavel's densely worded, confrontational subversions of the icons and characters of popular culture came to function not only as the films' "narratives," but also as theatrical "texts" which were destabilized or deconstructed by Warhol's additionally subversive interventions.[36] For example, for the filming of **Vinyl** (1965), from a script by Tavel that was based on Anthony Burgess's *A Clockwork Orange*, Warhol reportedly prevented the actors from learning their lines, so that the script had to be recited in an unnaturally stilted fashion from cue cards held up off camera, while the camera was set up so as to confine the actors within a claustrophobically small performance space. Without consulting Tavel, Warhol also placed Edie Sedgwick in the middle of the action at the last minute, and the film preserves a sudden shift in camera angle caused when the camera accidentally slipped during shooting.

Production photo of **Vinyl**, 1965
From left: Gerard Malanga,
John MacDermott, Tosh Carillo,
Ondine, unidentified, Edie Sedgwick

Edie Sedgwick in Reel One of **Poor Little Rich Girl**, 1965

Edie Sedgwick in Reel Two of **Poor Little Rich Girl**, 1965

Warhol had sought out Tavel's talents when he first started making sound films, because, as he put it, "now that we had the technology to have sound in our movies, I realized that we were going to be needing a lot of dialogue."[37] But soon thereafter, beginning in March 1965, Warhol began making an entirely different, unscripted series of films starring Edie Sedgwick, a beautiful young heiress whom he recently had met through Lester Persky. Warhol's 1965 films of Edie Sedgwick, can be viewed, to a certain degree, almost as documentaries — straightforward films of Edie simply being herself. The series, which Warhol initially called **The Poor Little Rich Girl Saga**[38] shows Edie in a variety of situations taken from her actual life: waking up in the morning in her apartment in **Poor Little Rich Girl**, having dinner with her friends at l'Avventura, her favorite dining spot, in **Restaurant**, hanging out with her friends in her apartment in **Afternoon**. In showing Edie in the act of playing herself, Warhol not only continued the tradition of portraiture which he had initiated in his earlier films, but focused on a subject that would continue to occupy him throughout much of his filmmaking career — the individual personality engaged in self-creating performance, evoked and transformed by the validating scrutiny of Warhol's camera into a true screen presence, the Warhol "Superstar." For Warhol, a Superstar had to be interesting enough to carry a film on their own — not by playing a particular role but simply by enacting "themselves," usually improvising their own dialogue without the aid of a script. Edie was perhaps the most unaffected figure in a long line of articulate, self-dramatizing personalities who would occupy the center of his screen.

In the Sedgwick films, Warhol began to expand beyond the supposedly rigid constrictions of his unmoving camera, which started to interact with Edie's unscripted movements with a variety of slow pans and zooms. **Poor Little Rich Girl** begins with a close-up of Edie's sleeping face; then the camera zooms back to follow her movements around her bedroom. This rather straightforward filming was undermined by Warhol's radical decision to include in the finished film one reel that had been shot, by mistake, entirely out of focus.[39] In this first reel, the blurred figure of Edie, silent in her morning preparations and accompanied by the nostalgic sounds of an Everly Brothers album, becomes increasingly alluring yet ungraspable, setting up a tension that is resolved in

the second, in-focus reel, in which a clearly visible Edie tries on clothes and talks to the off-screen Chuck Wein.

After the static framing of the minimalist films and early narratives, Warhol's camera would become an increasingly active participant in his films, providing a kind of spontaneous authorial commentary with its often radical movements, framings, exposures, and in-camera edits.[40] In **Lupe** (1965) and **Hedy** (1966), for example, the camera occasionally abandons the action, wandering down to the floorboards or up to the ceiling during crucial moments of the plot; by the end of 1966, Warhol would introduce his trademark strobe cut — a form of internal editing in which the camera and tape recorder are quickly turned off and then on again during filming, leaving a clear frame, a double-exposed frame, and a "bloop" on the soundtrack — as a further method of creative intercession into the action of his own films.

In 1965, in addition to the Tavel and Sedgwick series, which Warhol worked on simultaneously (and which themselves overlapped, when Edie appeared in Tavel-scripted films like **Vinyl** and **Kitchen**), Warhol made several other unique, performance-based films: **Drunk** (two reels of the filmmaker Emile de Antonio drinking a bottle of scotch and passing out); **Paul Swan** (a two-reel color portrait of the 80-year-old "aesthetic" dancer performing 50-year-old routines from his European tour); **Camp** (a variety review apparently inspired by Susan Sontag's *Notes on Camp*); and **My Hustler**, a realistic narrative, shot on location on Fire Island, which has since become a classic of gay cinema. By the fall of the year, Warhol was also beginning to experiment with films intended for double-screen projection, a genre he would put to good use in 1966 in both **The Chelsea Girls** and the Exploding Plastic Inevitable, his multimedia productions of the Velvet Underground's proto-punk rock-and-roll performances.[41]

The Exploding Plastic Inevitable, or EPI, an early and influential version of the multimedia light show, included most of Warhol's filmmaking organization in one capacity or another. Films were shown in multi-screen format behind the Velvet Underground as they played; many of Warhol's Superstars performed onstage with the band (including, at various times, Gerard Malanga, Edie Sedgwick, Ingrid Superstar, Mary Woronov, and Ondine); and colored lights, strobe lights,

"Strobe cut" frame sequence from
Bufferin, 1966, with Gerard Malanga

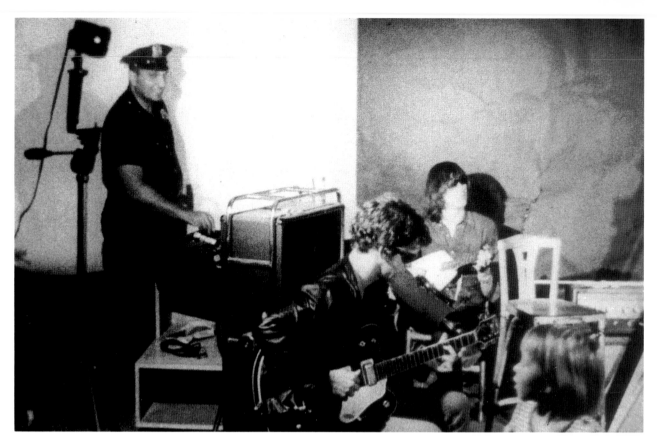

The Velvet Underground and Nico, 1966
From left: New York City police officer, Lou Reed,
Sterling Morrison, Ari Boulogne

and slides were projected around the auditorium by
Warhol and his technicians.[42] Like Warhol's minimalist
films, the EPI screenings redefined the experience of
film-viewing for its audiences, recontextualizing the
movies as part of an overwhelming theatrical environ-
ment of deafening music, strobe lighting, and confronta-
tional performance.

The EPI was a perfect venue for Warhol's by now
voluminous collection of films, especially the standard
33-minute reels, which were easily combined and inter-
changed within a multiscreen format. Although most
shows featured **Vinyl**, whose sadomasochistic activities
were mirrored by Malanga's and Woronov's whip danc-
ing on stage, nearly all of Warhol's films were shown
with the EPI at one time or another. In addition, a
number of films were shot specifically for these EPI
stagings, including **The Velvet Underground and Nico** (1966).
Other two-reelers like **Lupe**, **More Milk Yvette** (both 1965),
and **Hedy** (1966) were premiered in double-screen at
these performances.

IV.

I didn't expect the movies we were doing to be commercial.

It was enough that the art had gone into the stream

of commerce, out into the real world. It was very heady

to be able to look and see our movie out there in the real world

on a marquee instead of in there in the art world. Business art.

Art business. The Business Art Business.

Andy Warhol [43]

I think it would be great to make a $2- or $3-million

art movie where nobody would really have to go to it.

I thought that would be a good project to work on...

do something really artistic.

Andy Warhol [44]

From the beginning, it was Warhol's practice to finance the production of his films with earnings from the sale of his artworks; his economic success as an artist gave him the ability to realize ambitious projects, such as the **Screen Tests** and the 8-hour **Empire**, that few if any other independent filmmakers could have afforded to make. By 1965 he was spending many thousands of dollars a year on the making of noncommercial art films on which he expected no financial return.[45] This is not to say that Warhol was uninterested in financial success or big budget productions. As early as 1965, for example, he had tried to arrange outside financial backing for a commercial film based on the story of *Jane Eyre* and starring Edie Sedgwick, which was to be shot on location in Bermuda and was expected to make a lot of money.[46] Warhol's later moves into more commercial film production have generally been credited to (or blamed on) Paul Morrissey. Although Morrissey was certainly instrumental to this process, this shift must be seen in the context of Warhol's increasingly entrepreneurial interests, which led him, as an artist, to expand his activities into a variety of money-making ventures by the end of the 1960s. As Warhol said, "Making money is art and work is art and good business is the best art."[47]

Warhol's first commercial success, however, was an undilutedly avant-garde film, **The Chelsea Girls** (1966). Assembled from assorted sequences in a double-screen format which presented pairs of uncut, unrelated reels side by side, the film originally purported to represent situations unfolding in different rooms of the Chelsea Hotel, with separate episodes identified by room numbers.[48] In these episodes, various Warhol Superstars played themselves in scenarios that teetered on the edge between fiction and documentary. On one screen, in black-and-white, Ondine, in his self-created role as Pope, injects himself with amphetamine and flies into a rage when called a phony by a young woman, while on the other screen, Nico, bathed in colored lights, weeps silently.

After opening at the Filmmaker's Cinematheque in New York in September 1966, **The Chelsea Girls** attracted rave reviews not only from avant-garde critics such as Jonas Mekas, but from the mainstream press as well, most notably Jack Kroll in *Newsweek*, who hailed the film as a "fascinating and significant movie event...the Iliad of the underground."[49] The film played continuously at the

Ondine in **Father Ondine and Ingrid**,
Reel Two

Nico in **Nico in Kitchen**, Reel One

Ed Hood and Patrick Fleming in
Boys in Bed (The John), Reel Four

Brigid Polk (Berlin) in **Brigid Holds Court
(the Duchess)**, Reel Three

Mary Woronov, Susan Bottomly,
and Ingrid Superstar in
Hanoi Hannah and Guests,
Reel Six

Mary Woronov in **Hanoi Hannah
(the Queen of China)**, Reel Five

Marie Menken, Gerard Malanga,
and Mary Woronov in **Marie
Menken (The Gerard Malanga
Story)**, Reel Eight

Mario Montez, Ed Hood
and Patrick Fleming in
Mario Sings Two Songs,
Reel Seven

Ingrid Superstar, Susan Bottomly,
and Eric Emerson in **Color
Lights on Cast (Their Town
[Toby Short])**, Reel Ten

Eric Emerson in **Eric Says All
(The Trip)**, Reel Nine

Nico in **Nico Crying**, Reel Twelve

Ondine in **The Pope Ondine Story**,
Reel Eleven

Cinematheque and other New York theaters during that fall, and then, making an unprecedented jump from underground theaters to commercial exhibition, went into national release in 1967 and 1968, playing in major cities around the country and provoking police censorship in both Boston and St. Louis. The national success of **The Chelsea Girls**, while dependent on a rather sensationalized interest in the supposedly seamy underworld it revealed, was all the more remarkable in the face of the film's demanding aesthetic: the paired reels, unfolding side by side for 3-and-a-half hours, offered a difficult and densely textured form of nonlinear film narrative, a form originating in, and directly expressive of, Warhol's cumulative, continuous methods of film production. In 1967 Warhol also released ten of the individual episodes of **The Chelsea Girls** as separate feature films through the Filmmaker's Cooperative, including extra reels shot for but left out of the final version of the epic.[50]

In the spring of 1967, Warhol announced his next work-in-progress: a 25-hour film, eventually called ★★★★ **(Four Stars)**, which, he said, would include within it numerous individual feature films which would be released separately.[51] Warhol did in fact complete this extremely ambitious project by the end of the year. As **The Chelsea Girls** moved into national distribution in 1967, the Hudson Theater near Times Square offered to run as many movies as the Warhol film organization could provide, and Warhol and Paul Morrissey began producing a number of individual feature films shot and edited, for the first time, to meet the demands of a particular commercial market. This series of sex comedies — **I, a Man**, **Bike Boy**, **The Loves of Ondine**, **The Nude Restaurant**, and **Tub Girls** — featured various Warhol Superstars like Ondine and Viva in episodic narratives which involved a fair amount of nudity and sexual banter. The titles were designed for the "sexploitation" market, a new genre of soft-core pornography that emerged during the late 1960s in response to relaxed censorship laws.

These 1967 features were the first group of Warhol films to include a substantial amount of postproduction editing, a technique which, in Warhol's later cinema, seems to correlate almost exactly with degree of commercial intent. Unlike the earlier, more anarchic, full-reel films, the later features were increasingly shot, cut, and assembled in order to achieve the effect of a finished

Joe Spencer in **Bike Boy**, 1967-68

Viva and Ondine in **The Loves of Ondine**, 1967-68

product, or something like a manufactured fictional narrative. **The Loves of Ondine**, for example, attempts to restage Ondine's famous rage from **The Chelsea Girls** in a series of improvised confrontations with different women, within the context of a constructed narrative in which Ondine pretends to be a gay man trying to adjust to heterosexuality. By the time the film was released in 1968, it contained material from five different reels of film edited down to a running time of 86 minutes. The uncut reels shot for **The Loves of Ondine** as well as **I, a Man**, **Bike Boy**, **The Nude Restaurant**, and **Tub Girls** were included in the December 15-16 showing of ★★★★, as were a number of other individual reels and longer films shot during that year, including the 8-hour **Imitation of Christ**. This single screening of ★★★★ lasted 25 hours, with 94 full-length reels shown on two projectors in a single superimposed image.[52] By subsuming edited, commercially released features within the production and exhibition of the much larger, uncut, uncompromisingly avant-garde ★★★★ project, Warhol succeeded yet again in bridging the growing gap between his artistic and money-making interests.

Immediately after the screening of ★★★★, Warhol, Morrissey, and an entourage of actors departed for Arizona to make **Lonesome Cowboys**, starring Viva, Taylor Mead, Louis Waldon, Joe Dallesandro, and Eric Emerson, a gay spoof of the Western genre shot on location in the movie ghost town of Old Tucson. In the spring of 1968, the group traveled to California to shoot **San Diego Surf**, a surfing movie starring most of the cast from **Lonesome Cowboys** which was, ultimately, never released. The editing and completion of these ambitious projects was interrupted in early June, when Warhol was shot by Valerie Solanas and almost died. While Warhol was still in the hospital recovering from his wounds, Paul Morrissey, faced with a previous theatrical commitment to provide new films, made **Flesh**, the first "Warhol" film he would direct on his own. A narrative feature about a day in the life of a male hustler, starring Joe Dallesandro, **Flesh** was conceived as a kind of retaliation for John Schlesinger's **Midnight Cowboy**, which was being shot in New York that summer. Both Warhol and Morrissey felt that Schlesinger had appropriated their idea for a film about a male prostitute from **My Hustler**, made three years earlier, and decided to remake their hustler film in

response.[53] **Flesh** opened in September 1968 and was a considerable success, running continuously in New York City through May 1969.

Also during the summer of 1968, the Garrick Theater on Bleecker Street renamed itself the New Andy Warhol Garrick Theater, and began a long run of Warhol films which included reedited versions of the 1967 features. With the positive reception that **Flesh** received from critics and the now-continuous demand for theatrical runs of other Warhol films, Warhol's filmmaking operation became redefined, almost in spite of itself, as a moderately successful independent studio whose activities were, for example, regularly reported in the pages of *Variety*, the trade newspaper of the film industry. The opening, in May 1969, of **Lonesome Cowboys**, the first Warhol picture to be taken on by a commercial distributor, was equally successful, and completed the transition. From now on, the "Andy Warhol Films," produced by Warhol and directed for the most part by Morrissey, would be released primarily in commercial movie theaters within the context of mainstream entertainment cinema.

The last film Warhol himself directed was **Blue Movie**, shot in the fall of 1968 and released in 1969, initially opening under the title **Fuck**. This four-reel feature is a rather straightforward documentation of an afternoon tryst between Viva and Louis Waldon. Although it attracted a good deal of attention—first from the press and later from the law—because it showed an act of sexual intercourse, **Blue Movie** is almost a parody or deconstruction of pornography, concentrating on the affectionate relationship between its two stars, and presenting the act of sex in the most detached manner possible. The film was withdrawn from theaters after it was declared obscene by a panel of three judges from the New York State Criminal Court in the fall of 1969.[54] Warhol retaliated by publishing the film as a book through Grove Press, with a complete transcription of the dialogue and lots of stills.[55]

Once Warhol had decided to run his filmmaking operation as a money-making venture, Morrissey was a natural choice to take over as director, business manager, and spokesperson; in the 1970s Warhol's role in the making of the Warhol/Morrissey films shifted to that of producer, publicizer, and occasional cameraman.

As Warhol's principal filmmaking assistant since 1965, Morrissey had absorbed enough of the Warhol style— long shots, strobe cutting, acting in which the cast appeared to play "themselves"—to produce films that could credibly be released under the Warhol brand name. Yet the purpose of the Morrissey films—which was, in the credo of the entertainment industry, to give audiences what they wanted, a principle beautifully embodied by Morrissey's star Joe Dallesandro—was the opposite of Warhol's earlier films, which consistently sought to subvert, offend, or overthrow normal audience expectations. Warhol was well aware of these differences in approach, and his abdication of the director's role in favor of Morrissey can be understood as a complex and deliberate shift in his stance from artist/filmmaker to artist/businessman: if good business was the best art, and if films directed by Andy Warhol weren't good business, then the best art might be good business generated by Paul Morrissey's films.

The Morrissey films, beginning with **Flesh** and continuing through **Trash** (1969-70), **Women in Revolt** (1970-72), **Heat** and **L'Amour** (both 1971-72), **Andy Warhol's Dracula** and the 3-D **Andy Warhol's Frankenstein** (both 1973-74), are probably the best known "Warhol" films simply because they have been the most widely seen. In the light of this success, the earlier, more difficult Warhol films have retroactively come to be seen by some as crude, preliminary experiments in a historical progression leading inexorably, like the history of cinema itself, to the contemporary features made by Morrissey.[56] Such a view overlooks the fundamental shift in purpose between Warhol's film artworks and the later productions. The Morrissey movies have always rested uneasily within the Warhol filmography, and will continue to do so until the complexities of collaboration, influence, and intention which defined the Morrissey/Warhol relationship—and which have left specific traces in the films they made together—can be unraveled in a manner that does justice both to Warhol and to Morrissey's distinctive and very different talents as a filmmaker.

While Morrissey took over as director of the films, Warhol himself was becoming increasingly involved with another medium—television. Warhol's interest in television was inherent in his films from the beginning; his dream of a never-ending, all-inclusive film had already

been realized in the multi-channel 24-hour medium of broadcast television, his favorite viewing material. In fact, much of Warhol's film production seems to have been informed, often directly, by the formats and conventions of television. In addition to the unfinished **Soap Opera** (1964), a number of Warhol's films were structured, like television, as ongoing, open-ended collections of episodes generated by a single concept: **The Thirteen Most Beautiful Women**, **The Thirteen Most Beautiful Boys**, **Fifty Fantastics and Fifty Personalities**, **Couch**, **Kiss**, and **The Chelsea Girls** were all episodic and serial in nature, and conceivably could have been presented in the format of a weekly television show, just as single 3-minute **Kiss** reels were screened weekly as part of Mekas' underground film programs during the fall of 1963 under the title **Andy Warhol Serial**.

Warhol's interests in video and television recur throughout his filmmaking years. In 1965 he was loaned video equipment by the Norelco company, and shot tapes of Edie Sedgwick and other Factory personnel;[57] and in the fall of 1968 he was commissioned to shoot a color video of a chocolate ice cream sundae as an advertisement for the Schrafft's restaurant chain.[58] By the end of the decade, Warhol was expressing more and more interest in the medium of video: "My movies have been working towards TV. It's the new everything. No more books or movies, just TV."[59] Among his ideas at this time were a feature-length film shot on video for theatrical release on film,[60] and his own television show, a 6-hour program for NBC to be called "Nothing Special" (or "The Nothing Special"), which, modeled after surveillance video, would consist of nothing but people walking by a camera.[61] By 1970 Warhol had acquired a Sony Portapak, and shooting videotapes became a regular activity at the Factory.

In the 1970s and 1980s, Warhol became involved in more professional video and television production, at first developing ideas and pilots for series with Vincent Fremont, and then expanding into the production of color television shows directed by Don Munroe, such as **Fashion** (1979-80), **Andy Warhol's TV** (1980-83), and **Andy Warhol's Fifteen Minutes** (1985-87). In the last two series, which were picked up by cable television, Warhol achieved his dream of appearing as the host of his own television show. Other projects included the production of music videos for such groups as the Cars and Curiosity Killed the Cat, and promotional videotapes for fashion designers. The collection of Warhol's video and television productions, now in the possession of The Andy Warhol Foundation for the Visual Arts, comprises approximately 2,300 original tapes, equivalent in volume to the entire film collection.[62] In 1991, the Whitney Museum of American Art presented an exhibition of selected tapes from this collection; as of this writing, all the Warhol videotapes await preservation and further research, and the scope and contents of the collection are still widely unknown.

In Warhol's view, television and his movies were "just one whole big thing...a lot of pictures of cigarets, cops, cowboys, kids, war, all cutting in and out of each other without stopping."[63] Eventually, once preservation of the Warhol film and video collections has been completed, it will be possible to consider Warhol's films and videotapes together as a single prodigious body of work, the result of three decades of nonstop effort in which the artist seemed to be laboring to create his own version of an omnipresent media culture. It is hard to know which is more astounding—the extraordinary ambition of this project, or the extent to which Warhol actually succeeded in realizing it.

Despite the encyclopedic cataloguing of the collections, the specific history of Warhol's media production still remains largely undiscovered within the labyrinth of its own artifacts; certainly, the sheer volume of the film material has been a persistent and considerable obstacle for both physical preservation and film historical research. Traditional archival methodologies become inadequate in the face of Warhol's idiosyncratic film practice. For example, the standard filmographic catalogue, which lists finished films in the year in which they were released, seriously misrepresents the actual nature of Warhol's modular and extremely flexible film production, in which individual reels often accumulated their own histories as he used and reused them under different titles and in different formats.

In reconstructing this practice, it becomes necessary to distinguish between the conception and shooting of individual films — each with its own production history — and Warhol's subsequent and frequent reappropriation

of those works under a secondary set of exhibitionary concepts. In the repeated footage of **Sleep** and the extended screen time of the silent films, in the recycling of individual reels and the all-inclusive extravaganzas of ★★★★ and the EPI screenings, Warhol seems, remarkably, to have achieved an *inverse* shooting ratio, in which the cumulative duration of exhibited film works actually *exceeded* the original footage he shot. The efficiency — and strangeness — of this practice are unprecedented in the history of film production, and suggest that, in the end, Warhol's filmmaking will have to be reconstructed, both archivally and historically, in terms dictated primarily by his own unique conceptions of the medium.

My greatest thanks go to John G. Hanhardt, Curator of Film and Video and Director of the Andy Warhol Film Project at the Whitney Museum of American Art, who conceived of this project back in 1982 and has seen it through all its stages up to the present; without his vision and persistence the Warhol films would probably still be unavailable. Thanks also to Tom Armstrong who, in 1982, as Director of the Whitney, was instrumental in persuading Warhol to turn his films over to this project for preservation.

The preservation of the Warhol films is being conducted by the Department of Film at The Museum of Modern Art. I would like to thank Mary Lea Bandy, Chief Curator of the Department of Film and Video, for her capable leadership and support of this project. Jon Gartenberg, formerly Assistant Curator, handled the initial cataloguing of the Warhol Film Collection, and preserved the first group of films. Peter Williamson, film conservator, handles the physical inspections and laboratory work for each preserved film: his willingness to wade through the often overwhelming complexities of the Warhol films and his technical expertise have contributed inestimably to this project, especially in the beauty of the new prints. I would also like to thank Anne Morra, Assistant Curator, John Johnson, Senior Cataloguer, and Bill Sloan and Marilyn Mancino of the Circulating Film Library.

This project would not be possible without the enthusiastic support and cooperation of the Andy Warhol Foundation for the Visual Arts, Inc., which is funding both the research project at the Whitney and the preservation of the films at MoMA. Special thanks to Arch Gillies, Director, and to Vincent Fremont and

Fred Hughes, whose support has been an important asset for this project from the beginning. Thanks also to Jane Rubin, Administrator of the Collections, Dara Meyers-Kingsley, Director of the Film and Video Collections, Emily Todd, and Heloise Goodman. The inventories and cataloguing of the Warhol films held by the Foundation were conducted by Mirra Bank Brockman, Terry Irwin, and Adrian Marin; Paul Morrissey provided crucial assistance in identifying reels.

At The Andy Warhol Museum I would like to thank Mark Francis, Curator, Margery King, Assistant Curator, and Matthew Wrbican, Assistant Archivist for their help with the research for this project.

At the Whitney Museum of American Art, in addition to John G. Hanhardt, Curator of Film and Video, the following people have provided assistance to this project: Matthew Yokobosky, Assistant to the Curator, Film and Video, Lucinda Furlong, formerly Assistant Curator of Film and Video, Anita Duquette, May Castleberry, Sheila Schwartz, Jim Maza. I would like to express my personal gratitude to the interns who volunteered their time to assist me on this project: Christiana Perrella, Erin Kenny, Eliot Nolen, and especially Roy Grundmann.

Thanks also to the staff and librarians at Anthology Film Archives, the Avery Architectural and Fine Arts Library at Columbia University, the Billy Rose Theater Collection at the Lincoln Library for the Performing Arts, the Film Study Center at The Museum of Modern Art, and the Mid-Manhattan Library.

In addition, I would like to thank the following people for their help during the first three years of research: Yann Beauveais, Joe Carella, Lucinda Childs, George Custen, Jennifer Doyle, Rich Evangelista, Don Finnamore, Paul B. Franklin, Bob Goldstein, Sam Green, Robert Haller, George Hauser, Richard Hellinger, Jim Hoberman, David James, Ray Johnson, Russell A. Karel, Francene Keery, Steve Kokker, Richard Kozarski, Douglas Leigh, Miles McKane, Jonas Mekas, Debra Miller, Billy Name, Anne Marie Olivo, Moritz Pickshaus, Fred Reidel, Steve Seid, P. Adams Sitney, Jerry Tartaglia, John Warhola, Tom Waugh, Ben Weisman, Reva Wolf, Irwin Young.

The author is Adjunct Curator of the Andy Warhol Film Project at the Whitney Museum of American Art and consultant to The Museum of Modern Art on the preservation of the Warhol films.

NOTES

1. Paul Arthur, "Structural Film: Revisions, New Versions, and the Artifact," *Millennium Film Journal*, 1, no.2, (Spring Summer 1978), p. 5.

2. Paul Taylor, "Andy Warhol: The Last Interview," *Flash Art*, no. 133, April 1987, p. 43.

3. Since 1972, when Warhol's films were withdrawn, a number of books have appeared that have focused on or included extensive discussions of his filmmaking. These include Stephen Koch's *Stargazer: Andy Warhol's World and His Films* (New York: Praeger, 1973); Jean Stein and George Plimpton's *Edie: An American Biography* (New York: Alfred A. Knopf, 1982); Patrick Smith's *Andy Warhol's Art and Films* (Ann Arbor, MI: UMI Research Press, 1986); Victor Bockris's *The Life and Death of Andy Warhol* (New York: Bantam, 1989); David Bourdon's *Warhol* (New York: Harris N. Abrams, Inc., 1989); the British Film Institute's *Andy Warhol Film Factory* (London: BFI Publishing, 1989); David James' *Allegories of Cinema: American Film in the Sixties* (Princeton, NJ: Princeton University Press, 1989); the Centre Georges Pompidou's *Andy Warhol, Cinema* (Paris: Éditions Carré, 1990); and Maurice Yacowar's *The Films of Paul Morrissey* (Cambridge University Press, 1993). Of these, only Koch and Bourdon seem to have had access to a substantial number of the Warhol films for screening.

4. *Sleep* (1963), *Haircut (No. 1)* (1963), *Kiss* (1963-64), *Blow Job* (1964), *Eat* (1964), *Empire* (1964), *Henry Geldzahler* (1964), *Poor Little Rich Girl* (1965), *Vinyl* (1965), *The Life of Juanita Castro* (1965), *Beauty #2* (1965), *My Hustler* (1965), *Paul Swan* (1965), *Lupe* (1965), *The Velvet Underground and Nico* (1966), *The Chelsea Girls* (1966), *Bufferin* (1966), *I, a Man* (1967-68), *Bike Boy* (1967-68), *The Loves of Ondine* (1967-68), *The Nude Restaurant* (1967-68), *Lonesome Cowboys* (1967-68), *Flesh* (1968-69), and *Blue Movie* (1968). (Films are dated to the year they were made, not the year of release; double dates indicate films shot one year and edited or otherwise completed later.)

5. With some exceptions: as Jonas Mekas has related, *Andy Warhol Films Jack Smith Filming 'Normal Love'* (1963) was seized by the New York City police in 1964 and never recovered; a few other titles have not yet been located within the collection and may be missing; and some films may be in the possession of other people — Gerard Malanga, for

example, has the original of *Couch* (1964).

6. For a discussion of the cataloguing and inspection of the Warhol Film Collection, and a description of the initial phases of the research and preservation project, see Jon Gartenberg, "The Films of Andy Warhol: Preservation and Documentation," in the exhibition catalogue *The Films of Andy Warhol: An Introduction* (New York: Whitney Museum of American Art, 1988), pp. 15-17.

7. For a cogent discussion of the relationship between Warhol's films and gay pornography, see Tom Waugh, "Cockteaser," in Jennifer Doyle, Jonathan Flatley, and Jose Muñoz, eds., *Pop Out*, (Durham, NC: Duke University Press, 1994 [forthcoming]).

8. For example, Koch (1973, pp. 98-103) finds a lamentable "degradation" in the quality of Warhol's films beginning in 1967 and attributes this to the increasing influence of Paul Morrissey. Other critics like John Russell Taylor ("Paul Morrissey/ Trash," *Sight and Sound*, 41, no. 1 [winter 1971/72], pp. 31-32) welcomed Morrissey's contributions as a noticeable improvement in the Warhol films.

9. The fluidity of Warhol's film production can be seen in the compilation films *The Thirteen Most Beautiful Women*, *The Thirteen Most Beautiful Boys*, and *Fifty Fantastics and Fifty Personalities* (1964 –), which were apparently never finished, but instead consisted of shifting collections of *Screen Tests*, sometimes assembled according to who would be attending a particular screening; these works have not been found in the inventory of film materials, although a large number of individual *Screen Tests* associated with these titles have been identified.

10. Michael VerMeulen, "On the Promo Circuit with Andy Warhol," *The Chicago Reader*, September 19, 1975.

11. The most important influence on Warhol was unquestionably that of Jack Smith (see below), but other filmmakers influenced him as well. Warhol's epic *Sleep* (1963) seems to owe something to Willard Maas's *Geography of the Body* (1943), and his first narrative, *Tarzan and Jane Regained...Sort Of* (1963), is, like Ron Rice's *The Flower Thief* (1960), structured around improvised performances by Taylor Mead. The influence of Kenneth Anger's *Scorpio Rising* (1963) can been seen in *Couch* (1964) and *Vinyl* (1965). Warhol knew Willard Maas and his wife, the filmmaker Marie Menken, through his painting assistant Gerard Malanga, who had been Maas's student at Wagner College on Staten Island. Warhol's connections to Ron Rice seem less certain, but one of the original 100-

foot rolls in the collection is labeled "Film by Ron Rice. Taylor and me."

12. For discussions of interrelated developments in dance, theater, music, painting, performance, and film during this period, see Barbara Haskell, *Blam! The Explosion of Pop, Minimalism, and Performance, 1958-1964* (New York: Whitney Museum of American Art and W. W. Norton, 1984), including John G. Hanhardt, "The American Independent Cinema, 1958-1964;" and Sally Banes, *Greenwich Village 1963: Avant-Garde Performance and the Effervescent Body* (Durham, NC, Duke University Press, 1993).

13. Warhol's connections to avant-garde dance, music, and performance are complex and over-determined. For example, Warhol was friends with both Billy Name and Fred Herko, who were, respectively, the lighting designer and a dancer at the Judson Dance Theater; the choreographer James Waring appears, with Name and Herko, in *Haircut (No. 1)* (1963), and a number of other dancers appear in his *Screen Tests*, including Lucinda Childs, who also made a short film with Warhol called *Shoulder*. According to Billy Name, Warhol attended the seminal performance of Erik Satie's *Vexations* in New York in September 1963, and discussed Satie's use of repetition with John Cage after the performance (conversation with Billy Name, October 28, 1993); in this 18-hour, 40-minute performance, which was organized by John Cage, an 80-second piece of music was repeated 840 times by a changing roster of pianists, one of whom, coincidentally, was John Cale, later to become a member of the Velvet Underground (see Harold C. Schonberg, Richard F. Shepard, and Raymond Ericson, "Music: A Long, Long, Long Night (and Day) at the Piano," *The New York Times*, September 11, 1963).

14. See, for example, Yacowar (1993), p. 17: "When [Morrissey] later visited the filming of *Space* (1965), an Edie Sedgewick [sic] scene never released, his advice led to Warhol's first use of a camera movement."

15. *Tarzan and Jane Regained...Sort Of* (1963), for example, which was edited by Taylor Mead, contains all of these techniques, including a sound track created and narrated by Mead; Warhol makes a brief appearance in this film as "the Famous Director, Andy Warhol," carrying, surprisingly, such conventional accessories of filmmaking as a copy of the script and a set of clapsticks.

16. As a rule, Warhol's silent films were shot at sound speed and then projected at silent speed, to achieve slow motion. The projection time of Warhol's silent footage is thus 50

percent longer than the shooting time: 100 feet of 16mm film represents 2.77 minutes of shooting time at the standard sound speed of 24 frames per second (fps), but 4.16 minutes of projection time at the silent speed of 16 fps. To calculate running times in minutes, 16mm footage is divided by 36 for sound speed and 24 for silent speed at 16 fps.

To complicate matters further, around 1970 the industry standard for silent projection speed was increased from 16 to 18 fps in order to eliminate perceptible flicker. 16mm running time at 18 fps is calculated by dividing footage by 27. Since most projectors in use these days have an 18 fps silent speed, Warhol's silent films are now generally shown at a projection speed that is slightly faster than what he used in the 1960s; the difference is minuscule except for the very long films like the 8-hour *Empire*, which becomes only 7 hours and 11 minutes long at 18 fps.

17. These drawings, which were found taped onto 19 of the many 100-foot film boxes labeled *Sleep*, are not strictly storyboard drawings, but series of sketched film frames illustrating the shots on each roll, with written comments describing the content and quality of each shot. Additional notations seem to indicate later editing decisions, with some drawings crossed or torn out. These drawings were not made by Warhol but by an assistant, Sarah Dalton, whom he hired to log the footage (see John Giorno, "Andy Warhol's Movie 'Sleep,'" *You Got to Burn to Shine* [New York and London: High Risk, 1994], p. 138). The 52 original 100-foot rolls for *Sleep* found in the collection have not yet been preserved, inspected, or compared with the completed film, which was constructed entirely from print materials.

18. At its premiere on January 17, 1964, at the Gramercy Arts Theater in New York, *Sleep* was announced as an 8-hour film; Archer Winsten, who covered the screening for the *New York Post* ("Rages and Outrages," January 20, 1964), noted that the film was actually only five and a half hours long.

19. *Empire* does contain a few surprises. As E. S. Thiese has pointed out (Kurt Easterwood and E. S. Thiese, *The Films of Andy Warhol: A Seven-Week Introduction* [San Francisco Cinematheque, 1990], p. 24), the next-tallest building in the frame, to the left of the Empire State Building, is the Metropolitan Life Insurance Tower at Madison Avenue and 24th Street: the light on the top of this tower blinks to indicate the hours and quarter-hours (in Reel Two, for instance, it blinks nine times at nine p.m.). Although time in the film is seriously distort-

ed by the silent projection speed, which increases its duration by 50 percent, it is possible to follow the exact time of the shooting of *Empire* throughout the entire film. Another surprise is the sudden brief appearance of Warhol himself at the beginning of Reel Seven; apparently the lights in the office from which the film was shot were momentarily left on, and Warhol can be seen reflected in the window next to the glowing image of the Empire State Building.

20. Although *Batman Dracula* is generally listed in filmographies as a single film from 1964, it appears to have originally been two separate films, *Batman* and *Dracula*; 100-foot rolls and unfinished longer reels (spliced together with Scotch tape) found in the collection are labeled with only one or the other of the two titles. I have found no mention of the single title *Batman Dracula* earlier than 1969.

21. See Debra Miller, Billy Name's *Stills from the Warhol Films* (Munich: Prestel Verlag, 1994). Billy Name, who silvered the Factory with paint and foil in early 1964, was the lighting and set designer and official photographer for Warhol's movies; Name's photographs of the film production at the Factory offer invaluable documentation of Warhol's filmmaking practices in the 1960s. His publicity stills have often been mistaken for actual frame enlargements from the films.

22. Labels on the original film boxes for the 100-foot *Screen Tests* include, among many others, the following names: Salvador Dali, Marcel Duchamp, Robert Indiana, James Rosenquist, Jonas Mekas, Jack Smith, Harry Smith, Barbara Rubin, Susan Sontag, Grace Glueck, Barbara Rose, Andrew Sarris, Ivan Karp, Holly Solomon, Irving Blum, Dennis Hopper, Zachary Scott, Lucinda Childs, Kenneth King, Yvonne Rainer, Baby Jane Holzer, Bob Dylan, Donovan, members of the Velvet Underground, John Ashbery, Ted Berrigan, Allen Ginsberg, Edwin Denby, Edie Sedgwick, Gerard Malanga, Billy Name, Ondine, and Mario Montez.

23. I am grateful to Billy Name for making clear to me the distinction between the formal *Screen Tests*, stationary close-up films shot in the Factory, and other silent 100-foot portrait films that Warhol made of people dancing or otherwise demonstrating their talents, which were usually shot through prior arrangement on location outside the Factory (conversation with the author, June 24, 1993). The exact categorization of all these short films awaits preservation and further research.

24. Danny Fields described people weeping

during the filming of their *Screen Tests* because they had been told not to blink (Patrick Smith, *Andy Warhol: Conversations About the Artist* [Ann Arbor, MI: UMI Research Press, 1988], p. 289).

25. *Andy Warhol Photobooth Pictures* (New York: Robert Miller Gallery, 1989).

26. The "Living Portrait Boxes", which would have sold for $1,000 to $1,500, were described to Howard Junker in late fall 1964 as "just like photographic portraits except that they would move a little" (Howard Junker, "Andy Warhol, Movie Maker," *The Nation*, February 22, 1965, p. 207). The "Living Portrait Boxes" would have been constructed with Fairchild 400 8mm loop projectors, which had been used to exhibit three-minute excerpts from four of Warhol's films at the New York Film Festival in September, 1964; *The New York Times* described these loop projectors as "small box-type projectors resembling television sets designed to make it easy to show 8mm. movies in the home." (Eugene Archer, "Pop Artist Places Films in Festival," *The New York Times*, September 11, 1964).

27. The single largest group of *Screen Tests* found in the collection are the more than one hundred portraits of Philip Fagan, filmed from November 1964 through February 1965; Fagan was Warhol's boyfriend during this period (see Bockris, p. 179). Hand-written notes and sketches on the original film boxes, which are consecutively numbered and dated, indicate that these films were made as a series of lighting tests, with light source and exposures carefully noted.

28. Junker, pp. 207-8. The reels of *Banana* whose shooting is described in this article ended up in *Couch*.

29. A number of 1,200-foot reels labeled *Exploding Plastic Inevitable Background* have been found in the collection; some of these consist of assembled prints of *Screen Tests* and other short films of the members of the Velvet Underground, including close-ups of John Cale's eyes and Lou Reed's lips.

30. See the Malanga/Warhol listing in "Expanded Arts Bourse," *Film Culture: Expanded Cinema*, no. 43 (Special Issue, Winter 1966), p. 8.

31. Andy Warhol and Gerard Malanga, *Screen Tests: A Diary* (New York: Kulchur, 1967).

32. Andy Warhol, *The Philosophy of Andy Warhol (From A to B and Back Again)* (New York: Harcourt Brace Jovanovich, 1975), p. 99.

33. For a description of the making of this film and a transcript of the soundtrack, see

Ronald Tavel, "The Banana Diary," *Film Culture*, no. 40 (Spring 1966), pp. 43-66.

34. See the interview with Ronald Tavel in Smith, p. 294.

35. In addition to *Shower* and *Jane Eyre Bare*, 1965 works that he wrote for Warhol but which were never produced as films (although Tavel did stage *Shower* as a play in 1965), Tavel provided scenarios for the following Warhol films: *Harlot* (1964); *Screen Test #1*, *Screen Test #2*, *Suicide*, *Vinyl*, *The Life of Juanita Castro*, *Horse*, *Vinyl*, *Kitchen*, *Space* (all 1965); *Hedy, the Queen of China* (*Hanoi Hannah*) and *Their Town* (*Toby Short*) segments of *The Chelsea Girls* (1966); and *Withering Sights*, an unreleased 1966 feature. During these years, Tavel was also staging many of these same scripts as seminal works in the avant-garde Theater of the Ridiculous movement, which he founded in 1965.

36. Tavel has described Warhol's "destabilizations" in detail in his statement in the 1990 Pompidou catalogue, pp. 187-89.

37. Andy Warhol, *POPism: The Warhol '60s* (New York: Harcourt Brace Jovanovich, 1980), p. 90.

38. See Marylin Bender, "Edie Pops Up as Newest Superstar," *The New York Times*, July 26, 1965. *Restaurant* was originally called *Party Sequence* in *The Poor Little Rich Girl Saga*.

39. The first time Warhol filmed *Poor Little Rich Girl*, both reels were entirely out of focus because of a technical problem with the camera. Warhol then decided to reshoot the film and selected the first out-of-focus reel and the second in-focus reel as his final version. This is one of the few instances in which Warhol reshot a particular film in order to obtain a desired result. See Leonard Lyons, "The Lyons Den," *New York Post*, June 18, 1965; also Gerard Malanga quoted in Bockris, p. 165.

40. Contrary to some published opinions, nearly all of the Warhol films prior to *Flesh* (1968) seem to have been shot by Warhol himself, including the *Screen Tests*. On films shot with a stationary, tripod-mounted camera, Warhol would sometimes walk away from the camera during shooting, which could be quite disconcerting to his subjects; he would even work on silkscreens while the film cartridge was running out (conversation with Billy Name, June 24, 1993). In most of the films, however, Warhol's intelligent, subversive framing and camerawork are distinctive and recognizable. Warhol himself equated the role of cameraman with that of director, and both he and Paul Morrissey stated that Warhol himself filled that role

until Morrissey shot *Flesh* in 1968 (Glenn O'Brien, "Interview with Andy Warhol," *High Times*, 24 [September 1977], p. 36; Deac Rossell, "Paul Morrissey: Foreman in the Factory," *Boston After Dark*, January 26, 1971).

41. Paul Morrissey has said that the idea of the double-screen format was originally suggested by his habit, when screening reels as they came back from the film lab, of projecting two boring reels simultaneously; this practice led to the discovery that two reels worked better together than on their own. (Yacowar, p. 19). Billy Name recalls that he was the one who suggested that *The Chelsea Girls* be released in double screen (Miller). Regardless of who suggested it, Warhol's initial moves into multiscreen formats undoubtedly were influenced by concurrent developments in avant-garde film and multimedia performance, especially the "Expanded Cinema" festival held at the Filmmakers' Cinematheque in November and December 1965. Warhol's first double-screen production was a film of Robert Heide's play *The Bed*, shot in November 1965.

42. The first performances of Warhol's productions with the Velvet Underground were given at the annual dinner of the New York Society for Clinical Psychiatry at Delmonico's Hotel on January 13, 1966 (see Grace Glueck, "Syndromes Pop at Delmonico's," *The New York Times*, January 14, 1966), and at the Filmmaker's Cinematheque on February 8 of the same year, under the title "Andy Warhol Uptight." The best discussion of Warhol's involvement with the Velvet Underground and the EPI is Victor Bockris and Gerard Malanga, *Uptight: The Velvet Underground Story* (New York: Omnibus, 1983).

43. Warhol (1975), p. 92.

44. O'Brien, p. 36.

45. It is difficult to know exactly how much Warhol spent on his films. John Wilcock estimated that he was spending about $400 a week, or $20,000 a year, on film by 1965 ("Andy as Moviemaker," *The Village Voice*, May 6, 1965), while Paul Morrissey reported that Warhol spent $1,000 to $1,500 on each episode of *The Chelsea Girls* (quoted in Bockris, p. 192).

46. Although this film, *Jane Eyre Bare*, was never produced, a script was commissioned for it from Ronald Tavel, and production funds were supposed to be provided by Huntington Hartford (see Leonard Lyons, "The Lyons Den," *New York Post*, September 24, 1965; also Sterling McIlhenny and Peter Ray, "Inside Andy Warhol," *Cavalier*, September 1966).

47. Andy Warhol (1975), p. 92.

48. At the insistence of the hotel, the room numbers were dropped before the film went into national release at the beginning of 1967 (papers obtained from Anthology Film Archives and The Andy Warhol Foundation for the Visual Arts, Inc.).

49. Jack Kroll, "Underground in Hell," *Newsweek*, November 14, 1966, pp. 109-10.

50. See the Warhol listings in the *Filmmaker's Cooperative Catalogue*, no. 4 (New York: 1967), p. 155. *The John, Their Town (Toby Short), The Trip, Queen of China (Hanoi Hanna), The Duchess, The Pope Ondine Story, and The Gerard Malanga Story* are all listed as separate feature-length films from 1966.

51. See Richard L. Coe, "Andy Warhol and Associates," *The Washington Post*, April 26, 1967.

52. At this time, 87 of the 94 reels of ★★★★ have been located in the film collection and identified in numerical sequence; as research and preservation continue, it seems likely the remaining 7 reels will be identified as well. Whether or not it will be possible to recreate Warhol's projection of ★★★★ is another question: no notes or other papers have yet been found to indicate exactly how the reels were projected or how the sound tracks were handled. The projection arrangements and order of reels do not seem to have been entirely arbitrary; Warhol did hold experimental screenings of portions of ★★★★ beginning in the summer of 1967, one of which was attended by Michelangelo Antonioni (see Grace Glueck, "Warhol Unveils 25-Hour ★★★★ Film," *The New York Times*, July 8, 1967).

53. Warhol, pp. 280-81; also conversation with Billy Name, November 4, 1993. The Warhol film organization had not been appeased by Schlesinger's invitation for them to appear in the underground party sequence of *Midnight Cowboy*; Warhol did not appear in the film, but Viva had a small role as an underground filmmaker, and Morrissey, Taylor Mead, Ultra Violet, and others can be seen in the party sequence, along with a film of Ultra Violet shot by Morrissey.

54. See Morris Kaplan, "3-Judge Panel Here Declares Warhol's 'Blue Movie' Obscene," *The New York Times*, September 18, 1969. The obscenity judgment on *Blue Movie* was vacated by the U.S. Supreme Court in 1973; see Edward de Grazia and Roger K. Newman, *Banned Films: Movies, Censors & the First Amendment* (New York and London: R. R. Bowker, 1982), pp. 316-18.

55. *Blue Movie: A Film by Andy Warhol* (New York: Grove, 1970).

56. See, for example, Gene Siskel, "Morrissey's Search for American Comedy," *Chicago Tribune*, November 18, 1972.

57. The arrival of the Norelco video equipment at the Factory, and Warhol's conversations with Morrissey about it, are documented in Warhol's tape-recorded, transcribed book *a novel* (New York: Grove, 1968), pp. 16, 40-41, 56-57. The Norelco tapes have been located within the Andy Warhol Video Collection at The Andy Warhol Foundation for the Visual Arts, and are currently being transferred from the non–standard Norelco format to one-inch masters.

58. The commercial was shot at the Videotape Center of New York, and featured a close-up of a chocolate sundae topped with whipped cream and a maraschino cherry, with colors electronically altered by Warhol (Harold H. Brayman, "Warhol and Underground Sundaes: Schrafft's Will Never Be the Same," *The National Observer*, October 28, 1968). To accompany the commercial, Schrafft's added an "Underground Sundae" to its menu, described therein as "vanilla ice cream in two groovy heaps with three ounces of mind-blowing chocolate sauce." (John S. Margolies, "TV-The Next Medium," *Art in America* 59, no. 5 [September-October 1969], p. 48).

59. Margolies, p. 48.

60. "The Underground Surfaces," *Variety*, October 25, 1968.

61. Paul Carroll, "What's a Warhol?" *Playboy*, 16 (September 1969). See also Joseph Gelmis, "Above Ground with Andy," *Newsday*, June 14, 1969.

62. See *Andy Warhol's Video & Television* (New York: Whitney Museum of American Art, 1991), with an essay by John G. Hanhardt. This catalogue includes a Selected Videography which outlines the scope of Warhol's works in the medium.

63. Gelmis.

Girl in Park, 1948
Oil on masonite, 24 3/4 x 19 3/4 in. (62.9 x 50.2 cm)
Collection Paul Warhola Family
On loan to The Westmoreland Museum of Art, Greensburg, Pennsylvania

Bennard B. Perlman

THE EDUCATION OF ANDY WARHOL

In September 1945, when Andy Warhol and I entered
Carnegie Institute of Technology as freshmen art stu-
dents, the school represented a middle-ground approach
to educating future artists. Already raging then was the
current debate as to the advantages of talented young
people pursuing their training at an art institute (where
studio courses hold sway to the complete neglect of a
general education) as opposed to their enrolling in a col-
lege or university art department (where immersion in
art is less pervasive). At Carnegie Tech there seemed an
ideal balance, not only of the courses offered but of the
faculty as well. Yet the education of Andy Warhol did
not begin there, but in the Warhol home years before.

Not surprisingly, the interest in art shown by
Andrew Warhola – he occasionally dropped the "a" in
his last name as early as 1942 – commenced during his
formative years. As his brother John told me, "Andy
owes a lot to his mother because, to keep the three boys
quiet, she used to say, 'The one who draws the best pic-
ture will get a candy bar,' so we used to sit around the
table, and she would show us how to draw. She was
real religious and would tell Andy to draw an angel.
She would always start out with the angel, and then
maybe a butterfly."

Andy was about six then and his mother sometimes
produced a quick sketch of the subject, which he copied.
Julia Warhola came to realize that communication
with her youngest son could easily be accomplished
through the visual language of art, since both she and
Andy's father, Andrej, natives of Czechoslovakia,
conversed in Slavic around the house, and she spoke a
fractured English.

Andy's older brother, Paul, born six years before
him, also encouraged his sibling.

*I was very influential with Andy because I got him started.
After he was about six years old and we had no radio or any
kind of entertainment like that, it was going on Saturdays to
the movies – I used to take Andy to the Schenley or the
Oakland or the Strand [movie theaters], and then to the
museum a lot.*

*When we were stuck at home in the wintertime we did
a lot of sketching. And Andy showed the talent. Most of those
drawings were out of magazines: football players, airplanes,
and the like.*

The Warhola family originally lived at 73 Orr
Street, in a wooden house in which they occupied just
two rooms (it was there that Andy was born), then at
55 Beelen Street and 6 Moutrie Street. All were within
a few blocks of each other in Pittsburgh's Hill District,
overlooking the industrial complex, blast furnaces, and
belching smoke of the Jones & Laughlin Steel Company.
It was there that Andrej Warhola was employed.

In 1934 the family moved to 3252 Dawson Street in
Oakland, within walking distance of Carnegie Institute,
with its Museum of Art, Museum of Natural History,
Music Hall, and Library, and the rolling hills and oasis of
greenery known as Schenley Park.

The Dawson Street home was a step up for the
Warholas; their recently built two-story brick duplex
was complete with front porch, backyard, and inside
plumbing. And it was right across the street from
Holmes Elementary School, where Andy was enrolled in
the first grade in September 1934. Andy was quickly

labeled "artistic," according to Catherine E. Metz, his second-grade teacher:

He was a good little artist in second grade. I remember him as an average student in reading and arithmetic, but this little kid was very, very good at drawing. As he went through school, all of his teachers seemed to recognize his art ability, and they would get him to come in and maybe make a border for the room or something.

As Andy progressed to the higher grades at Holmes, the art requirement became more technical. Nick W. Kish, who lived in the same block as the Warholas and attended elementary and high school with Andy, remembered:

The type of art we had at Holmes School was more in the form of science art. We had art in science, drawing leaves and a caterpillar with crayons. We tried to get it as close as possible to the real colors....The teacher always had something in mind that she wanted you to do. The drawings were either made from a picture or from the real thing, because we had in our science class everything, from baby alligators and baby lizards to aquariums.

Nick Kish quickly became Andy's best friend. They shared similar interests and backgrounds; Kish's parents came from a village in Hungary just sixty miles from where Andy's mother and father were before they immigrated to America. "Andy and I both liked art," Kish said, "but he liked freehand art and I was more inclined to be the mechanical type."

The boys would regularly visit each other's homes to draw, sketching each other, or trees viewed from the back porch, or the sky, or girls. "The girls were always drawn from the imagination," Kish pointed out. "At that time, any girl who had not been properly introduced would not walk into your house without mom or dad kicking them out." Some Saturdays the two of them went to Schenley Park, found a comfortable spot, and just sat there to gaze at the haze and the smoke coming out of J & L Steel. They would eventually turn to sketching, and were as likely to draw each other's hands as to draw some aspect of the industrial scene.

The Oakland neighborhood was dominated by blue-collar workers, and the Depression was taking its toll. Andy's father, always handy around the house, added a

bathroom so the second floor could be rented out, which arrangement forced all five of the Warholas to sleep in the attic for a period of two years. Andy's mother sought to supplement the family income and, in a way, the first Campbell's soup-can art was fashioned by her. She cut empty cans into narrow vertical strips, bent them outward, and affixed colorful crepe paper to the ends. When the neighbors said they couldn't afford them, she set out on foot each day to sell her creations for twenty-five cents apiece in more affluent neighborhoods.

Sometimes Julia Warhola's earnings went directly to buying something for her youngest son. John Warhola recalls:

When Andy was about eight he wanted a movie projector. My dad couldn't afford to buy it so my mother would do some housework one or two days a week. I remember she got a dollar a day, and this projector was around ten dollars, so she saved the money up and got it for Andy. He'd buy a film of Mickey Mouse or something like that and show it on the wall over and over again. When a relative would give him a quarter he'd save it and then buy another film. That's where some of it started — he really wanted to do some work with the camera. When he was about nine years old we had a Kodak Brownie camera....Andy would take pictures of just about anything.

In the spring of 1937, when Andy was eight, and again the following spring, he became ill and missed about two months of school. Confined to bed, he spent much of his time playing with paper-cutout dolls, and a Charlie McCarthy puppet, and poring over a growing collection of comic books. His brother Paul showed him how to put wax over the surface of a comic strip, turn it over on a piece of paper, and rub the back in order to transfer the image. Although the wording came out backwards, Andy was always excited by the results.

Despite an excessive number of missed school days, Andy was passed along to the next grade both years. Yet the illnesses left their mark on his frail body, and for the rest of his life, he shied away completely from any type of physical activity. As happens so often with youngsters who shun sports and group activities, Andy became adept at entertaining himself, often remaining in the house, absorbed in art and music. He took violin lessons when he was nine. And he developed another interest that would last all his life. John recalls that

"Andy used to send away for pictures of movie stars, beginning with Shirley Temple. And he would say that he'd like to be a movie star or a tap dancer."

Andy Warhol's first educational experience beyond the confines of his home or school came when he was enrolled in Joseph C. Fitzpatrick's Saturday morning art class at the Carnegie Institute while he was in the fourth grade. The sessions were free, with two students participating from each school in Allegheny County upon the recommendation of their art teacher. Andy would attend these classes for four years.

Fitzpatrick was a legend to thousands of Pittsburgh children. Beginning before ten o'clock each Saturday morning, scores of youngsters would arrive by streetcar, auto, and chauffeur-driven limousine, and make their way into Carnegie Institute's elegant Music Hall. There Fitzpatrick would greet them and prepare to weave his magic over as many as 300 students at a time. He spoke to them about the satisfaction of observing nature, and gave them a love of looking. He taught them to treasure the Carnegie Institute structure as though it were their own home – urging them never to pass by without going in to search for something new in the art and natural history exhibitions. He instilled in them a love for the edifice itself, for its marble columns, and the statues on its façade. The students were spellbound.

They knew that this was serious business. Paper, a pencil, crayons, and a small masonite board to lean on were provided to the youngsters as they entered, together with a weekly handout on which they were to write down something they saw during the previous week, as well as sketch a new subject they had observed. Fitzpatrick assured me:

Andy was a very good student. He was extremely talented and could do very realistic work, and he could do it with a decorative quality that was very becoming.

From the class every week I had what they called an honor roll, and the people who were on the honor roll [stood] at easels on the stage and would make a large drawing of the smaller one they had done. Then they would walk to the microphone, announce themselves...and explain their drawings....
Andy was up on the stage in that honor roll many times.

Prompted by the Saturday class, Andy intensified his art activities outside school. He and Nick Kish

Portrait of Nick, 1942
Oil on canvas board, 11 x 9 in. (27.9 x 22.9 cm)
Collection Mr. and Mrs. Nick William Kish

embarked on a series of crayon self-portraits. "We used to sit and draw ourselves using the bedroom mirror," Kish explained.

We'd sneak upstairs. Our parents had those big four-foot dresser mirrors, and we used to show ourselves the way [we thought] others saw us, and [the results] were horrible. We didn't think too much of ourselves. Andy's self-portraits were always very white because his skin was so fair. In fact, in one of them he took chalk and put it over his face in the drawing, at which point both of us burst out laughing because it looked like death warmed over. It was probably done when he was about twelve.

At this time, in 1941, Andy produced his first portrait in oils, a painting of Nick. "It seems like it took quite a few rainy days and weekends," Kish recalled, "because he would draw the outline of me, then he'd stop and I would do him. He was teaching me how to get a human face, so it was sort of a training session. 'This is what I'm doing, now you do that of me,' Andy would say." A year later Andy made a second oil of Nick, and although this time he worked from a photograph, the subtlety of facial tones and shading is unusual for so young an artist. The canvas was signed "A. Warhol."

Andy Warhola, 1942,
one month before his
fourteenth birthday

The boys also experimented with producing moving images.

We used a flashlight with clear wax paper and cut out outlines of what we thought were human beings and animals, and ran it across the round opening in a box in front of the flashlight to see if we could get it on the wall. We experimented with wax paper, cellophane, and a few other clear plastics, and when we put the flashlight on it we would get a kind of double image that we tried to filter out.

It was Andy's idea. He was trying to get something curved so that the double silhouette would blend into one. We toyed with that two or three times over the period of a month, and then gave up on it. We could make the images move if they were pushed along in front of the flashlight.

1942 was a traumatic year for Andy as he prepared to leave Holmes Elementary for Schenley High School. His brother Paul was leaving the family circle to join the Navy. Andy's father, who had taken a construction job in West Virginia, fell ill and died on May 15. The tragedy left its mark on the teenager, making him appear distant and withdrawn.

In high school Andy once again excelled in art. Mary Adeline McKibbin, one of his art teachers, remembers that "his work was unusually sensitive and his line drawings always delicate. He was quiet, sensitive, intense. In my classes he seemed to pal with no one, but to become immersed in his work. He was in no way a problem, but hard to know personally." In a pencil self-portrait produced in her ninth-grade class, Andy accu-

rately recorded his pronounced lips and the bulbous end of his nose, features that added to his self-consciousness.

Fitzpatrick, who had been teaching art in another high school, was transferred to Schenley, where he taught Andy and again became an important influence in his life. Because Fitzpatrick's high-school students were older than those in his Saturday class and fewer in number, he could take a more advanced approach. "They would make many sketches first and then select the one they liked best that might be made into a painting," he reminisced. "They also did portraits, but never in an academic way. The students would pose for each other, with the class moving the desks around in a circle." Andy became so adept at capturing a likeness that his teacher asked him to draw portraits at one of the Arts and Crafts Center's annual fundraising Fun Fairs, where they were sold for a dollar a piece. "He did very nice ones, too," Fitzpatrick said.

At Schenley, art was an elective. Andy's class met three times a week, and because pupils could drop the course at any time, the teacher had to make it sufficiently relevant and challenging to keep his students. Fitzpatrick explains, "I tried to create an atmosphere of art by putting up art reproductions and frequently talking about them. And I taught the classes to save newspaper pictures of art, and we'd talk about them, too. But they never had a picture in front of them when they did a drawing or painting."

Fitzpatrick adds that he encouraged Andy to study art after graduation, without specifying a school, so by the time Andy was in his senior year, he began to think of following in the footsteps of his mentor and becoming an art teacher.

Between September 1942 and June 1944, when Andy was in the ninth and tenth grades, he earned straight A's or S's (satisfactory) in every subject: English, mathematics, science, social science, art, health education, and (a year of each) Latin and French. Because both of his brothers had gone directly from high school into the work force, their father, Andrej Warhola, had left what was then a considerable sum of money, $1,500, earmarked for Andy to attend university. And Andy recognized the importance of earning above-average grades in order to accomplish this.

In part because of his academic achievements and in part because schools were accelerating male students

so that they could graduate prior to being drafted, Andy skipped the eleventh grade and entered his last year at Schenley in September 1944. But at this point his grades took a nosedive.

The reason had less to do with Andy's having missed his junior year than with his mother's having been diagnosed as having colon cancer. She was operated on the very month that Andy entered the twelfth grade. "I was at the hospital all day," John Warhola recalled. "It was a five-hour operation. Andy came down after his high-school classes were over and the first thing he said to me was, 'Did Mama die?'"

"She remained in the hospital about six weeks, and it took almost a year for her to recuperate. I switched my work hours from four to midnight, with Andy taking over when he came home from school." During his mother's illness, Andy dropped the art elective soon after the fall term began, and he received no grades for art his final year in high school.

Now his out-of-school activities were virtually limited to art sessions with Nick Kish, and even those were relegated to weekends. Kish remembered:

Andy and I were both outcasts, which is why we sort of got together. We didn't loaf with the cliques on the corners. The fellas on either end of Dawson Street either played cards or shot craps. They were noisy and sometimes seemed to wait for the police car to roll around. They weren't breaking the law, but we just felt that wasn't the way we wanted to spend our time.

As graduation from Schenley High School loomed, Andy and Nick, having determined they would continue on together, began to check out the prospects for higher education in the area. When Kish settled on the University of Pittsburgh with the idea of majoring in engineering, Andy decided on Pitt, too. They filled out their applications together and hand-delivered them to the school. Since courses in the university's art department were limited to art history, Andy intended to enroll as an education major in preparation for becoming a teacher.

Andy's high school record was forwarded to Pitt in March 1945 and his final grades in mid-June. It listed his "character trait rating" as highest in Reliability, Industry, and Emotional Stability, and lowest in Leadership, Acceptance by Classmates, and Service. He graduated fifty-first in a class of 278. As Andy and Nick prepared to enter the university that fall, the U.S. military

intervened. Nick, who was older than Andy and eligible for the draft, received his induction notice in July.

Now Andy was faced with the prospect of going to Pitt, where the number of students enrolled in the School of Education was as large as the total enrollment in some small colleges, or seeking admittance to the much smaller Carnegie Institute of Technology, where an art-eduction option was available in the Department of Painting and Design. He chose the latter. Acceptance to Carnegie Tech was not a foregone conclusion, however. In addition to qualifying grades, applicants to the College of Fine Arts were required to take so-called technical tests to determine, according to the catalogue "the relative fitness of the applicant to undertake professional study in the field selected." These tests were prerequisite to all classes, and candidates were "judged on a competitive basis, and admitted according to their rank and the capacity of the department."

The on-site tests for the Department of Painting and Design lasted four days and challenged applicants with typical classroom problems. Some involved the ability to draw various subject matter placed before the group, including the human figure; others probed creativity and the imagination.

The technical tests were Carnegie Tech's counterpart of the stringent entrance requirements for the École des Beaux-Arts in Paris, which has a similar four-day ordeal to test various areas of art knowledge and ability. It is likely that the Carnegie version was instituted at the suggestion of art professor Russell Hyde, who had been teaching at Tech since 1924 and whose own schooling included the Beaux-Arts, Académie Julian, and the Sorbonne.

When classes began in 1945, the first week of October, Andy was among the sixty freshmen enrolled in painting and design. The majority of the group was female. World War II had ended just the month before; only four of the handful of males were veterans.

Andy was easy to overlook in such a crowd, for at five-feet nine-inches tall and weighing just 135 pounds, he lacked a prominent presence. To those of us who came to know him, Andy was a mild-mannered, soft-spoken, naive introvert. I never heard him shout, never saw him in a fit of rage. He often seemed awkward, timid, vulnerable, and nonverbal, and his pale skin gave him a gaunt appearance.

At Schenley High School, Andy sometimes had been the only student wearing a white shirt and tie; at Carnegie Tech he quickly adopted the garb of the art student: a well-worn tan corduroy sports coat over a navy blue turtleneck sweater and paint-splattered jeans. Brown-and-white saddle shoes were popular, and his were unique, painted black over the areas that originally were white.

During his freshman year, fifteen of the thirty hours of class each semester were devoted to Drawing I, which focused on "analytical observation and the means of expressing volume, spatial position, illumination, and texture." It should have been a trouble-free experience, except that Andy had had virtually no exposure to the medium of charcoal or to applying the principles of perspective, two of the mainstays of the course.

The class was taught by Roy Hilton, a man with impeccable manners and taste in clothes. We called him Mr. Tweed because of his three-piece suits, and assumed he was British; he was actually from Boston. A week into the semester we were asked to draw our first nude model, a shocking and embarrassing experience for many of the freshmen who had never been exposed to a naked female body. Andy's face grew paler than usual, and a coed whose easel was beside his thought he was about to faint.

One of the first assignments for a large charcoal drawing was a still-life composition of a stool and an easel with a drawing board leaning against it. Andy thought more in terms of outlines than tones, and he found it difficult to master a light touch with the charcoal necessary for the subtle shades of gray between black and white. Hilton's admonition was, "Don't put lights in the dark areas and darks in the light." Andy found the necessary discipline a constant struggle.

But it was perspective that became the bane of his freshman year. He did not subscribe to the class motto, "If it's tiltin' see Hilton," preferring instead to enlist the aid of his classmates. I recall responding in front of a stairway on the ground floor of the Fine Arts Building: "Look how you can see more of each step below eye level, and how the treads disappear above the eye level." He saw it but couldn't do it.

Andy also experienced difficulty with the course in color, which dealt with the elements of hue, value, and intensity, and how to control and manipulate them. It was taught by the department chairman, Wilfred Allen

Readio, a faculty member since 1921, whose crewcut gave him the aspect of a sergeant to seventeen-year-olds like Andy and me.

Readio enjoyed toying with the class in order to make a point, as he did in assigning us to look at a sunset and paint it (no easy task, given the soot-laden skies over Pittsburgh). When our handiwork was tacked up on the wall the following week, Andy's was wrong—and so was everyone else's! There was no problem with the blended transition from yellow to orange, red, green, blue, and purple; we had simply failed to darken the value of the hues as they ascended from the horizon.

Large Munsell Color Charts were mounted permanently on the wall, and during the semester we were expected to match particular color chips with tempera paint, create optical illusions, and experiment with the five categories of color harmony. All of this presented problems for Andy.

The second term of our freshman year became extremely competitive; the rat race was brought on by the department chairman's startling announcement that some 300 war veterans had applied for admission to the department, and though the school had never enrolled a midyear class, it had decided to do so now. Fifteen of that number would begin in a special section and continue through the summer, then be absorbed into our class in the fall, when we would start our sophomore year together. In order to accommodate the veterans, the low fifteen from among us would be dropped at the end of the semester.

Three years before Andy entered Carnegie Tech, the department had introduced a new group of required courses—Thought and Expression, History of the Arts and Civilization, Individual Psychology, and Social Orientation—intended to broaden the general education of art students. The freshman requirement was Thought and Expression, calculated to develop what the catalogue called "intellectual curiosity and effective expression through contact with varied experiences including a wide range of reading...and appreciation and interpretation of literature, especially modern; and in oral and written composition."

The instructor was Gladys Schmitt, a well-known author and native Pittsburgher, and while Andy was intrigued by the course, writing was not his forte. An even greater challenge for him was the requirement to stand

before the class and express his thoughts, for invariably he would utter a few sentences and then freeze, unable to continue. It was a painful experience for all of us.

Each student's semester grades in art were determined by the faculty in a process referred to as "judgment." For this procedure, all student works were arranged by last names in alphabetical order on a wall that ran the entire length of the building. A long bench mounted on casters provided room for six of the nine instructors, including the department chairman, some elder statesmen, and the lone female.

When the faculty arrived at the end of the wall, in front of Andy's art, a young teacher declared, "He's not going to fit," at which point Russell Hyde responded, "You can't do this. You're wrong. I want you to give this kid another chance. Let him go and finish the summer with the class of veterans." And Samuel Rosenberg, like Hyde a senior faculty member, also came to Andy's defense.

Rosenberg, who had not yet taught him, happened into the drawing studio just as Andy, in tears, was cleaning out his locker. Rosenberg asked what was wrong, and when Andy explained that he had flunked out, the professor advised him to go to summer school, get credits for Drawing I, and he would be readmitted.

On May 29, Andy received his report card. The grades were C's and D's, plus an R (repeat) in Thought and Expression. Accompanying it was the notation "Suspended until advancement in Drawing I." Andy took Rosenberg's advice and enrolled in the summer-school class which was, coincidentally, taught by Russell Hyde.

Some of the classwork involved drawing field trips to Oakland, like the time the students went to Forbes Field, where a circus was being set up. Then one day Hyde told Andy, "You must quit drawing the things that you think I want. You have got to do things the way you want them, and be damned with what I think, be damned with what anybody else around you thinks. Go do it the way you see it, to please yourself, or you'll never amount to anything." He also advised Andy to carry a sketchpad at all times, and to draw the life around him. This pep talk was a turning point in Andy's education and his career in art.

The drawing course was combined with working part-time for his brother Paul, who had come home from the Navy and was plying the neighborhoods in a

Women and Produce Truck, 1946
Women and Children Behind Produce Truck, 1946
2 Drawings: ink and pencil on paper, 12 x 18 in. (30.5 x 45.7 cm) each
Founding Collection, Contribution
The Andy Warhol Foundation for the Visual Arts, Inc.

small panel truck hawking fruits and vegetables. Andy not only weighed and sold the produce, and kept children from playing too close to the vehicle, he began to fill his sketchbook with one drawing after another. In a burst of creative activity unlike any he had previously experienced, Andy captured the essence of female shoppers and their offspring in spontaneous, continuous-line, animated compositions.

In his renderings, a group of women gab while one of them leans into a truck, her dress hiked up, her breasts uncovered; elsewhere four playful children encircle their hassled mother. The artist included himself toting groceries in both arms, his hands filled with baskets, as an overweight woman directs him to her home. "He used to sell the drawings for a quarter," Paul Warhola recalled. "He'd make a dollar or so."

When classes resumed that fall, students were urged to submit evidence of their self-motivated summer art activities in competition for a Martin B. Leisser Prize, presented each year in memory of the Pittsburgh artist who had helped persuade Andrew Carnegie to add an art school to his technical college. And it was Andy Warhol who was declared the winner from among the previous year's freshman class.

On November 22, 1946, the award ceremony was held in the fine arts gallery, where a collection of Andy's captivating sketches was hung. This represented Andy's first one-man show. The Leisser Prize carried with it a check for forty dollars, and while the money was significant, the achievement was even more so, in marking Andy as a standout sophomore.

Having earned a B in the summer make-up class, Andy embarked on an anatomy course also taught by Russell Hyde, but now the freedom of the summer's drawing was gone. Andy was forced to harness his creative bent in order to produce accurate copies of a human skeleton and a full-size plaster cast of a male figure.

The class regularly gathered around the statue and spent countless hours trying to capture its proper proportions, employing red and blue colored pencils to denote muscles and tendons. Although Andy's efforts occasionally elicited the notation "Good drawing" from his instructor, renderings of the torso, an upraised arm, a hand or foot did not hold much appeal for him. He could express himself more readily in still-life painting, taught by Samuel Rosenberg, whose goals included "a variety of techniques," "development of memory," and "abstract means for the expression of space." There was an emphasis on mood, for instance, when we were assigned to paint a composition containing a raincoat, hat, umbrella, and chair beside a window, then match an overcast and gloomy atmosphere outside with the one created inside the room.

One early assignment, related to the courses in anatomy and figure construction, was to produce a self-portrait in oils with only black, white, and burnt sienna. Since Andy had been depicting his own features for years, he chose experimentation over realism. When the likenesses were lined up along a wall of the studio, someone in the class inquired, "Who the hell is that? Is that your sister?" Andy replied matter-of-factly, "No,

Anatomical Drawing, 1946-1947
Watercolor, colored pencil, and graphite on paper
15 x 11 in. (38.1 x 27.9 cm)
Founding Collection, Contribution
The Andy Warhol Foundation for the Visual Arts, Inc.

I always wanted to know what I would look like if I had long hair and was a girl." His classmates and the professor were shocked.

Esther Topp Edmonds was a Carnegie alumna who had been an instructor at the school for twenty-seven years, yet the problems she posed to the class in Drawing II appeared fresh and challenging. One day a cot was rolled into the room, and a student directed to lie down on it, then throw back the covers, at which point we were to draw the network of folds as they appeared on the sheets and pillow. On another occasion Professor Edmonds requested that we each take off one shoe, place it on the table in front of us, and produce a charcoal drawing of it, including every scuff mark and crease. Years later I would wonder whether Andy recalled that experience when he inaugurated his series of stylish shoe drawings for the I. Miller advertisements.

Although other aspects of the still-life painting course involved abstractions (some hard-edged, others produced with textures of screening), and oils used to create monoprints, it was in a class in pictorial and structural design that Andy demonstrated his powers as an illustrator. Taught by William Charles Libby, a

Tech graduate who had joined the faculty the previous year, the course offered Andy the opportunity to further the technique he had employed in his prize-winning Leisser entries.

In Charles Kermit Ewing's freshman course, Pictorial and Decorative Design, Andy had been exposed to the basic principles of organization in line, form, and color. The initial problem was to place three rectangles of varying sizes on a sheet of paper so that none of the spaces between them was identical.

Now the elements and principles of design were part of our artistic vocabulary, and we were challenged to produce an illustration for the Katherine Anne Porter novella *Old Mortality*. The story involves two sisters in a convent school who are allowed to leave on weekends in the company of their father. One day they attend a horse race in which their uncle has an entry. Andy's depiction captured the four family members inside the clubhouse, the father speaking animatedly to his daughters.

Andy's characterization of the uncle carefully followed the author's portrait of "a shabby fat man with bloodshot blue eyes....His fat back bowed slightly in his loose clothes, his thick neck rolling over his collar." There is a fluidity about the scene through Andy's use of wet washes of red and yellow watercolor on the female figures, juxtaposed against more somber blue-grays and browns throughout the nondescript background. The mood and expression of Andy's masterful painting were right on target.

Other Warhol watercolors for Pictorial Design displayed a similar quick-sketch, continuous-line approach: a multitude of colorful figures on a stairway and balcony, a raucous gathering in a bar. It is no coincidence that their subject matter and mood evoke Toulouse-Lautrec's art, for Andy had seen a major exhibition of that artist's work at Carnegie Institute earlier in the semester.

Sometimes Andy focused on an intimate yet melancholy scene, as in his watercolor of an inebriated couple in a saloon, calling to mind Picasso's oil, *Harlequin and His Companion*, from 1900, and his 1904 etching, *The Frugal Repast*. Andy likewise revealed an uncanny ability to transform the most mundane circumstances into a thought-provoking design. Typical is a pen-and-ink and watercolor of a woman, child, and dog at a soda fountain. The humans are depicted in a repetitive pose – the

Untitled, 1947
Ink and watercolor on paper, 7 1/4 x 5 3/8 in. (18.4 x 13.6 cm)
Private collection

Miranda and Maria at the Races, 1947
Ink and watercolor on paper, 8 1/2 x 7 1/2 in. (21.6 x 19.1 cm)
Collection Howard L. Worner
On loan to The Butler Institute of American Art,
Youngstown, Ohio

Untitled, 1947
Ink and watercolor on paper, 8 x 7 1/2 in. (20.3 x 19.1 cm)
Private collection

Untitled, 1947
Ink and watercolor on paper, 7 3/8 x 5 3/16 in. (18.7 x 13.2 cm)
Private collection

mother gazing at her child, who looks at the dog. A soda jerk stares at the floor, where a scoop of ice cream has fallen from the youngster's cone. The happiness usually associated with a child given an ice cream has suddenly been replaced by sadness, a mood further emphasized by the predominating melancholy blue tones in the watercolor washes.

Andy's artistic coming-of-age was reflected in his second-year turnaround in art grades — six B's, two C's — despite the fact that he was now in competition with the contingent of former GIs. However, Andy was still plagued by academic subjects, earning only a D when he repeated Thought and Expression under the tutelage of Raymond Edward Parshall, a Yale Ph.D.

After two years at Carnegie Tech, students were required to declare the option they would follow as juniors and seniors: pictorial design, industrial design, or art education. Anticipating this, Andy and I paid a visit to Sam Rosenberg, the kind, portly father figure who had become our favorite instructor. Each faculty member had an office/studio available for conferences or just plain chitchat. Upon entering his, one was dazzled by an array of luminous canvases with surfaces enriched by a spectrum of glazed colors. "Mr. Rosenberg," I began, "we would like to become artists, but how do you earn a living from painting?" He replied forthrightly, "Well, look what I'm doing."

Andy was still considering a teaching career so these words were reassuring, yet he was unaware of the demands of the profession. When a classmate asked him about his life's ambition, Andy replied that he wanted to teach children how to play. Rosenberg, who had been conducting adult classes at the Young Men's and Young Women's Hebrew Association for years, arranged for Andy to teach a class of teenagers there after school. Since the Y was across the street from the Carnegie Museum, transportation posed no problem.

This proved a short-lived experience, however, because of Andy's shy, quiet manner. The trial run strongly suggested that the art-education option was not for him. He chose pictorial design instead.

Free from having to enroll in a makeup class during the summer of 1947, Andy prepared himself for his future as an artist by joining four classmates who had set up a communal studio in an old carriage house opposite the Carnegie campus. Although Andy's presence there was

limited to evenings plus some Saturdays and Sundays, the experience provided him with a sense of camaraderie and independence, as well as a tranquil workplace, free from the constant interruptions he had to endure when he tried to work at home. In the studio, he transformed some of his sketches into paintings and worked from a nude model arranged for by the group.

On weekdays Andy was otherwise occupied, having landed a job at the Joseph Horne department store in downtown Pittsburgh, where he was assigned to the display department. Here he entered the world of commercial art, producing backdrops for street-level windows intended to entice the public inside by means of fanciful, eye-catching designs. The display manager, who had previously worked in New York, liked almost everything Andy did, while Andy, for his part, was amazed that he could devote so much of his time to poring over the pages of *Vogue* and *Harper's Bazaar* for inspiration and be paid for it.

Just as Andy began his fall classes as a Pictorial Design major, an exhibition of magazine art opened at Carnegie Institute. Until now his own illustrations had been for theoretical classroom assignments, but here he could study examples of this art by well-known professionals like J. C. Leyendecker, from early rough sketches to the finished product.

Not lost on Andy was the fact that this collection of magazine art occupied galleries adjacent to the Institute's *Paintings in the United States* annual. Perhaps, for the first time, he realized that commercial and fine art could be considered as equals. This point was emphasized by Homer Saint-Gaudens, the Carnegie Institute's director, who was quoted in the newspapers as saying, "We are apt to make too much of a distinction between commercial art and fine art. When a commercial artist is good he becomes a fine artist."

During 1947–48, Andy's six class hours of pictorial design were split between two instructors, Robert L. Lepper and Howard L. Worner, who were opposites in almost every way. Lepper had been teaching at Carnegie Tech, his alma mater, for seventeen years; Worner had just left a job as art director for the Armstrong Cork Company to replace Roy Hilton on the Tech faculty. Professor Lepper stressed the conceptual, Professor Worner the practical side of problem solving. And while Lepper labeled Andy "the least likely to succeed,"

Worner called him "the only student with a saleable product."

Class projects ran the gamut from designing a full-color album record cover for Stravinsky's *Firebird Suite* to a two-color title page for Earl Derr Biggers's *Seven Keys to Baldpate*; from a hypothetical magazine ad for Magnavox headlined "Music Comes to Life!" to a double-page spread for a *Saturday Evening Post* story, *Tugboat Annie*, that called for hand-lettering and positioning columns of type on the pages to work with the art. Whatever the project, Andy always seemed to produce a solution unlike anyone else's, so that his finished art stood out and captured attention.

A case in point was one of Howard Worner's assignments that called for illustrating the following dramatic climax from Willa Cather's short story *Paul's Place*. Worner modified Cather's description by designating the nearby Panther Hollow Bridge as the site of the suicide, "The sound of an approaching train woke him...he stood watching the...locomotive, his teeth chattering....Then when the right moment came he jumped...."

Worner designated the site of the suicide as the nearby Panther Hollow Bridge and expected the class to go to there and consider it from various angles. He had chosen a story set at the turn of the century so students would visit the library to locate images of fin-de-siècle trains and clothing. This was clear to everyone except, apparently, Andy.

When the completed illustrations were tacked up on the wall for a critique, there were numerous examples showing the figure of Paul silhouetted in the dazzling headlight of an onrushing locomotive, of his body in midair as the train sped by, of his lifeless form sprawled on the ground below. And then there was Andy's illustration—a striking red blob of tempera paint. Standing before it, Professor Worner turned to the class and observed: "It could be catsup," to which Andy replied, in a nearly inaudible voice, "It's supposed to be blood."

Howard Worner argues to this day that there should have been two sets of grades, one for the quality of the work, the other for how well it followed the dictates of the assignment. In Andy's case, the faculty had long been used to compromise, yet when the marks for pictorial design were decided, he received A's for both semesters.

During his junior year, twice as many class hours

Two Dogs Kissing, 1947
Tempera on masonite, 32 x 17 in. (81.3 x 43.2 cm)
Collection Paul Warhola Family
On loan to The Westmoreland Museum of Art, Greensburg, Pennsylvania

were spent in painting and drawing as in design, and
Sam Rosenberg encouraged experimentation and artistic
freedom. There were occasional examples of specific
requirements, as when he directed the class to visit the
Paintings in the United States exhibit, choose a particu-
lar portion of a favorite canvas, and attempt to repro-
duce a six-inch-square of it in detail. The assignment
necessitated making an accurate drawing with color
notes in the gallery, then painting that segment from
memory back in the classroom.

Andy's other oils for Rosenberg's course included a
painting of a pair of canines on their hind legs, nose to
nose, with their paws in a human embrace through a
wire fence that separated them. The work, which he
called *Two Dogs Kissing*, was inspired by a frequent
encounter between his own pet and the one next door.
Nearly three feet high, the painted images appear on the
verge of breaking out of their compositional enclosure.
Rosenberg allowed Andy to fly, to express himself
unhampered by stringent demands, which helps explain
why this teacher remained his favorite.

In the painting-and-drawing class, Andy's individual
outlook and sense of design were demonstrated again
and again. When the professor took the class to the
Highland Park Zoo in the fall, we all sketched the
giraffes, emphasizing their distinctive characteristics.
Andy eliminated the long neck and small head, and
focused instead on the body and spindly, seemingly
knock-kneed legs.

His pen-and-ink animal sketches were single-line
delineations, but shortly thereafter he saw reproductions
of the broken-line drawings of Ben Shahn, examples of
their imposition over tempera and casein. Rosenberg
brought the work of the social realist artist to our atten-
tion and mentioned the Shahn retrospective then at The
Museum of Modern Art in New York. Andy admired
Shahn's work and adopted a variation of his inked line
technique, so exaggerated at times that it resembled a
staccato stroke like the saw-toothed edge of a blade.
The technique later evolved into Andy's own distinctive
drawing method, the blotted line.

Although it has been theorized that Andy's blotted
line stemmed from the Bauhaus school and, in particular,
the reproduction techniques advanced by László Moh-
oly-Nagy, or that it derived from a suggestion made by
instructor Robert Lepper, Lepper himself disputed both
accounts. In fact, Andy discovered the blotted line acci-
dentally, when he accompanied a group of classmates
to the University Grill, an Oakland hangout, and made
an ink sketch, then blotted it with a paper napkin.

Like everyone else, I was attracted to the magical
nature of Andy's broken-line effect, and one day after
the painting and drawing class when we were alone in
the studio, I asked him, "How do you do that?" and he
replied: "I'll show you." He made a line drawing in
pencil, traced it, then hinged the tracing paper onto a
piece of illustration board and inked the underside of
the tracing paper, and rubbed it against the board as he
went. If a line had partially dried before he pressed it,
small gaps would occur; if a portion of the inked line was
too thick, a small blot resulted.

Andy produced a continuing supply of pencil draw-
ings for what would become blotted-line monoprints, for
he never forgot Russell Hyde's advice to carry a sketch-
pad wherever he went. Sometimes he traveled downtown
to the bus station and recorded the variety of people and

poses he found there; on other occasions a park bench was his observation post.

On Sundays Andy would buy an all-day pass and ride streetcars all over the city, sketching the characters he observed. But he soon discovered that when an un-witting model realized he or she was being drawn, they became self-conscious and moved to another seat or occasionally left the trolley altogether. To avoid ending up with a batch of unfinished drawings, Andy combined disguise with the quick-sketch technique he had learned as a freshman. He took a shoe box, wrapped it up like a package, cut one end but left it hinged, placed a pencil stub and a stack of paper inside, and with this set forth on his forays to capture the gestures of his unsuspecting subjects. After some practice the results proved most successful, and Andy referred to the resultant drawings as products of his Shoe Box Studio.

Andy's achievements in art continued, yet his success with academic subjects remained elusive. In the spring of 1948, the second half of his junior year, he was enrol-led in Social Orientation, a study of the human personal-ity from the standpoint of the social and cultural factors that influence its development. Weekly written assign-ments were required, and the professor, Dr. James Butt Klee, would single Andy out and say: "Andy Warhola, I want to see your papers have a little more substance and be a little less poetic." Sitting beside him, I noticed Andy became more and more distracted, doodling instead of taking notes. A month before the end of the term he dropped the course and repeated it in summer school, earning a B.

In August 1948, two weeks after he turned twenty, Andy received a belated birthday present from the school: notification that he was one of four winners of the Mrs. John L. Porter Prize for Progress, accompanied by a voucher for twenty dollars. The formal presentation was made during the annual Carnegie Day ceremonies in November, an event in observance of Andrew Carnegie's birthday.

By his senior year, Andy Warhol had become a leg-end in the department. When the art students invited the faculty to their "Take It Easel Club" spoof, dubbed "Oaklandhoma," the instructors countered by parading before the students, each carrying a copy of the same painting to suggest that we all copied Andy.

MODERN DANCE CLUB

Row 1: A. Warhola, A. Gelman, J. Kneidler.
Row 2: P. Dittler, J. Block,
Row 3: Miss D. Kanrick.

Every woman registered at the Carnegie Institute of Technology is eligible for membership in the Modern Dance Club if she has participated in a Modern Dance class at Tech or if she has done previous work in modern dance. Membership is by invitation only. The program of the club is designed for those interested in technique of expression in movement and in seeing how other pro-fessional and amateur groups express themselves. The students work on improvement of body technique and on devices which contribute to dance composition.

Merry Christmas and Happy New Year from André, 1948
Ink and tempera on paper, 10 x 20 1/2 in. (25.4 x 52.1 cm)
Collection Elizabeth Musser Githens

Despite this acclaim, Andy remained as shy and retiring as ever — a listener, an observer, a loner, always the odd man out when a group of students got together and paired off. He never participated in social dancing but he did join the college's Modern Dance Club, even though its stated policy was that "Every *woman* registered at Carnegie Institute of Technology is eligible for mem-bership." Andy was the lone male.

Club members danced to music from a record player, and Andy tried to keep up with the others but appeared awkward and uncoordinated. He came into art class one day with his elbows bruised from learning to fall, yet he never tired of observing the coeds demon-strating the techniques of expression through movement. Soon dance entered his art as subject matter. A 1948 greeting card he designed showed a smiling figure assum-ing five dance positions, (captioned "Merry Christ-mas and Happy New Year from André"), and an oil, *Dancers*, contained simplified, stylized, flat-pattern figures based loosely on Picasso's *Three Dancers* of 1925.

Left:
Cano Cover, 1948
Ink and tempera on paper

Right:
Untitled, 1949
Lithograph, 9 1/4 x 5 1/2 in (23.5 x 14 cm)
Collection Elizabeth Musser Githens

When the time came for a student photographer to take a picture of the Modern Dance Club for the 1949 *Thistle*, the Carnegie Tech yearbook, four female members in leotards smiled and looked directly into the camera, while Andy, in a dark shirt, gazed off to the side. This apparent bashfulness was not limited to females and to dancing. In a photograph from the 1948 *Thistle* of the Beaux Arts Society, nine of the dozen students posing on a stairway are male, yet there, too, Andy, standing opposite me, looks off to the side while everyone else stares straight ahead.

During his senior year, Andy ventured into extra-curricular activities, becoming art editor of *Cano*, the school's new creative writing monthly. Although he produced numerous spot drawings to accompany articles and as filler, his most notable contribution was a cover design for the November 1948 issue, in which fifteen violinists were placed in rows across the entire surface. Each musician has a round, oversized head and is depicted in blotted outlines placed against a bright red background. This may well represent the first published example of his blotted-line technique.

In his final two semesters, Andy's Painting and Drawing course was again taught by Samuel Rosenberg. In order to provide as much freedom as possible, the professor allowed seniors to paint subjects of their own choosing in any of a variety of media, including oil,

gouache, and egg tempera. Several of the works were enhanced by frames also produced by the students.

Andy's choice of subject matter, color, and technique continued to be singular. One day he brought in a tiny statue of Shiva, no bigger than his finger, and a huge piece of fabric, but when he painted them the sizes were reversed: the Hindu deity, in blues glazed over red, occupied the entire height of the canvas, while the floral-leaf fabric, in yellow and yellow-green, was reduced to a minor shape behind the figure.

A classmate recalled another composition. Andy was next to him, "splashing yellow, blue, and cadmium red paint on the canvas and having it run down, forming droplet patterns. He called it Rain. I always thought it was a brilliant solution to a storm theme."

And then there was a problem with unassigned subject matter in which we were to produce a flat pattern relying solely on hue, value, and intensity to achieve a feeling of depth. Andy used mostly hot colors — pinks, reds, oranges, and yellows — combined with Indian red and alizarin crimson mixed with white. His canvas was aglow, all the more so because it was partially over-painted in a pointillistic technique. And what was the subject matter he chose for these variations of warm, inviting hues? The least imaginable: a sow with six suckling piglets.

Yet the oil by Andy that most awed the class that year was of the Phipps Conservatory (see p. 146) in Schenley Park. He transformed the greenhouse's glass façade and dome into a veritable fairyland, fashioning the multitude of panes into patterns of every color. All of us thought it wonderfully inventive, never dreaming that his clothing the conservatory in a coat of many colors was based on observation. It had escaped everyone else's notice that the panes of glass in the main section of the nineteenth-century structure were actually old glass-plate photographic negatives. Andy and Nick Kish had discovered this years before; if they were inside looking out, they could see the faint images on some of the panels. But more often the two of them sat outside for an hour or two, watching the rainbow effect of the sun's rays as they moved across the edifice.

During his senior year Andy and his classmates had the artist Balcomb Greene as an instructor. Greene had recently been named by *ARTnews* as one of the ten best artists in the United States; he created marvelous abstract figures whose colors and forms were partially dissolved by intense light. But at Carnegie Tech his talent seemed wasted when he was assigned to teach History of Painting and Sculpture.

Although Greene spoke in a monotone, and it was often difficult to concentrate while viewing slides in a darkened room first thing in the morning, the class was hypnotically fixed on his dramatic face and figure. Greene was over six feet tall and his lean form, high cheekbones, and chiseled features, partially masked by smoke from a dangling cigarette, became all the more theatrical in the bright glow from the slide projector.

Greene placed a good deal of emphasis on Daumier, already a favorite of Andy's, because 1948 marked the hundredth anniversary of the July revolution that had exiled France's Louis-Philippe, and Daumier's political cartoons were widely reproduced. Yet it was the textbook for the course, Roger Fry's *Vision and Design*, that exerted a special influence on Andy. On one page were reproduced two nearly identical tarot cards of a winged celestial figure jumping up from the orb of the sun with a smaller sphere of the moon in her arms. The first card illustrated was thought to have been designed by Andrea Mantegna, the second by Albrecht Dürer. By assigning this text, was Balcomb Greene condoning copying?

While Andy had done display work at Joseph Horne's, he had found inspiration in fashion magazines. Now he turned to such popular news weeklies as *Life* for pictures on which to base at least one major illustration for the course on pictorial design. There were times when even Andy proved himself more adept at copying than at inventing.

One of Robert Lepper's assignments was an illustration for Robert Penn Warren's 1946 novel *All the King's Men*, a bestseller and Pulitzer Prize winner. The plot concerns a demagogue who is ultimately murdered – the book was a veiled story of Louisiana governor Huey Long. In Andy's striking illustration, the dominant figure of the politician crowds the left-hand border, his outstretched arm in the act of being lowered to quiet an assembly of people gathered before him. Most of the men, women, and youngsters included in the scene appear to look toward the viewer rather than the governor, their misdirected attention and incongruous size indicate that they were produced from photographs by the blotted-line technique.

Copying photos, especially someone else's, was forbidden in those days, but it must have seemed a natural progression for Andy in applying his blotted-line process. If he originally traced his own drawings, why not trace photographs in magazines and newspapers? In this regard he was ahead of the rest of his classmates, as well as the faculty and most of the art world.

If Andy carried the day with his Robert Penn Warren illustration, despite its recycled figures, his most original achievement was a children's book so sophisticated in its drawings and story line that it appealed to adults as well. It is about a Mexican jumping bean named Leroy bought by a man who wants to make his children happy, and as they watch Leroy jump, they are. Then one day a bug crawls onto Leroy's shell and tells him about the beautiful world outside, making the jumping bean sad because he is unable to see it. The bug then places Leroy on the stove, and the bean pops open and sees a gorgeous scene resembling a huge Turkish carpet. But in that era of fairy tales with happy endings, Andy concluded his story differently. Leroy dies.

Much of the yearlong pictorial design course was consumed by the so-called Oakland Project, a major study of the section of Pittsburgh lying just beyond the

Illustrations for **Leroy**, 1948-49
Tempera, ink, and pencil on board
Top, 11 1/8 x 17 1/8 in. (28.3 x 43.5 cm);
bottom, 20 5/8 x 13 7/8 in. (52.4 x 32.5 cm)
Founding Collection, Contribution
The Andy Warhol Foundation for the Visual Arts, Inc.

Living Room, 1948
Tempera and watercolor on cardboard, 15 x 20 in. (38.1 x 50.8 cm)
Collection Paul Warhola family

Carnegie Tech campus. Professor Lepper conceived of it as more complex than our simply going into the thoroughfares as artist-reporters, recording everything in sight. We were to become sociologists and anthropologists, organizing the subjects encountered into such categories as people, shelters, goods and services, topography, public service, ceremonial observances, and government activities.

Andy knew the area better than anyone else; he was the only member of the class who had lived in Oakland almost his entire life. After Lepper's semiweekly directives, we would fan out along the main arteries of Forbes and Fifth avenues, and the small streets connecting them. Here could be found a rich diversity of subject matter, from neighborhood stores, movie theaters, and small hotels to Carnegie Institute, the Syria Mosque, Forbes Field, and the University of Pittsburgh's Cathedral of Learning, a soot-stained, forty-two-story pseudo-Gothic skyscraper disparagingly referred to by Tech students as the "inverted mineshaft."

We must have appeared like a band of gypsies, toting sketchpads of various kinds, and fishing-tackle boxes that held pens, pencils, crayons, pastels, brushes, inks, and watercolors. We set out each Monday and Friday afternoon to produce a visual portrait of a community, to fill each of Lepper's categories with a plethora of examples.

"Now, take one specific house," he would advise. "Go out and do the residence that's interesting. Then tell me how it's constructed. How do the windows fit, and the roof, so you begin to see the solidity of what you're drawing." Once again we searched the streets for a house with individual identity and perhaps even charm. And after these sketches were completed, Lepper said, "Now I want you to take one single room in this house based on what you think the people would be like who live in it." He wanted us to imagine what the inhabitants were like and what kind of furniture and knickknacks they owned. That is when he lost Andy. After all, Andy lived in Oakland. Why not simply produce a painting of his own living room? And that is what he did.

In Andy's depiction, the Warhola living room was plain yet comfortable. It contained a straight-back chair, a rocker, and an upholstered piece lined up across the foreground on an oriental rug, with a three-cushion sofa in front of curtained windows in the rear. The easy chair

and couch were protected by slipcovers, while newspapers and lace doilies made the space appear lived in. On the right was the brick fireplace his father had built, though Andy was careful to omit the family photographs and trinkets that normally decorated the mantelpiece, for fear that his deception would be discovered. It never was.

Another, even more specific assignment for the Oakland Project, was a personal retrospective including depictions of significant events in each student's life, a sort of evolutionary self-portrait. For this Andy reached back to his early years, even before the family moved to the Dawson Street house with its inside plumbing. One drawing showed him as a young child sitting in an outhouse perusing a Sears Roebuck catalogue. And his final self-portrait, in pencil and watercolor, presented a full-face, three-quarter-length figure peering straight into a mirror, his arms crossed, clutching his upper arms.

To help the class become what he called "pictorial anthropologists," Lepper assigned the reading of Ruth Benedict's *Patterns of Culture*, which had just been reissued in paperback following the author's death. We were told to do relevant illustrations, and one passage in particular appealed to Andy:

The American tendency at the present time [of societal conformity and fear of deviation] leans so far to the opposite....Middletown is a typical example of our usual urban fear of seeming in however slight an act different from our neighbors. Eccentricity is more feared than parasitism. Every sacrifice of time and tranquility is made in order that no one in the family may have any taint of nonconformity attached to him....The fear of being different is the dominating motivation recorded in Middletown.

Andy made a drawing of a bespectacled man sticking out his tongue, leaving no doubt whatsoever about his fear of being different. The caption reads: "WHAT KIND OF POT! Benedict-patterns of Cultures west-Middle town."

As an acknowledged nonconformist, Andy now resurrected one of his earlier line drawings of a boy picking his nose and turned it into a painting in which one nostril of a pronounced proboscis, thrust into the viewer's face, is jabbed by the subject's forefinger. He titled it *The Broad Gave Me My Face, But I Can Pick My Own Nose* and, together with an oil titled *I'm a Bird When I Fly*, submitted it to the 39th Annual Exhibition of the Associated Artists of Pittsburgh in January 1949.

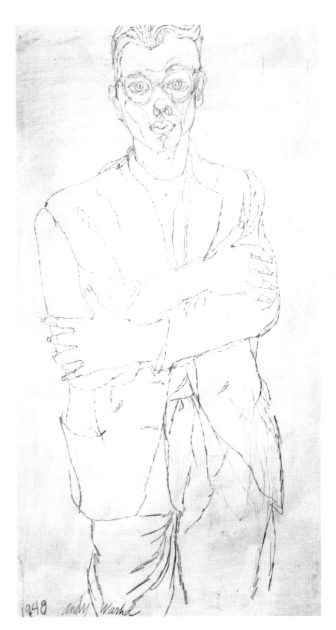

Self Portrait, 1948
Pencil and watercolor on cardboard, 16 x 8 5/8 in. (40.6 x 21.9 cm)
Collection Ethel and Leonard Kessler

What Kind of Pot?, 1948-49
Pencil on paper
11 x 8 1/2 in. (27.9 x 21.6 cm)
Founding Collection, Contribution
The Andy Warhol Foundation
for the Visual Arts, Inc.

Nose-picker, 1948-49
Pencil on paper
11 x 8 1/2 in. (27.9 x 21.6 cm)
Founding Collection, Contribution
The Andy Warhol Foundation
for the Visual Arts, Inc.

Why Pick on Me?, 1948-49
Ink and tempera on masonite, 29 15/16 x 26 in. (76 x 66 cm)
Collection Ethel and Leonard Kessler

The show regularly was dominated by Carnegie Tech faculty, alumni, and students, and Andy had been represented in it for the first time the previous year by the painting, *I Like Dance*, and a print, *Dance in Black and White*, the former featuring an unusual harlequin figure and a homemade frame of unfinished wood. In both 1948 and 1949 the artist listed his name as "Andrew Warhol" when presenting his entries.

The 1949 Associated Artists jury for paintings and drawings was composed of George Grosz, Joe Jones, and Morris Kantor, and when they came upon Andy's nose-picker, the regular cadence of "accepted" or "rejected" was broken. Grosz and Jones reportedly engaged in a prolonged debate over it. According to hearsay, Jones, a painter of pastel-colored farm scenes, objected to the uncouth subject matter, the lack of realistic drawing, the calligraphic background, and even the provocative title. Grosz, whose own satirical art showing the moral decay in Germany following World War I had contained many of the same elements, is said to have praised these very characteristics. Jones supposedly referred to Andy's painting as "repulsive"; Grosz used the word "great." Ultimately Morris Kantor, an artist whose work focused on New York interiors with psychological and sometimes surrealistic overtones, sided with Jones. To lessen the disappointment of the nose-picker's rejection, Andy's other submission was included in the show.

Andy's last hurrah before leaving Carnegie Tech and Pittsburgh occurred when he submitted the rejected work, creatively retitled *Why Pick on Me*, to the Arts and Crafts Center for a group show by two dozen Painting and Design students from the Carnegie Tech class of 1949. The show was scheduled from June 11 through July 3, so as to be on view at the time of graduation on June 16. A total of 111 entries, including paintings, prints, ceramics, and jewelry, were paraded before a jury consisting of Sam Rosenberg, Gertrude Temeles, and Benton Spruance, a Philadelphia artist who was in town for a show of his lithographs at the Carnegie Institute.

In addition to *Why Pick on Me*, Andy's other submission, *Harpist*, depicting a bulbous-headed figure whose thin, blotted-line arms embrace the instrument, was also accepted. Yet of 33 works exhibited, it was *Why Pick on Me* that drew the most attention from crowds of graduates, their families, and curiosity seekers who flocked to the Center, many specifically to view Andy's previously outlawed painting.

Carnegie Tech's fifty-second graduation was held at the Syria Mosque, and although "Andrew Warhola" was mentioned in the program as among the forty-eight Painting and Design students slated to receive Bachelor of Fine Arts degrees, there are some, including classmates and one of his brothers, who believe that Andy's degree was not awarded at that time. Professor Howard Worner explained:

My recollection is that Andy did not take Physical Training [Physical Education] and that he was told that all he had to do, in effect, was go over and roll the tennis courts for a couple of afternoons and it would suffice, but he wouldn't do it... I don't think he was on the platform [at graduation]. My impression is that he didn't get his diploma until years later.

Twenty-five years later, after he had become a revered legend at his alma mater, stories circulated that Andy was denied his sheepskin, either because he had emblazoned his name in fuchsia on every step of the Fine Arts Building from the basement to the second floor, or because he had scrawled his moniker over the word "yield" on a traffic sign adjacent to the building, on Margaret Morrison Street. Carnegie Tech's official record, on Andy's transcript, reads, "6/16/49 – awarded Bachelor of Fine Arts in Pictorial Design."

When, in the summer of 1949, Andy departed Pittsburgh for New York City, prepared to embark on a new phase of his life and art, he left behind a network of friends and his shy, boyish personality. In the ensuing years he gradually evolved into the public's image of him – never quite accurate – of a flamboyant publicity-seeker wanting to be the center of attention, whether covered in gold body paint or posing in the company of the beautiful people at a Manhattan nightspot.

Although Andy Warhol was catapulted to the very apex of Pop Art and culture through the many masterpieces he created in Manhattan, his phenomenal achievement could not have been realized without the earlier nurturing of teachers, family, and friends in his own hometown.

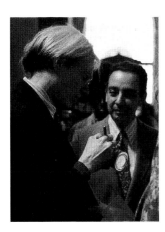

Andy Warhol and Bennard Perlman
September 14, 1975

My special thanks to Tom Armstrong, Director of The Andy Warhol Museum, who invited me to record my memories of four years as a fellow student of Andy Warhol at Carnegie Tech. I also thank Margery King, Richard Hellinger, and Christina Smith for the cooperation and help in my research.

For information about Andy Warhol's childhood and youth I am indebted to his older brothers, Paul and John Warhola, who responded generously to my endless questions, and to his nephew, James Warhola. Special thanks also are due to Andy's neighbors and schoolmates at Holmes Elementary and Schenley High schools, who dug back into their memories of over half a century to help provide a picture of his early years: Nick W. Kish, Harry Rodis, Herbert Summer, James R. Agras, and John Chirigos. Important contributions were made by Catherine E. Metz, Andy's second-grade teacher, and Joseph Fitzpatrick, who inspired him in the Saturday morning art classes at the Carnegie Institute and at Schenley High School.

Among those who are to be thanked at Carnegie Mellon University are Lola Porpora, Registrar; Jay T. Carson, of the Development Office for the College of Fine Arts; Gabrielle V. Mickalek, University Archivist, Hunt Library; Bonnie Domagala, from Alumni Information Services; Susan S. Ringel, Assistant Editor of Carnegie Mellon Magazine; Steven L. Calvert, Director of Alumni Affairs at Alumni House; and Ann Powers, Manager of the Alumni Data Base in Warner Hall.

A debt of gratitude is due to Howard L. Worner, retired professor from Carnegie Tech's Department of Painting and Design, and Andy's and my fellow classmates in that department, Class of 1949, who responded to my request for reminiscences with letters and phone calls: Mernie Wurts Berger, Beverly Huggler Braun, Herta Christie Douden, Arthur L. Elias, John P. Fisher, Hubert J. Fitzgerald, Betty Musser Githens, Jean Kniedler Jones, Leonard H. Kessler, Stephen P. Kiselick, Robert A. Korn, Paul F. Kuzma, Dr. Eugene R. Myers, Herbert C. Saiger, Jeanne MacDonald Simpson, Lila Davies Singelis, Virginia Steinbach Starr, Lois Fahnestock Strickler, Walter P. Uptegraff, and Charles T. (Jack) Wilson. And from members of the Class of 1950, I thank Virginia Gorman Atkins, Ruth Lipsick Lipsky Belkin, Jack R. Garver, William H. Goodworth, Norman C. Rosfeld, Jr., Joan Kramer Stoliar, and Analee Gelman Stone.

My most heartfelt appreciation goes to my wife, Miriam, Carnegie Tech Class of 1950, without whose continuous moral support The Education of Andy Warhol *might never have been written.*

Compiled by Margery King

"I come from nowhere."

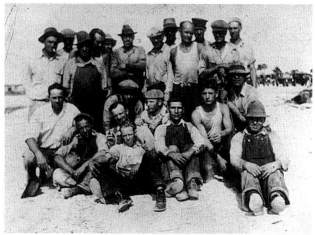

1928

Andrew Warhola born in Pittsburgh on August 6, to Julia and Andrej Warhola, Carpatho-Rusyn immigrants from Mikova, in the Medzilaborce region of the Slovak Republic, the former Czechoslovakia. He had two older brothers, Paul, born in 1922, and John, born in 1925.

Andrej Warhola was a construction worker. Julia Warhola made flowers from tin cans and colored paper, and painted eggs in the folk-art tradition of Slovakia. She also worked part-time, cleaning houses.

1934

After living in small apartments, the Warholas bought their own home, at 3252 Dawson Street. (Warhol lived there until he moved to New York.)

Entered Holmes Elementary School.

1936

Began collecting comic books and, given a child's movie projector, he projected cartoons on the walls of his home.

1937

Around age nine, developed an interest in photography and took pictures with the family's Kodak Brownie.

From about 1937 to 1941, attended free Saturday art classes taught by Joseph Fitzpatrick at Carnegie Institute.

At age eight or nine, was stricken with St. Vitus's dance (chorea) and confined to the house for more than two months.

1939

Began collecting photographs of movie stars at about age 11.

The family regularly attended St. John Chrysostom Byzantine Catholic Church at 506 Saline Avenue.

During his childhood, Warhol colored, made paper cutouts, drew, and painted.

Signed a portrait he painted of his friend Nick Kish with the name A. Warhol.

Graduated from Holmes Elementary and entered Schenley High School. While at Schenley, Warhol took elective art classes.

His father, Andrej Warhola, died.

1945

Graduated from Schenley High School, having skipped the eleventh grade.

Admitted to Carnegie Institute of Technology (now Carnegie Mellon University) and enrolled in the Department of Painting and Design. He studied with artists Balcomb Greene, Robert Lepper, Samuel Rosenberg, and Howard Worner. Warhol was the only member of his family to attend college.

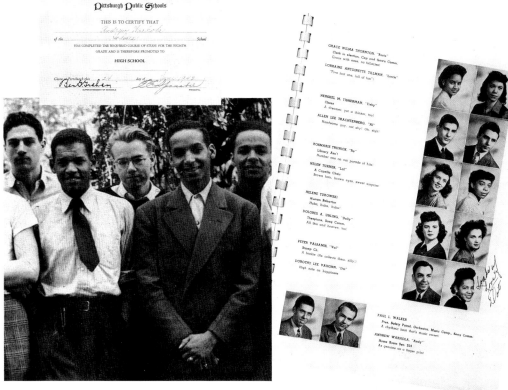

"No, no I don't love my name so much. I always wanted to change it. When I was little I was going to take 'morningstar,' Andy Morningstar."

"THEY HAD SO MANY CHILDREN," according to artist-huckster Andy Warhola, "they didn't know what to do." So the mothers brought them to his vegetable truck while they chatted. His prize-winning drawings satirize customers of a huckster route in Oakland and Homestead last Summer.

1946

Fared poorly in his first year at Carnegie Tech and was required to take a summer class in drawing.

Drawings he made over the summer awarded the Martin B. Leisser Prize and exhibited at Carnegie Tech's Fine Arts gallery. The drawings were based on Warhol's observations while working with his brother selling fruit from a truck.

SATIRE OF TOMATO-SQUEEZERS is explained by Andy Warhola to Jane Bicht, fellow art student at Carnegie Tech. His sketches won one of the Leisser Art awards. He's 18, a graduate of Schenley High.

Artist-Huckster Sketches

1947

In 1947–48, began to experiment with a blotted-line printing technique that became one of the mainstays of his 1950s commercial work. The blotted-line drawings were made by tracing over an existing drawing with ink and blotting the still-wet ink with a second piece of paper.

Rented a studio with fellow Carnegie Tech students over the summer.

Took a summer job in the display department at the Joseph Horne department store in downtown Pittsburgh.

Was a member of Carnegie Tech's honorary Beaux Arts Society.

1948

Warhol's painting *I Like Dance* and his print *Dance in Black and White* included in the annual exhibition of the Associated Artists of Pittsburgh.

Became art editor for the student magazine *Cano* and designed the cover for the November issue.

Won the Mrs. John L. Porter Prize for Progress at Carnegie Tech.

Joined Carnegie Tech's Modern Dance Club.

1949

Warhol's painting *The Broad Gave Me My Face, But I Can Pick My Own Nose* rejected by the jury for the annual exhibition of the Associated Artists of Pittsburgh. Members of the jury included the artist George Grosz, who was said to have praised the work. It was subsequently included in a student exhibition at Pittsburgh's Arts and Crafts Center.

Graduated from Carnegie Tech with a bachelor of fine arts degree in pictorial design.

"I had a job one summer in a department store looking through Vogues and Harper's Bazaars and European fashion magazines for a wonderful man named Mr. Vollmer. . . .

Mr. Vollmer was an idol to me because he came from New York and that seemed so exciting. I wasn't really thinking about ever going there myself, though."

Moved to New York City with classmate Philip Pearlstein and rented an apartment on St. Mark's Place at Avenue A. Warhol and Pearlstein subsequently moved to 323 West 21st Street, where they rented a space from dancer Franziska Boas.

Began work as a commercial artist. Tina Fredericks, art editor at *Glamour* magazine, hired Warhol to illustrate the article "What Is Success?" for the September issue.

Throughout the 1950s and into the early 1960s, Warhol contributed illustrations to a great variety of commercial projects.

1950

Moved to 74 West 103rd Street, where he shared an apartment with Victor Reilly and other dancers. Warhol later moved to 216 East 75th Street.

1951

Did newspaper illustrations advertising the CBS radio feature "The Nation's Nightmare," for which he received an Art Directors Club Medal. Throughout the 1950s, Warhol received numerous awards from the Art Directors Club and the American Institute of Graphic Arts.

1952

His first solo exhibition, "Fifteen Drawings Based on the Writings of Truman Capote," held at the Hugo Gallery, New York (June 16–July 3). Warhol had become fascinated with

the young author of *Other Voices, Other Rooms*, and he wrote and called him repeatedly and went to great lengths to try to meet him. The two later developed a friendship, which continued until Capote's death in 1984.

Contributed illustrations to Amy Vanderbilt's *Complete Book of Etiquette*, published by Doubleday.

Julia Warhola moved to New York to live with her son, and continued to live with him until 1971. They shared their home with numerous cats.

1953

Produced the illustrated books *A Is an Alphabet* and *Love Is a Pink Cake* with his friend Ralph T. Ward, which were signed "by Corkie and Andy." Warhol gave these and other books to clients and associates.

Around this time Fritzie Miller began to act as Warhol's agent for commercial art.

Designed sets, including a group of folding screens, for the Theatre 12 group. Warhol also took part in the group's dramatic readings.

Moved to a larger apartment, at 242 Lexington Avenue. He later rented an additional apartment in the same building.

1954

Exhibited in both group and solo shows at the Loft Gallery, New York. Among the works Warhol exhibited were marbleized-and folded-paper works displayed on the walls, floors, and hanging from the ceiling.

Produced the illustrated book *25 Cats Name Sam and One Blue Pussy*, with text by Charles Lisanby. These and other books were hand-colored at parties with friends and associates.

Began spending time at Serendipity, a café then located on East 58th Street. Decorated with Tiffany lamps and Art Nouveau furnishings, the café was frequented by people from the fashion and design worlds. Warhol exhibited and sold his work there.

1955

During this period, used rubber stamps to create repeated images of birds and other designs, which were usually hand-colored. Warhol employed this technique through the early 1960s.

I. Miller spring ad mats

Selected by the shoe company I. Miller to illustrate its weekly New York Times advertisements. He worked on the

campaign with company vice-president Geraldine Stutz, advertising director Marvin Davis, and art director Peter Palazzo. The award-winning advertisements were a great success and further established Warhol's reputation as an illustrator.

Shoe of the evening, beautiful shoe.

Produced the illustrated book *A la Recherche du Shoe Perdu*, with poems by Ralph Pomeroy.

Nathan Gluck began to work for Warhol as a part-time studio assistant, and continued to assist him on projects until the early 1960s.

1956

Warhol's "Studies for a Boy Book" exhibited at the Bodley Gallery, New York (February 14–March 3). In the 1950s, Warhol filled numerous sketchbooks with his drawings of young men.

Exhibited gold-leaf-collaged shoe drawings in his "Golden Slipper Show or Shoes Shoe in America" at the Bodley Gallery (December 3–22). His gold shoes were the subject of a spread in the January 21, 1957, issue of *Life* magazine.

A Warhol drawing of a shoe included in the exhibition "Recent Drawings U.S.A." at The Museum of Modern Art, New York (April 25–August 5).

Produced the illustrated book *In the Bottom of My Garden*.

Designed Christmas cards for Tiffany & Co., and continued to do so for a number of years.

"If they told me to draw a shoe, I'd do it, and if they told me to correct it, I would — I'd do anything they told me to do, correct it and do it right . . . after all that 'correction,' those commercial drawings would have feelings. . . . The process of doing work in commercial art was machine-like, but the attitude had feeling to it."

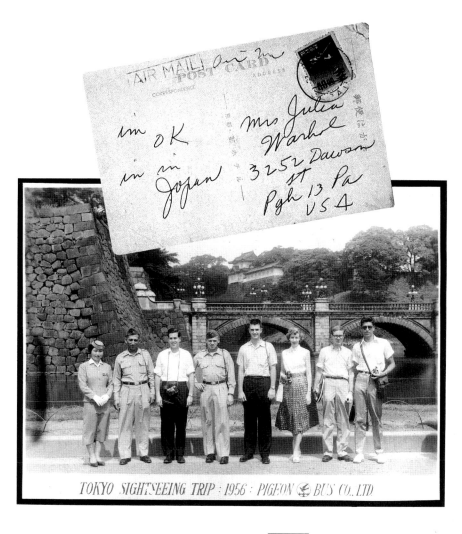

TOKYO SIGHTSEEING TRIP : 1956 : PIGEON 🕊 BUS CO., LTD.

At about this time, became acquainted with the photographer Edward Wallowitch. Warhol used traced and projected images from Wallowitch's photographs, as well as other photographs and images from the New York Public Library's picture collection in his own works.

Took a world tour with Charles Lisanby from June 16 to August 12, and traveled to San Francisco, Honolulu, Tokyo, Hong Kong, Manila, Djakarta, Bali, Singapore, Bangkok, Siem Reap (Angkor Wat), Colombo, Calcutta, Katmandu, Benares, New Delhi, Agra, Aurangabad, Cairo, Luxor, and Rome.

1957

Exhibited "A Show of Golden Pictures" at the Bodley Gallery (December 2–24).

Produced *A Gold Book*, with drawings printed on gold paper, and published *Holy Cats* "by Andy Warhol's Mother," with illustrations by Julia Warhola.

Underwent cosmetic surgery on his nose.

Formed Andy Warhol Enterprises, Inc.

1958

In the late 1950s, began to do illustrations for the Fleming Joffe leather company, and continued to do so until the early 1960s.

1959

Produced the fantasy cook-book *Wild Raspberries* with Suzie Frankfurt.

Julia Warhola, who contributed lettering to her son's illustration projects, received awards from the Art Directors Club and the American Institute of Graphic Arts, inscribed to "Andy Warhol's Mother."

Met the filmmaker Emile de Antonio, who was a friend and agent to artists. De Antonio later introduced Warhol to Frank Stella and Eleanor Ward (owner of the Stable Gallery in New York), among others.

173

"Once you 'got' Pop, you could never see a sign the same way again. And once you thought Pop, you could never see America the same way again. . . . We were seeing the future and we knew it for sure. We saw people walking around in it without knowing it, because they were still thinking in the past, in the references of the past."

1960

Painted his first works based on comics and advertisements, enlarging and transferring the source images onto his canvases with an opaque projector.

In 1960 or 1961, Warhol met Henry Geldzahler, a curator at the Metropolitan Museum of Art in New York, who became a close friend.

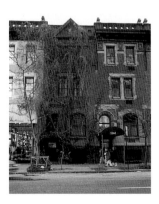

Acquired a town house at 1342 Lexington Avenue, which accommodated his growing collections of art, furniture, and objects.

Irving Blum and Walter Hopps of the Ferus Gallery in Los Angeles visited Warhol's studio late in the year or early in 1961 and viewed his work.

Warhol and his friend Ted Carey commissioned a double portrait of themselves by Fairfield Porter. Warhol later donated the painting to the Whitney Museum of American Art in New York.

1961

Showed his paintings *Advertisement, Little King, Superman, Before and After*, and *Saturday's Popeye* behind a display of dresses in a window of the Bonwit Teller department store.

Acquired Jasper Johns's drawing *Light Bulb* from the Leo Castelli Gallery in New York. Ivan Karp, of the Castelli Gallery, showed him Roy Lichtenstein's paintings based on comics.

Ivan Karp visited Warhol's studio to view his work. Leo Castelli also saw his work, but declined to represent Warhol at the time because he was already representing Lichtenstein.

1962

Used rubber stamps to create *S & H Green Stamps* and other works, and made *Do It Yourself* paintings, based on paint-by-numbers images.

Began paintings of Elizabeth Taylor, using tabloid and publicity photographs as sources.

Started a series of paintings of death and disasters, the first of which was based on a photograph of a plane crash that appeared on the front page of the *New York Mirror* on June 4.

The Ferus Gallery exhibited Warhol's 1962 *Campbell's Soup Can* paintings (July 9–August 4). The show included thirty-two 20-by-16-inch works, ranging in variety from cream of asparagus to vegetarian vegetable.

Warhol's work shown at the Stable Gallery (November 6-24). The exhibition included *Baseball, Close Cover Before Striking, Coca-Cola, Dance Diagram, Do It Yourself, Elvis, Marilyn*, and disaster paintings. The *Dance Diagram* paintings were displayed on the floor.

Included in the exhibition "New Painting of Common Objects," curated by Walter Hopps at the Pasadena Art Museum (September 25–October 19).

Included in the exhibition "The New Realists" at the Sidney Janis Gallery, New York (October 31–December 1).

Featured in a May 11 *Time* magazine article on Pop artists.

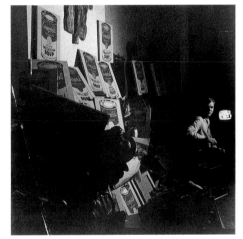

Shortly after starting to use hand-cut silkscreens to reproduce his own drawings of dollar bills, Warhol turned to the photo-silkscreen technique, which became one of his primary methods of production.

Began his *Marilyn* paintings after Marilyn Monroe's death on August 5.

Began paintings of Elvis Presley.

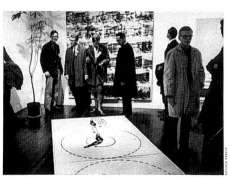

ANDY WARHOL OPENING AT THE STABLE GALLERY
It's a long way from Giorgione.

175

"Oh when will I be famous when will it happen?"

Began his series of *Jackie* paintings after President Kennedy's assassination on November 22.

Bought a 16mm movie camera.

1963

Established a studio in a vacant firehouse, formerly Hook and Ladder Company 13 on East 87th Street. Later in the year, moved his studio to 231 East 47th Street. This space, which became known as the Factory, was painted silver and covered with silver foil by Billy Name (Billy Linich), who moved in. Filled with Warhol's art, music, and constant

activity, it attracted artists, college students, celebrities, New York lowlife, and photographers, who documented the scene.

The poet Gerard Malanga became Warhol's studio assistant. He appeared in Warhol's films and other productions.

Made *Statue of Liberty* and began *Electric Chair* paintings.

Made multiple-image portraits of the collector Ethel Scull and others, based on photographs of his subjects taken in photobooths.

Made the films *Sleep, Andy Warhol Films Jack Smith Filming "Normal Love,"* *Kiss*, and *Tarzan and Jane Regained...Sort of*, which was shot in Los Angeles.

Warhol's *Elvis* paintings shown at the Ferus Gallery (September 30–October). He drove cross-country for the exhibition with Gerard Malanga, the underground actor Taylor Mead, and the painter Wynn Chamberlain. In California Warhol attended the opening of the Marcel Duchamp exhibition at the Pasadena Art Museum, and met the artist. Dennis Hopper threw a "Movie Star Party" for Warhol; among the guests were Troy Donahue, Peter Fonda, and Sal Mineo.

Included in the exhibition "Six Painters and the Object," organized by Lawrence Alloway at the Solomon R. Guggenheim Museum, New York (March 14–June 12). The exhibition traveled in an expanded form to the Los Angeles County Museum of Art.

Included in the exhibition "The Popular Image" at the Washington Gallery of Modern Art, Washington, D.C. (April 18–June 2). The exhibition traveled to the Institute of Contemporary Art, London.

Met Jonas Mekas, the filmmaker, writer, and champion of avant-garde cinema, who ran the Film-Makers' Cooperative and the Film-Makers' Cinematheque in New York. Warhol attended underground-film screenings organized by Mekas, who was responsible for early showings of Warhol's films.

Began to frequent dance concerts and performances at Judson Church in Greenwich Village, where he saw Yvonne Rainer's *Terrain*, with lighting designed by Robert Rauschenberg, and became acquainted with the dancer and choreographer Fred Herko.

Baby Jane Holzer, Taylor Mead, and Ondine (Robert Olivo) became Factory regulars at about this time. All appeared in Warhol's films.

1964

Made *Self-Portrait* paintings based on photobooth photographs.

"... that had always fascinated me, the way people could sit by a window or on a porch all day and look out and never be bored, but then if they went to a movie or a play, they suddenly objected to being bored. I always felt that a very slow film could be just as interesting as a porch-sit if you thought about it the same way."

Made the *Thirteen Most Wanted Men* series for the façade of the New York State Pavilion at the 1964 New York World's Fair. After officials objected to the work, Warhol allowed it to be painted over.

Made *Brillo Box, Heinz Box* and other box sculptures, which were exhibited at the Stable Gallery (April 21–May 9).

Began *Flowers* paintings, which were shown at the Castelli Gallery (November 21–December 17).

"I like boring things."

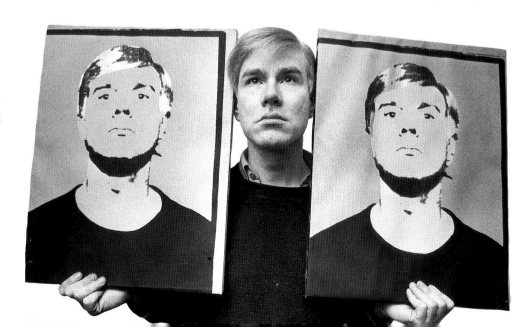

"My mind is like a tape recorder with one button—erase."

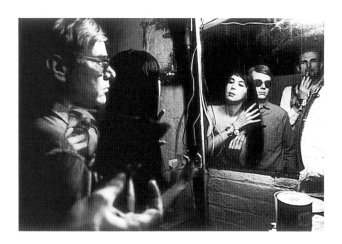

Made the films *Blow Job, Eat, Batman, Dracula, Couch, Empire, Henry Geldzahler*, and *Harlot*, his first with live sound, and began filming *Screen Tests*.

Acquired his first tape recorder around this time. It became his constant companion, and he taped thousands of hours of conversations, documenting all aspects of his life and work.

Warhol's disaster paintings exhibited at the Galerie Ileana Sonnabend, Paris (January–February).

His painting *Orange Disaster No. 5* included in the Pittsburgh International (now the Carnegie International) exhibition at the Museum of Art, Carnegie Institute, Pittsburgh (October 30, 1964–January 10, 1965).

A Warhol film installation exhibited at the New York Film Festival. It consisted of short segments of *Eat, Haircut, Kiss*, and *Sleep* on 8mm film loops shown on viewers, with a soundtrack by LaMonte Young.

Received an Independent Film Award from *Film Culture*, the avant-garde film periodical edited by Jonas Mekas.

Dorothy Podber entered the Factory and shot a bullet through a stack of *Marilyn* paintings. These paintings came to be known as *Shot Marilyns*.

1965

Made the films *Screen Test #2, The Life of Juanita Castro, Poor Little Rich Girl, Vinyl, Restaurant, Kitchen, Beauty #2, My Hustler, Camp, Paul Swan, More Milk Yvette*, and *Lupe*.

Previewing the 1966 Recorders

tape recording

50¢ OCTOBER 1965

Exclusive Photos of Andy Warhol's Far Out Underground Videotapes

First experimented with video, using equipment lent to him by *Tape Recording* magazine in preparation for an article about him. Warhol returned to video in the 1970s and 1980s.

Designed the cover for the January 29 issue of *Time*, illustrating the article "Today's Teen-Agers" with a series of photographs taken in a photobooth.

While in Paris in May for the opening of his *Flowers* exhibition at the Galerie Ileana Sonnabend, Warhol described himself as a "retired artist" and said he planned to devote himself to film.

Canadian customs officials refused to accept Warhol's box sculptures—scheduled to be exhibited at the Jerrold Morris Gallery in Toronto—as art, thereby making them subject to a 20-percent duty.

A retrospective of Warhol's work, organized by Sam Green, held at the Institute of Contemporary Art, University of Pennsylvania, Philadelphia (October 8–November 21). The opening, attended by Warhol and an entourage, was mobbed.

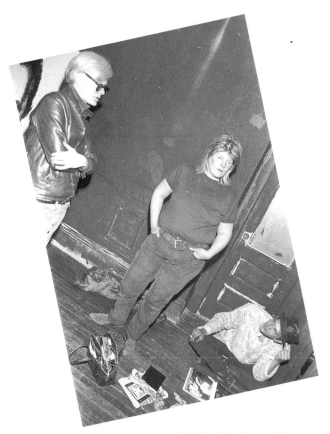

Brigid Polk Berlin and Ultra Violet (Isabelle Collin Dufresne) began to frequent the Factory at about this time. Both appeared in Warhol's films, and Berlin remained a close friend until Warhol's death.

"The Fifty Most Beautiful People" party hosted by the film producer Lester Persky at the Factory. William Burroughs, Montgomery Clift, Judy Garland, Allen Ginsberg, Rudolf Nureyev, Tennessee Williams, and others attended.

Edie Sedgwick became an important figure at the Factory, attending events with Warhol and starring in his films.

Met Paul Morrissey, who worked with him on film projects.

Paul Morrissey

Constantin-Film

1966

Began his collaboration with the rock group the Velvet Underground and introduced Nico (Christa Päffgen) to the group. Warhol had first heard the Velvet Underground perform at the Café Bizarre in New York.

Produced the Exploding Plastic Inevitable, multimedia "happenings" featuring the Velvet Underground and performance, film, and light shows. The Velvet Underground traveled and performed on college campuses and elsewhere; they appeared at the opening of Warhol's exhibition at the Institute of Contemporary Art

in Boston. Warhol rented space in the Polski Dom Narodowy (Polish National Home) at 23 St. Mark's Place in Manhattan's East Village for performances of the Exploding Plastic Inevitable.

SUNDAY OCT. 30
3PM & 8:30PM
ANDY WARHOL
Presents
HALLOWEEN
★ MOD ★
HAPPENING
THE EXPLODING
PLASTIC INEVITABLE
LEICESTER AIRPORT
Off Route 56 Leicester, Mass.

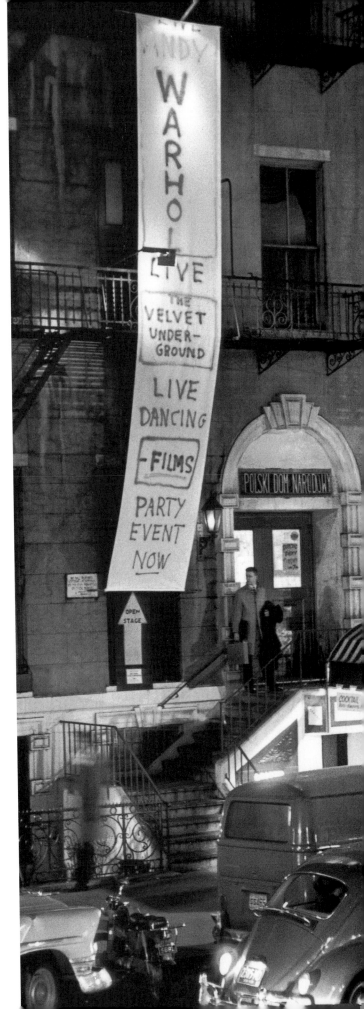

For his exhibition at the Castelli Gallery (April 2–27), Warhol covered the walls of one room with his *Cow* wallpaper and filled a second, white-walled room with his floating *Silver Clouds*. The *Silver Clouds*, made of helium-filled metalized plastic film, were created with the assistance of Billy Klüver, an engineer and one of the founders of Experiments in Art and Technology (E.A.T.).

Made the films *The Velvet Underground and Nico*, *Hedy*, *The Chelsea Girls*, and *Bufferin*, and began ★★★★ (*Four Stars*), which included footage for a never-released film on the assassination of John F. Kennedy. *The Chelsea Girls*, inspired by life at New York's Chelsea Hotel, was shown with two different reels of film projected simultaneously.

It was distributed widely and received national media attention; *Newsweek* called it "the *Iliad* of the underground."

Produced the first album by the Velvet Underground and Nico, and designed the album's cover. It pictured a banana skin which could be peeled off to expose a pink banana.

The Institute of Contemporary Art, Boston held an exhibition of Warhol's work (October 1–November 6).

The following advertisement appeared in the February 10 issue of *The Village Voice*: "I'll endorse with my name any of the following: clothing AC-DC, cigarettes small, tapes, sound equipment, ROCK N' ROLL RECORDS, anything, film, and film equipment, Food, Helium, Whips. MONEY!! love and kisses ANDY WARHOL, EL 5-9941."

Made a promotional appearance at the Abraham & Straus department store, screening "FRAGILE" on a paper dress worn by Nico.

Gave away the bride at a "mod wedding" at the Michigan State Fair Grounds Coliseum in Detroit. Sponsored by a food chain, the event featured a performance of the Exploding Plastic Inevitable. The newlyweds were given a trip to New York City and a screen test at the Factory.

Warhol and Factory regulars began to hang out at the bar-restaurant Max's Kansas City on Park Avenue South near Union Square, a meeting place for New York's avant-garde.

Invited to Truman Capote's "Black and White Dance" in honor of Katharine Graham. Mr. and Mrs. Henry J. Heinz II, Rose Kennedy, Marianne Moore, Mr. and Mrs. William S. Paley, Frank Sinatra, and more than 500 others attended the event at the Plaza Hotel.

Made *Self-Portrait* paintings, which were included in the United States Pavilion exhibition at Expo '67 in Montreal.

Designed the poster for the fifth New York Film Festival.

Invited to show *The Chelsea Girls* at the Cannes Film Festival. Warhol attended the festival, but the screening was canceled.

Conducted a college lecture tour, first bringing Factory associates along as speakers, then having Alan Midgette impersonate him for a number of engagements.

Joe Dallesandro, Candy Darling (James Slattery), and Viva (Susan Hoffman) became Factory regulars. All starred in Warhol's films.

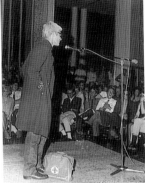

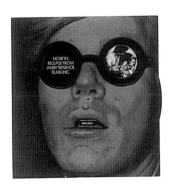

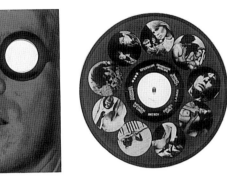

Made the films *I, a Man; Bike Boy; Imitation of Christ; Loves of Ondine;* and *The Nude Restaurant.*

Showed ★★★★ (*Four Stars*) at the New Cinema Playhouse. The 25-hour film, which included footage also used for Warhol's other 1967 films, was run on two projectors, creating a superimposed image.

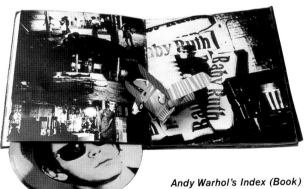

Andy Warhol's Index (Book) published by Random House, and *Screen Tests/A Diary*, a collaboration between Warhol and Gerard Malanga, published by Kulchur Press.

Met Frederick W. Hughes at a benefit for the Merce Cunningham Dance Company that included a performance by the Velvet Underground, held at the architect Philip Johnson's Glass House in Connecticut. Hughes became a close associate and Warhol's exclusive agent and business manager.

ANDY WARHOL presents Joe Dallesandro in FLESH

"The lighting is bad,
the camera work is bad,
the projection is bad,
but the people
are beautiful."

Shot the film *San Diego Surf*, produced *Flesh*, directed by Paul Morrissey, and made *Blue Movie*. Warhol began to take a less active role in filmmaking.

Made the film *Lonesome Cowboys* in 1967–68.

Schrafft's restaurant chain, in a bid to change its image, hired Warhol to create a television advertisement. The ad featured an ice-cream sundae in psychedelic colors.

The artist's *Silver Clouds* used as the set for Merce Cunningham's dance *RainForest*.

a "a novel", a transcription of tape recordings featuring Ondine, published by Grove Press.

1968

Moved the studio to 33 Union Square West, to a white-walled loft space occupying the entire sixth floor of the building. Warhol later rented additional space on the eighth floor for his private studio, and on the tenth floor.

On June 3, Valerie Solanas, a periodic Factory visitor and the founder and sole member of S.C.U.M. (Society for Cutting Up Men), entered the studio and shot Warhol. Critically wounded, he was hospitalized for nearly two months.

"When somebody threatens me
I don't listen to them any more."

A retrospective of Warhol's work, organized by Pontus Hulten and Kasper König, held at the Moderna Museet, Stockholm (February 10–March 17). As part of the exhibition, the façade of the museum was covered with the artist's *Cow* wallpaper. Warhol attended the opening of the exhibition, which traveled to the Stedelijk Museum, Amsterdam; the Kunsthalle, Bern; and the Kunstnernes Hus, Oslo.

Warhol's work included in "Documenta 4" in Kassel, Germany (June 27–October 6).

Jed Johnson hired as an assistant. Soon after, he moved in with Warhol and his mother.

"I could never finally figure out if more things happened in the sixties because there was more awake time for them to happen in, or if people started taking amphetamine because there were so many things to do that they needed to have more awake time to do them in."

Warhol's production of commissioned portraits began to increase. Many were based on his Polaroid photographs of sitters—patrons, friends, and celebrities. These portraits formed a significant part of Warhol's artistic output throughout the 1970s and 1980s.

Acquired a Sony Portapack video camera and began to work regularly with video.

Worked with Cowles Communications to create the "Rain Machine," an installation that incorporated a fountain and Xographic (3-D) prints of flowers, in connection with the Los Angeles County Museum of Art's Art and Technology Program. It was exhibited in the United States Pavilion at Expo '70 in Osaka, Japan.

At the suggestion of John and Dominique de Menil, curated "Raid the Icebox I with Andy Warhol," a selection from the storage rooms of the Museum of Art at the Rhode Island School of Design. The exhibition opened at the Institute for the Arts, Rice University, Houston (October 29, 1969–January 4, 1970), and traveled to the Isaac Delgado Museum, New Orleans, and the Museum of Art, Rhode Island School of Design, Providence.

In 1969–1970, produced the film *Trash*, directed by Paul Morrissey.

The first issue of *Interview* magazine published in the fall. It began as a "monthly film journal."

A one-man exhibition of Warhol's work held at the Nationalgalerie, Berlin (March 1–April 14).

Included in The Metropolitan Museum of Art's "New York Painting and Sculpture: 1940–1970," curated by Henry Geldzahler (October 18, 1969–February 1, 1970).

Vincent Fremont began to work for Warhol. He became a close associate, working with the artist on video and television projects, and eventually becoming his executive manager.

A major retrospective of Warhol's work, organized by John Coplans, held at the Pasadena Art Museum (May 12–June 21). The exhibition traveled to the Museum of Contemporary Art, Chicago; the Stedelijk Van Abbe Museum, Eindhoven; the Musée d'Art Moderne de la Ville de Paris; the Tate Gallery, London; and the Whitney Museum of American Art, New York. At the Whitney, much of the show was hung on Warhol's *Cow* wallpaper.

Grove Press published the *Blue Movie* film script.

The first monograph on Warhol, by the art historian Rainer Crone, published by Praeger.

Bob Colacello began to work for *Interview*. He became the magazine's executive editor and a close associate of Warhol.

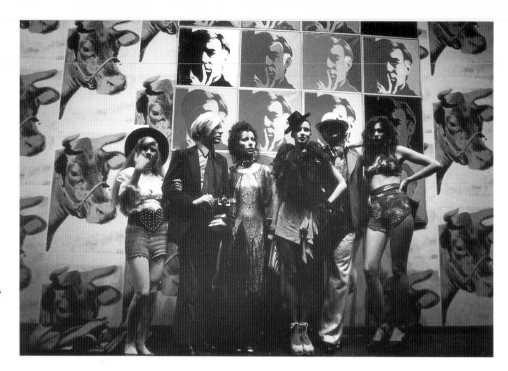

"I think every painting should be the same size and the same color so they're all interchangeable and nobody thinks they have a better painting or a worse painting. And if the one 'master painting' is good, they're all good. Besides, even when the subject is different, people always paint the same painting."

Designed the album cover of the Rolling Stones' *Sticky Fingers* in collaboration with Craig Braun. It featured a male torso in jeans with a working zipper, and was nominated for a Grammy Award.

Warhol's play *Pork*, based on life at the Factory, performed at the La Mama experimental theater, New York, and at the Round House, London.

1971

Began consistent videotaping of *Factory Diaries*, spontaneous recordings of visitors and life at the studio, with subjects ranging from David Bowie performing a pantomime to Warhol painting. Warhol, according to Vincent Fremont, "would have liked the camera to run constantly."

Warhol and Paul Morrissey acquired a twenty-acre compound with five buildings and beachfront property in Montauk, Long Island. Lee Radziwill, Mick Jagger, Truman Capote, Peter Beard, and other friends spent time there.

1972

Began *Mao* paintings, drawings, and prints.

Made the print *Vote McGovern*, picturing a green and blue portrait of Richard Nixon, for George McGovern's presidential campaign.

Audited by the Internal Revenue Service. Warhol was audited annually until his death.

Removed the films he had directed from distribution .

Warhol's mother died in Pittsburgh. She had returned there from New York in 1971.

1973

Made the videos *Vivian's Girls* and *Phoney*, co-directed with Vincent Fremont.

Appeared in the film *The Driver's Seat* with Elizabeth Taylor.

Ronnie Cutrone became Warhol's studio assistant in 1973–74.

1974

In the mid–1970s, developed an idea for an "invisible sculpture" that would use motion-detector alarms activated by movement in a space.

Began assembling "Time Capsules" in standard-sized boxes. This collection of objects and ephemera dating from the 1950s through the 1980s eventually numbered more than 600 boxes.

In 1973–74, co-produced the films *Andy Warhol's Dracula* and *Andy Warhol's Frankenstein* (in 3-D), both shot in Italy and directed by Paul Morrissey.

Maos exhibited at the Musée Galliera, Paris (February 23– March 18). They were hung on Warhol's *Mao* wallpaper.

In 1971–72, produced the films *Women in Revolt!*, *Heat*, and *L'Amour*, directed by Paul Morrissey.

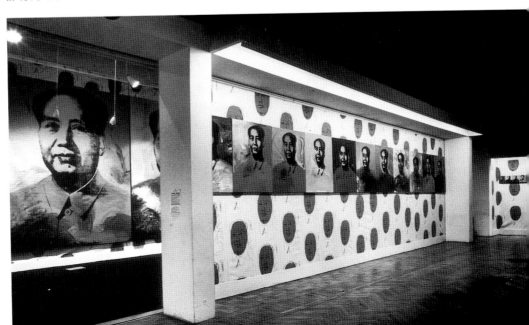

Moved the studio to the third floor of 860 Broadway. This larger space, complete with a paneled conference room and decorated with furniture, objects, and art, also housed the expanded *Interview* staff. Luncheons with Diana Vreeland, David Hockney, Eric de Rothschild and other cultural and society figures, patrons, and *Interview* advertisers were held in the conference room. Warhol no longer referred to the work space as "the Factory," and 860 Broadway became known as "the office."

"Business art is the step that comes after art. I started as a commercial artist, and I want to finish as a business artist. After I did the thing called 'art' or whatever it's called, I went into business art. I wanted to be an Art Businessman or Business Artist."

Acquired a town house at 57 East 66th Street. Jed Johnson was responsible for decorating the house, which was filled with art, furniture, and collectibles.

1975

Made the video *Fight*, co-directed with Vincent Fremont, in which a fight was played out between Brigid Berlin and Charles Rydell.

The Philosophy of Andy Warhol (From A to B and Back Again) published by Harcourt Brace Jovanovich.

Made *Ladies and Gentlemen* paintings, drawings, and prints, which depicted transvestites.

Produced *Man on the Moon*, with book, music, and lyrics by John Phillips, directed by Paul Morrissey. The musical played briefly at Broadway's Little Theatre.

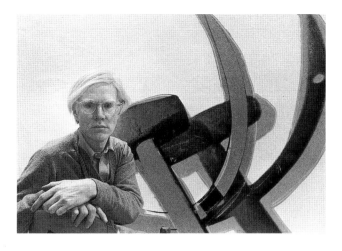

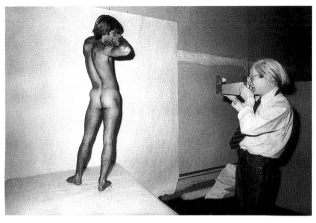

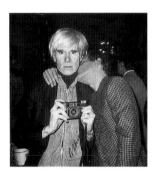

1976

Made *Skull* and *Hammer and Sickle* paintings.

Produced the film *Bad*, directed by Jed Johnson.

Began dictating his detailed diary to Pat Hackett each weekday morning over the telephone. The dictations formed the basis of *The Andy Warhol Diaries*, published posthumously by Warner Books.

A retrospective of Warhol's drawings, organized by Rainer Crone, held at the Württembergischer Kunstverein, Stuttgart (February 12–March 28). The exhibition traveled to the Stadtische Kunsthalle, Düsseldorf; the Kunsthalle, Bremen; the Städtische Galerie im Lenbachhaus, Munich; the Haus am Waldsee, Berlin; the Museum moderner Kunst, Museum des 20. Jahrhunderts, Vienna; and the Kunstmuseum, Lucerne.

1977

Made *Torso* paintings and drawings.

Exhibited in the Arts Council Hall, Kuwait (January). Warhol, Fred Hughes, and Jed Johnson attended the opening of the exhibition.

Warhol's *Hammer and Sickle* paintings exhibited at the Galerie Daniel Templon, Paris (May 31–July 9).

"Andy Warhol's 'Folk and Funk'," an exhibition of Warhol's folk art collection curated by Sandra Brant and Elissa Cullman, held at the Museum of American Folk Art, New York (September 20–November 19).

Began to frequent Studio 54 with friends Halston, Bianca Jagger, and Liza Minnelli. The West 54th Street discotheque attracted celebrities from many spheres.

1978

Made *Self-Portraits* with skulls, *Shadows*, and *Oxidation* paintings.

A retrospective of Warhol's work, organized by Erika Billeter, held at the Kunsthaus, Zurich (May 26–July 30). The exhibition traveled to the Louisiana Museum, Humlebaek, Denmark.

Warhol's *Torsos* exhibited at the Ace Gallery, Venice, California (September 24–October 21).

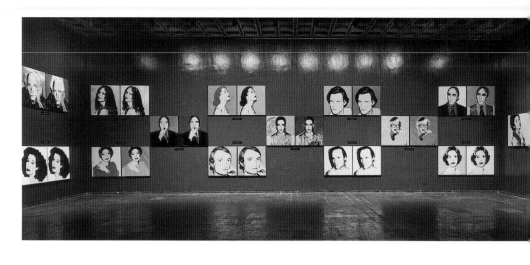

Began making *Retrospective* and *Reversal* paintings, using images from earlier works.

In 1979–80, produced the ten-episode video program *Fashion*, directed by Don Munroe.

Andy Warhol's *Exposures*, with photographs by Warhol and text co-written with Bob Colacello, published by Andy Warhol Books/ Grosset & Dunlap.

Warhol's *Shadow* paintings exhibited at the Heiner Friedrich Gallery, New York (January 27–March 10). Warhol hung the paintings edge to edge and described them as "one painting with eighty-three parts."

"Andy Warhol: Portraits of the 70s" shown at the Whitney Museum of American Art (November 20, 1979–January 27, 1980). The exhibition, organized by David Whitney, included portraits of Giovanni and Marella Agnelli, Leo Castelli, Dennis Hopper, Mick Jagger, Roy Lichtenstein, John Richardson, and Julia Warhola.

Made *Shoe* paintings and prints, adding diamond dust to the images.

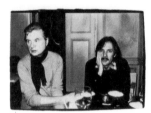
Liza Minnelli & Linda Blair

Francis Bacon & friend

Federico de Laurentiis

Diana Ross & daughter

CPLY

DVF, Marqués de Portago, & Bianca Jagger

Mr. & Mrs. Joseph E. Levine

Jasper Johns & Christophe de Menil

Anne Waldman & Robert Wilson

Carole Bouquet & Sam Spiegel

Talking Head Tina Weymouth & Christopher Makos

Mr. & Mrs. Tom Seaver

"I have a social disease. I have to go out every night."

From 1980–82, developed *Andy Warhol's TV*, directed by Don Munroe, a series of half-hour video programs patterned after *Interview* magazine.

POPism: The Warhol '60s, by Warhol and Pat Hackett, published by Harcourt Brace Jovanovich.

Exhibitions of Warhol's photographs held at the Museum Ludwig, Cologne (August 20–September 28), and the Stedelijk Museum, Amsterdam (August 28–October 26).

Modeled for a life mask intended for a Warhol robot in a theater project conceived by the director Peter Sellars and the producer Lewis Allen.

Jay Shriver became Warhol's studio assistant.

During a visit to Rome, Warhol and Fred Hughes had an audience with Pope John Paul II.

1981

Made *Dollar Signs*, *Guns*, and *Knives* paintings and drawings.

Produced and starred in three one-minute episodes of *Andy Warhol's TV*, directed by Don Munroe, for the NBC television program "Saturday Night Live."

Warhol's *Disaster* paintings shown in the exhibition "Westkunst" in Cologne (May 30–August 16).

Began to be represented by the Zoli modeling agency around this time.

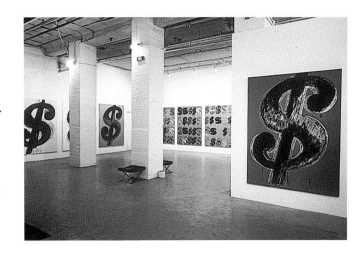

1982

Made *Crosses* paintings and drawings.

The Castelli Gallery exhibited Warhol's *Dollar Sign* paintings (January 9–30).

Designed a poster for Rainer Werner Fassbinder's film *Querelle*.

An exhibition of Warhol's *Guns, Knives*, and *Crosses* held at the Galeria Fernando Vijande, Madrid (December 16, 1982–January 21, 1983).

An exhibition of the works of Beuys, Rauschenberg, Twombly, and Warhol from the Marx collection shown at the Nationalgalerie, Berlin

(March 2–April 12). It traveled to the Städtisches Museum Abteiberg, Mönchengladbach.

Warhol's 1982 *Zeitgeist* paintings shown in the group exhibition "Zeitgeist" at the Martin-Gropius-Bau, Berlin (October 15–December 19).

Traveled to Hong Kong and Beijing with Fred Hughes and photographer Christopher Makos.

"I worked hard and I hustled, but my philosophy was always that if something was going to happen, it would, and if it wasn't and didn't, then something else would."

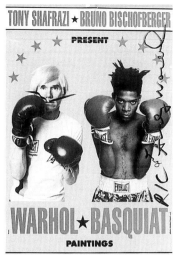

Warhol's 1983 *Toy* paintings exhibited on his *Fish* wallpaper and hung at child's eye-level at the Bruno Bischofberger Gallery, Zurich (December 3, 1983–January 14, 1984).

Appeared in a Japanese television commercial for TDK videotape.

1984

Made *Rorschach* paintings.

Made a music video for the Cars' "Hello Again." Conceived and directed by Warhol and Don Munroe, the video also featured Warhol.

1983

Warhol, Jean-Michel Basquiat, and Francesco Clemente began collaborating on paintings. Warhol and Basquiat, who were close friends and made portraits of each other, worked together for a number of years.

During this period, started a series of works, many of them hand-painted, based on advertisements, commercial imagery, and illustrations.

Designed the official poster for the Brooklyn Bridge Centennial.

"Collaborations: Jean-Michel Basquiat, Francesco Clemente, Andy Warhol" exhibited at the Bruno Bischofberger Gallery, Zurich (September 15–October 3).

Moved his studio, the *Interview* magazine offices, and all other operations to a former Consolidated Edison building at 22 East 33rd Street.

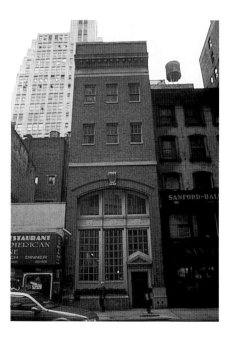

1985

Made *Absolut Vodka* paintings, which were used in "Absolut Warhol" advertisements. These were the first in a series of ads created by various artists.

Exhibited his *Invisible Sculpture*—consisting of a pedestal, a wall label, and Warhol himself displayed in a showcase—at the downtown nightclub Area.

"Andy Warhol's Fifteen Minutes" aired on MTV from 1985 to 1987. These half-hour programs, directed by Don Munroe, featured celebrities, artists, musicians, and designers, with Warhol as host.

America, with photographs and text by Warhol, published by Harper & Row.

Appeared as a guest star in an episode of the ABC television program "The Love Boat," produced by Douglas S. Cramer and Aaron Spelling.

Appeared in a television commercial for Diet Coke.

Began to be represented by the Ford modeling agency.

1986

Made *Last Supper* and *Camouflage* paintings.

Made *Self-Portrait* paintings, which were exhibited at the Anthony d'Offay Gallery, London (June 9–August 22).

The Dia Art Foundation, New York, mounted an exhibition of Warhol's 1960–62 hand-painted images (November 5, 1986–June 13, 1987).

Warhol's *Oxidation* paintings shown at the Larry Gagosian Gallery, New York (November 7–December 24).

Optioned the film and television rights to Tama Janowitz's book *Slaves of New York*.

Appeared in advertisements for the financial services company Drexel Burnham Lambert.

1987

The artist's *Last Supper* paintings shown at the Palazzo delle Stelline, Milan (January 23–March 21). Warhol attended the opening of the exhibition.

After suffering for years from medical problems, admitted to New York Hospital for gall-bladder surgery. The operation was successful, but complications during recovery caused Warhol's death the following day, February 22.

"If visitors can't see the original Last Supper, they can cross the street and see mine."

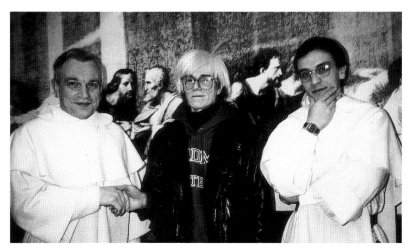

Overleaf:
Last Supper, 1986
Installed on the 4th floor, The Andy Warhol Museum

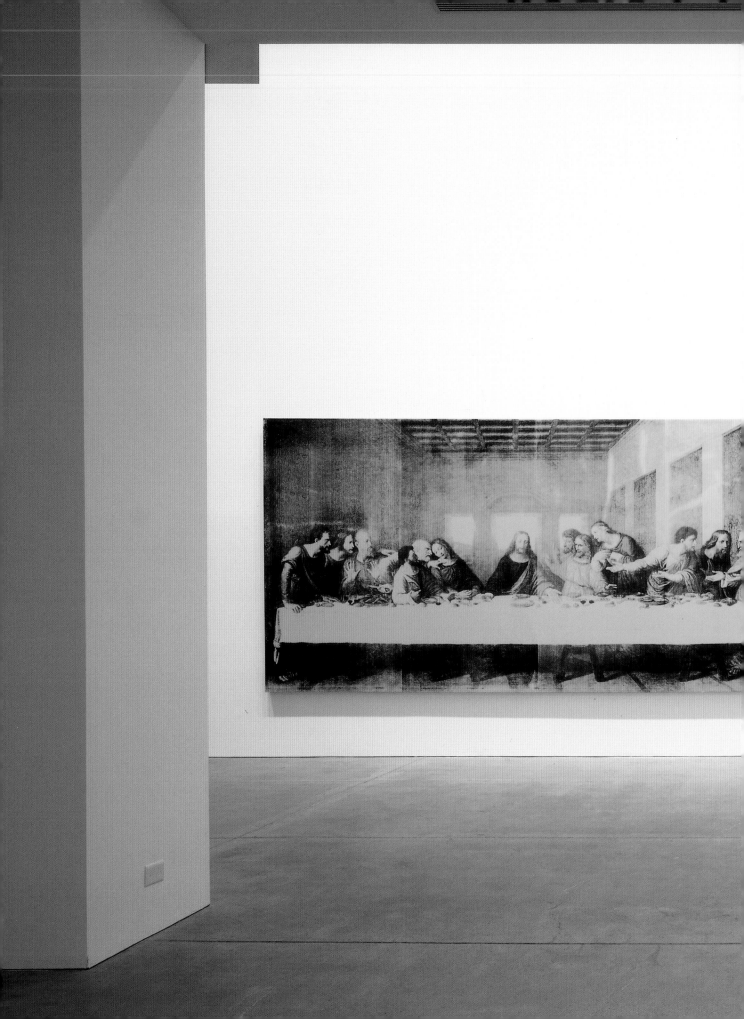

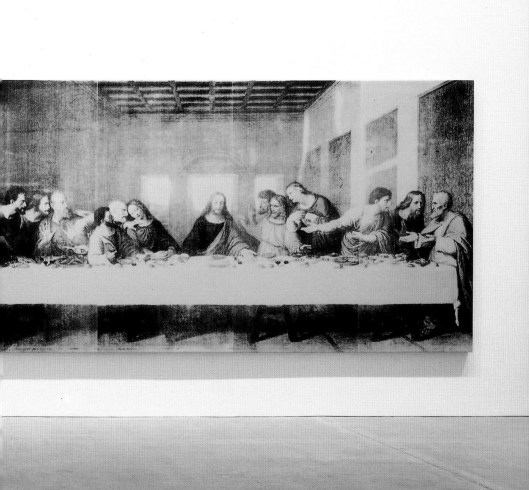

Richard Hellinger

THE ARCHIVES OF
THE ANDY WARHOL MUSEUM

On the night of February 22, 1987, Andy Warhol, having undergone a successful gallbladder operation, died in his hospital bed from an apparent cardiac arrest. His business manager and confidant, Frederick W. Hughes, and other close associates moved quickly to protect Warhol's art and property. His studio and house were sealed and their contents secured.

Unbeknownst to most of his acquaintances, Warhol had filled his town house at 57 East 66th Street with a treasure trove of fine art, furnishings, objets d'art, and jewelry — all uncatalogued and much of it tucked into shopping bags and boxes stacked in rooms so full that doors could not be completely opened or closed. Only the foyer, living room, kitchen, and Warhol's bedroom and bath were relatively free of clutter. The rest of the 27-room town house had served as a warehouse for the objects he acquired each day.

Sotheby's auction house was called in to inventory and sell the artist's personal property. A team of appraisers labored for months, producing a six-volume auction catalogue. News of Warhol's limitless collecting interests, ranging from "Canova to cookie jars," caught the public's imagination, and long lines of the curious formed in the days before the sale to view selected lots of his belongings. The auction spanned a ten-day period, from April 23 to May 3, 1988, and resulted in the sale of a staggering amount of "collectibles." Time magazine called it "the most extensive estate sale in history and one of the glitziest." Aside from the record $25.3 million it generated, the auction established Andy Warhol as an insatiable collector who was interested in everything and could part with nothing.

Dining room at 57 East 66th Street, 1987 195

Storage area at 22 East 33rd Street

Stairs at 57 East 66th Street

Warhol's will specified that the proceeds from the sale be used to create The Andy Warhol Foundation for the Visual Arts, which also received the artist's art and archives. When the Warhol Foundation, Dia Center for the Arts, and Carnegie Institute decided in 1989 to collaborate in establishing The Andy Warhol Museum, they agreed that the artist's entire archives should go to the museum as the basis for a research center devoted to Warhol and his work.

Left behind after the Ruhlmann furniture, the Folk Art and the Curtis photographs were carted away and sold by Sotheby's, the bags and boxes of archival material from Warhol's house included a revealing collection of the artist's source materials, business records, and ephemera. An even larger — and equally disorganized — group of archival items came from Warhol's studio at 22 East 33rd Street, the fourth and final Factory. Here, boxes on floor-to-ceiling shelving in the basement gave a semblance of order. Warhol had begun using one-and-a-half foot cubic boxes in the early 1970s to facilitate storing and moving the accumulations at the Factory. The contents of these boxes, filled on an almost daily basis by Warhol and his assistants, as well as the chaotic clutter of numerous shopping bags, steamer trunks, and assorted piles, make up a significant part of the archival collections of The Andy Warhol Museum.

The Warhol Museum archives currently consists of approximately 8,625 cubic feet of material. It includes 42 volumes of Warhol scrapbooks; the business records of Andy Warhol Enterprises; an entire run of *Interview*

magazine from 1969 to the present; 12,000 acetates; hundreds of brushes, paints and assorted artist supplies; an original set of silkscreens; Warhol's posters; more than 600 boxes Warhol called Time Capsules, as well as what are known as Miscellaneous and Idea Boxes; more than 10,000 hours of Warhol audio and video tapes; and numerous personal effects. In addition, the museum is actively soliciting documents and memoirs related to Warhol and his work from the artist's friends and associates, some of whom have already agreed to be interviewed as part of an oral history project.

Much about Warhol can be learned from the thousands of pieces of correspondence he saved — letters, postcards, bills, invitations, junk mail, etc. — which are scattered throughout the archival collections: a letter from a gallery owner turns up in a pile of canceled checks, while letters from a Warhol Superstar are found in a cookie tin containing used batteries and a broken camera.

Warhol, however, is seldom the author of any of the correspondence. Except for technical instructions to film processors and silkscreeners, telephone numbers jotted on scraps of paper, and an occasional postcard from his travels that he sent to his mother who had moved to New York to be near him, Warhol seems to have rarely written anything down and — aside from contracts for the exhibition or sale of his artwork — never to have carried on any formal correspondence about his art or the creative process that accompanied its making.

In place of written correspondence, Warhol con-

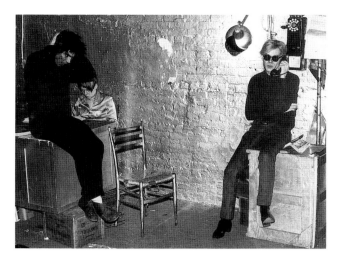

Andy and friends at the Factory

ducted most of his affairs—from business transactions and gallery negotiations to matters of love and friendship—on the telephone, using one of the pay phones at the Factory or his home phone. Warhol loved to talk on the telephone, and he routinely called someone first thing in the morning and last thing at night. He tape-recorded a great number of these conversations; the museum's archives contains more than 3,000 separate reels and cassettes of audiotape recordings, many of them highly personal.

The lack of written communication may have been one of the ways Warhol guarded his privacy. Indeed, he went even further, and actively disseminated misinformation about himself. Published biographical material about Warhol was almost always inaccurate. Exhibition catalogues often listed his birthplace as Philadelphia or McKeesport or Cleveland, and writers were frequently forced to make a random guess about his date of birth. In camouflaging the truth about his background, Warhol created an aura of mystery about himself.

Warhol remained a contradiction and enigma throughout his life, even to those who knew him best. While the public figure could be seen nightly, mingling with some of the most fashionable people at the most influential parties, the private man lived quietly with his mother, Julia Warhola. A symbol of all that was hip and countercultural, Warhol remained a devout Catholic who attended mass regularly. Although numerous people throughout the world viewed him as self-confident and irreverent, many of his associates saw him as shy and

apprehensive. These familiar and oft repeated descriptions of Warhol, however, tell only part of the story. It is precisely because so much remains to be discovered and understood that these archival collections are important and being made accessible.

While the Warhol Museum archives is divided into primary categories, researchers will not find the linear archival formats of more traditional collections. The apparent chaos within each category will be preserved because it accurately reflects the atmosphere of feverish activity that characterized the daily life of the artist and his studio. Reorganization of the material by conventional standards would lead to a significant loss of information. A fuller and truer understanding of the artist is gained by experiencing the capricious and chaotic structure imposed by Warhol than by examining individual items isolated from their original context. The challenge to the Warhol Museum is to maintain this apparent chaos while preserving the collections and making them accessible in a coherent way. Like a contemporary-culture archeological dig, the layers of disorder will reveal valuable insights into Warhol and his time.

One of the most illuminating of the archival collections is the group of boxes called Time Capsules. They are emblematic of Warhol's compulsive collecting habits and of his knack for finding purpose and humor in even the most mundane activities. Typically, he turned these boxes into more than a convenient way of storing his daily accumulations by declaring them to be Time Capsules. The concept for his Time Capsules originated in

the mid 1960s, but Warhol started making them in earnest in the early 1970s. The resulting collection of more than 600 boxes and file cabinets records every aspect of his daily life. After the Time Capsules are fully catalogued, they will stand as the most comprehensive record of Warhol the artist, filmmaker, author, publisher, music producer, businessman, celebrity, and collector. They will also serve as an intriguing window on American culture and society during those years.

The contents of the Time Capsules range from formal and somber to frivolous and humorous, and are always surprising. They offer invitations to the White House from the Ford, Carter, and Reagan administrations, as well as announcements to more hip engagments, such as film premieres, fashion shows, and Studio 54; letters and gifts from starstruck fans; and pleas and

harangues of the mentally deranged, including death threats scrawled in red ink by disappointed would-be Superstar, Valerie Solanas, who nearly made good on her threat to kill Warhol when she shot him at the Factory in 1968. After that, Warhol limited access to the Factory to close friends, well-known celebrities, potential clients, and employees.

Decorative paper boxes, designer perfume bottles, and brightly colored cookie tins are also found in the Time Capsules, as well as the newspapers Warhol preferred – the Daily News, the New York Post, and the Village Voice. On occasion he kept just the front page; at other times he threw the entire paper into the box. Magazines relating to the art and film worlds and a variety of underground publications and tabloid journals are also commonly found in the Time Capsules. They

Artist Materials: Tools and Supplies

Brushes, paint, canvas, stretchers, unused painting linens, painting scraps, solvents and inks, paper, and other supplies used in Warhol's art-making. Also audio, video, film, photography and computer equipment, tools, and hardware.

Idea Boxes and Miscellaneous Boxes

Idea Boxes: Warhol's personal collections packed by, or under the direction of, the artist. *Miscellaneous Boxes*: A great variety of material, including personal effects from Warhol's town house on East 66th Street and photographic imagery; some packed before the artist's death, others after.

Acetates and Silkscreens

A group of 24,380 objects, including ruby masks, tracings, maquettes, opaque-on-film, screened-on-mylar, trial proofs, stencils, carbons, and linens. Also 163 silkscreens mounted on their original frames, with some as large as 4 x 6 feet.

often contain an article about the artist or the Factory or, more significantly, a source image for one of Warhol's artworks.

Travel to exotic places provided yet another opportunity to collect. The in-flight menu, napkin, and embossed airline silver service, along with complimentary two-ounce liquor bottles, and cigarette packs, were all carted back to his house or studio and eventually deposited in a Time Capsule. Numerous photographs, an odd work of art, and many personal items continue to turn up as these boxes are catalogued.

While some Time Capsules record a single day's activity, others hold materials from a two- or three-month period, and the contents of many of them predate their actual creation. For example, Time Capsule #20 labelled "TC '60s Paulette Goddard's Shoes" does indeed contain a pair of Miss Goddard's shoes, but it is mostly filled with Julia Warhola's letters and personal articles from the 1950s. Time Capsule #4, dated 1968, contains a complete 12-week record of the correspondence received by Warhol when he was in the hospital recuperating from his gunshot wounds.

Another important part of the archives is an extremely rich collection of some 5,000 paper-based objects. Created shortly after Warhol's death in 1987 and now housed in the Archives Study Center on the third floor of the museum, it will serve as the initial archival research collection for museum visitors and Warhol scholars. Since the Study Center collection was drawn from various sources and organized after the artist's death, this material is arranged thematically and chronologically.

Study Center Collection

A small but informationally rich collection including sketches for Warhol's commercial and fine artwork, documentary photographs, and personal correspondence. Housed in the Archives Study Center on the third floor of the Museum.

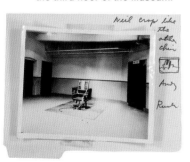

Audiotapes

A total of 3,110 audiotapes consisting of 2,394 Warhol cassettes, 431 Warhol reel-to-reel tapes, 156 opera reel-to-reel tapes, 71 Billy Name (Linich) opera tapes, nine Julia Warhola reel-to-reel tapes, as well as commercial cassettes of singers.

Warhol's Films on Videotape

Films that have been preserved by the Andy Warhol Film Project and transferred to videotape. The Andy Warhol Film Project is a joint effort between The Museum of Modern Art and the Whitney Museum of American Art, with the cooperation and support of The Andy Warhol Foundation for the Visual Arts, to research, preserve, exhibit, and distribute Warhol's films. Films will be added to The Andy Warhol Museum's collection as they are preserved and become available during the ten-year Film Project.

In spite of the relatively small size of the Study Center collection compared to the amount of material in the Time Capsules, it provides a wealth of historical, cultural, and aesthetic information spanning Warhol's entire career, from his earliest work in 1947 at Carnegie Tech to the last days of his life in 1987. Many of the images in recently published exhibition catalogues and scholarly books and journals came from this section of the archives.

Prominent in the Study Center collection are the source materials which show how Warhol used standard news service black-and-white photographs or a page torn from a teenager's fan magazine as the basis for a completed work of art. A dramatic example is the original photograph, bearing Warhol's cropping and written instructions for enlargement, which served as the source for the Electric Chair series of the 1960s. On the back of

this image is the chilling, previously unrecorded caption:

This is a view of the death chamber and electric chair in Sing Sing Prison at Ossining, NY, in which convicted atom spies Julius and Ethel Rosenberg are slated to be electrocuted. 1/13/53

Magazine illustrations depicting Hollywood stars or news events played an important part in Warhol's creative process. The Study Center collection has the original magazine clippings and photographs Warhol used for his portraits of Elizabeth Taylor, Tab Hunter, and Troy Donahue. The most striking image is the original 1953 publicity photo of Marilyn Monroe that served as the source for the Marilyn series of paintings.

The most disturbing imagery in the collection relates to the Disaster series Warhol did in the early to mid 1960s. These files document numerous scenes of

Business Records

Business records of the artist and Andy Warhol Enterprises including Montauk accounts, Andy Warhol Enterprises employee expense accounts, check stubs, canceled checks, unpaid bills, paid bills, IRS information, miscellaneous receipts, letters, bank statements, insurance policies, and assorted papers.

Scrapbooks

Forty-two volumes of press clippings from 1966 to the present relating to Warhol's work, his private life, and his public life. The small scrapbooks have plastic sleeves and pockets containing newspaper and magazine articles, miscellaneous invitations, announcements, and correspondence. The large scrapbooks have newspaper and magazine articles glued or taped on heavy black pages.

contemporary violence in America — car crashes, suicides, and assassinations — including news photos of the Kennedy assassination that provided Warhol with the source imagery for the Jackie series.

This portion of the collection offers significant insight into the way Warhol selected and manipulated mass-produced images of American popular culture. His choices and handling of imagery clearly exhibit a mastery of commercial and fine arts methods. These source materials further illustrate his uncanny ability to transform some of the most poignant and, at times, horrific representations of our culture into fine art.

Much of Warhol's active social life is recorded in the Study Center collection by appointment books, social calendars, and guest books. An outstanding example is the guest book from "Eothen," Warhol and Paul Morrissey's Montauk, Long Island beach house, which served as a summer gathering place for Warhol's entourage and friends, including Mick and Bianca Jagger, Lee Radziwill, Dick Cavett, and John and Michelle Phillips, among others. The Rolling Stones used the house as their rehearsal studio for their 1975 tour of the United States. The small bound book contains photographs, drawings, Polaroids, and poetry. The personal contributions of the guests reflect their intimate relationship with the artist and the Hamptons social scene during the early 1970s.

In addition to covering the 40 years of Warhol's creative output, the Study Center collection has many early documents, particularly photographs of the Warhola family. They include candid images of previous generations in Slovakia, as well as many photos from the artist's early years in Pittsburgh.

The fragility and value of most of the objects in the

Time Capsules

More than 600 one-and-a-half cubic foot boxes and standard-sized file cabinets, packed by Warhol or under his direction, containing materials related to a specific time and place.

Interview Magazine

A complete set of Andy Warhol's *inter/VIEW*, later renamed *Interview*, a monthly magazine, from the first issue of October 1969 to the present.

Interview Business Records

Various paper and microfiche documents pertaining to advertising, financial, and editorial matters, as well as subscription sales of *Interview* magazine.

Related Non-Warhol Collections

A collection-in-formation of archival documents, records, and memoirs of individuals related to Warhol and his work.

Non-Warhol Artworks

A diverse collection of art and materials collected by or given to the artist.

Warhol Museum archives prohibit unrestricted public access. To provide access while ensuring preservation of the original documents, the museum has long-term plans to create a digital database of the collections on a CD-ROM storage system. The database will give researchers the capability to search, display, and print images as well as text, and also allow them to listen to audio material from the archives.

In the meantime, six audio-video carrels are available in the Archives Study Center. Visitors will be able to see Warhol's video productions, such as The Factory Diaries, and videotape transfers of his motion pictures, including *Kiss*, *Lonesome Cowboys*, and *Trash*; listen to the entire collection of recordings by the Velvet Underground; and watch episodes from "Andy Warhol's TV" or his 1985 appearance on the network television series "The Love Boat."

Original documents, photographs, and artifacts from the archives will also be integrated into exhibitions throughout the museum on a rotating basis. These archival displays, together with the resources of the Archives Study Center, will play a key role in enriching the visitor's understanding of the range and depth of Warhol's accomplishments, and provide valuable insight into the times and circumstances surrounding his life and creativity. Through the vast and varied collections of The Andy Warhol Museum, this multitalented American artist will continue to surprise and delight the audience he loved best — everyone.

Clothing, Furniture and Collectibles

A sizeable assortment of clothing collected by or given to Warhol, and furniture, mostly desks, lamps, chairs, and decorative objects, many from his studios at 33 Union Square West, 860 Broadway, and 22 East 33rd Street. A few pieces date back to the artist's first, "silver" Factory at 231 East 47th Street.

Videotapes

All aspects of video work done by Warhol or for Andy Warhol Enterprises, beginning in the mid-sixties, for different media including television (many of the tape formats are now obsolete). Includes the earliest video productions, such as *The Factory Diaries*, and episodes of "Andy Warhol's TV."

Published Materials

Books published by and about Warhol, miscellaneous books owned by Warhol, hundreds of posters created or collected by Warhol, and Sotheby's six-volume Warhol estate auction catalogue.

Source images for **Jackie**, 1963-64
Collage and pencil on paper, 14 3/8 x 9 7/8 in. (36.5 x 25.1 cm)
Founding Collection, Contribution
The Andy Warhol Foundation for the Visual Arts, Inc.

Telephone, 1961
Synthetic polymer paint and silkscreen on canvas, 80 x 61 in. (203.2 x 154.9 cm)
Founding Collection, Contribution
The Andy Warhol Foundation for the Visual Arts, Inc.

This publication was organized for The Andy Warhol Museum by Doris Palca, publications consultant, and edited by Fannia Weingartner, with the help of Anna Jardine, Linda Olle and Joan Weakley. Research assistance was provided by Valerie Chirigos, Nina D'Amario, Tamara Embrey, Heloise Goodman of The Andy Warhol Foundation for the Visual Arts, Inc., Lisa Miriello, Jane McNichol, Scoti Nadig, and Kate Smith; Research for disc by Matt Wrbican, and Pier Djerejian.

Crowd, 1963
Pencil and silkscreen on paper
28 1/2 x 22 5/8 in. (72.4 x 57.5 cm)
Founding Collection, Contribution
The Andy Warhol Foundation for the Visual Arts, Inc.

Design: Bethany Johns Design, Bethany Johns and Georgianna Stout
Printing: Dr. Cantz'sche Druckerei, Ostfildern–Ruit bei Stuttgart
Printed in Germany

Photograph Credits

Claudio Abate, courtesy Schirmer/
Mosel: p.118 top
Cris Alexander: p.186 top right
Shigeo Anzai: p.57 top, middle
Stephen Barker © 1990: p.32
Sam Bolton: p.187 bottom left
Richard Bryant: p.47
Martin Bühler, Public Art Collection
Basel: p.45
Bruno & Eric Bührer Fotografik: p.43
middle two
Rudolph Burckhardt: p.80
Geoffrey Clements © 1992, Fairfield Porter,
Portrait of Ted Carey and Andy Warhol, 1960,
Oil on canvas, 40 x 40 in. Whitney Museum
of American Art: p.174
Bob Colacello: p.185 top left
Dan Cornish/ESTO © 1987: p.56
Nell Cox: p.123
Rainer Crone Archives: p.174 top right
Prudence Cuming Assoc. Ltd.: p.53 top right
Elly Davis: pp.174 lower left, 190 lower right
Lee B. Ewing © The Solomon R.
Guggenheim Foundation, Inc. p.48 left
Foto Felici: p.189 bottom left
Nat Finkelstein: p.180 top left
Jim Frank: p.78 left
Gianfranco Gorgoni: pp.108 bottom,
181 bottom right, 184 top, 187 top left,
188 bottom right
© Werner Graf: p.56, interior view
Gary Gråves: p.57 bottom
Bror H. Gustavsson: p.182 bottom right
David Heald © The Solomon R.
Guggenheim Foundation,Inc.: p.48
right and middle
Frank Heny: pp.26, 27, 59 top, 62, 68
bottom right
© Ken Heyman, Black Star: p.177 bottom
Evelyn Hofer: p.194
Dennis Hopper: p.178 top left
Bill Jacobson: p.58 top
R. W. Johnston Studios of Pittsburgh,
March 24, 1913: p.39
Jonas Portrait Photography: p.22 left
Per-Anders Jörgensen: p.50 top
Jane Lombard: pp.23, 30
© Roy Lichtenstein: p.80
Magnum: p.76
Christopher Makos: pp.186 top left,
187 top and bottom right, 189 bottom right,
191 bottom right
Gerard Malanga: p.20
© Fred McDarrah: pp.72, 176 top right,
179 right
Norman McGrath © 1987: p.196
Patrick McMullan: pp.181 top left,
187 middle right

Jeannette Montgomery: p.20
The Museum of Modern Art, New York:
p.82
Billy Name: pp.99 top right, 106 bottom,
111 bottom, 120, 127-131, 176 middle,
bottom right, 177 middle, 178 bottom right,
180 top right
Philip Pearlstein: p.170 bottom left
Phillips/Schwab: pp.110, 116, 117
Photo ISO: p.49 LeWitt installation
Rico Polentarutti: p.45 top
Grai St. Clair Rice: p.190 top right
Paul Rocheleau: pp.23 right, 28, 33, 35, 59
middle, 61, 66, 68 top, bottom left, 69-71,
192-3
Robert P. Ruschak: p.22 right
Doris Lockheed Saatchi: p.53 left
Steve Shapiro: p.179 middle left
Harry Shunk: p.188 top, back cover
Alfred Statler: p.175 bottom right
Richard Stoner: pp.2-3
Squidds & Nunns: p.52 interior view
Joseph Szaszfai, Yale University Art
Gallery: p.81
Jeanne Trudeau: p.36
© 1960 Turner Entertainment Co.: p.106 top
Thomas van Leeuwen: p.55
Bruce White: pp.175 top left, 177 middle
right, 181 bottom left, 183 bottom middle,
184 middle right, 185 top right